tips, inspiration and instruction in all mediums

How did you paint that?

100 ways to paint
SEASCAPES, RIVERS & LAKES
VOLUME 1

international
artist

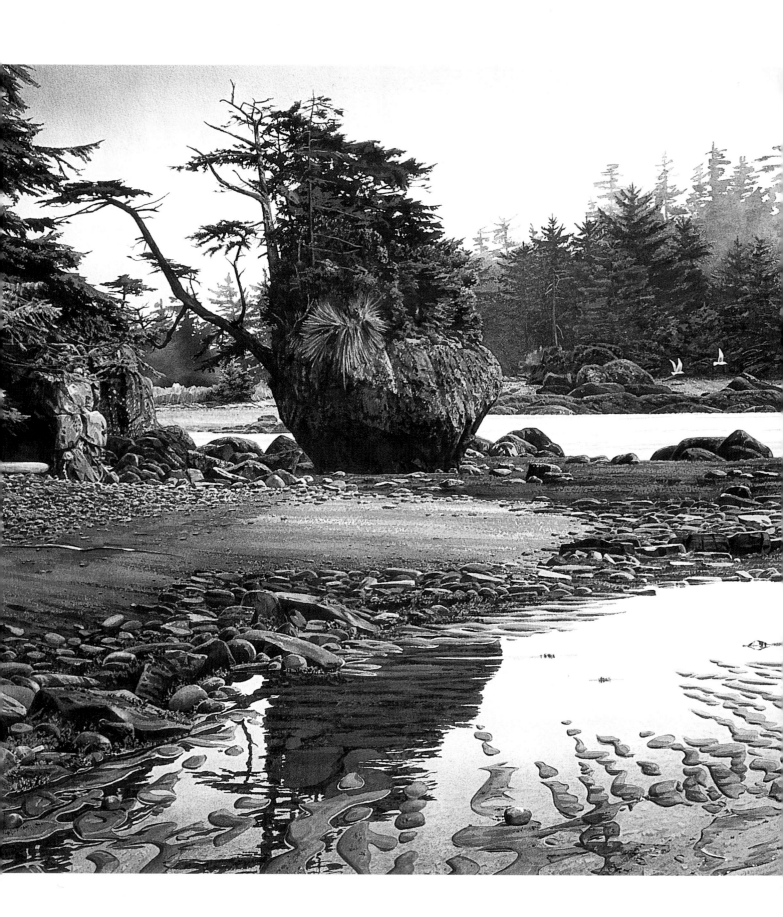

How did you paint that?

100 ways to paint
SEASCAPES, RIVERS & LAKES
VOLUME 1

international
artist

rol Evans, *Shaman's Rock*, watercolor, 27 x 42" (69 x 107cm)

International Artist Publishing, Inc
2775 Old Highway 40
P.O. Box 1450
Verdi, Nevada 89439

Website: www.internationalartist.com

© International Artist 2004

Edited by Larry Charles and Terri Dodd
Designed by Vincent Miller
Typeset by Cara Herald and Lisa Rowsell

ISBN 1-929834-45-4

Printed in Hong Kong
First printed in paperback 2004
08 07 06 05 04 6 5 4 3 2 1

Distributed to the trade and art markets in North America by:
North Light Books,
an imprint of F&W Publications, Inc
4700 East Galbraith Road
Cincinnati, OH 45236
(800) 289-0963

Oil

2, 3, 5, 9, 10, 11, 13, 16, 17, 18, 19, 23, 24, 25, 26, 27, 28, 30, 31, 32, 34, 35, 36, 37, 38, 39, 43, 44, 49, 50, 52, 55, 57, 59, 60, 63, 64, 65, 66, 68, 69, 71, 73, 74, 75, 78, 79, 80, 81, 82, 85, 91, 93, 95, 96, 100

Watercolor

1, 7, 14, 15, 20, 40, 41, 47, 51, 54, 61, 62, 67, 72, 77, 87, 89, 90, 99

Acrylic

4, 8, 12, 21, 45, 46, 48, 56, 84, 88, 94, 97, 98

Pastel

6, 22, 29, 33, 42, 53, 76, 83, 86, 92

Gouache

58

Encaustic

70

Acknowledgments

International Artist Publishing Inc. would like to thank the master artists whose generosity of spirit made this book possible.

Diane Ainsworth 81
Evelyne S. Albanese 25
Lorna Allan 84
Marilyn Allis 40
Kathy Anderson 57
Patrick Anderson 80
Willo Balfrey 53
Nikolo Balkanski 65
Martin Bashford 12
Lori Beringer 75
Betty J. Billups 3
Brian Blood 82
Winsome Board 6
Tom Bond 99
John Bowen 20
Gail Boyle 95
Bob Brandt 64
Roger Dale Brown 38
Ryan S. Brown 16
Armand Cabrera 36
Bruno Capolongo 70
Keith Cardnell 91
John L. Chapman 21
Jane Flavell Collins 61
Eugene Conway 49
Harold V. Coop 98
Kay Cornell 74
Susan M. Cottrell 33
Debi Davis 73
Andrew Dibben 67
Patrick Dillon 37
Robert Dutton 4
Alun Edwards 87
Carol Evans 1
Lorenzo Ferreiro 46
Carolyn Finch 85
Bill Fravel 54
Thomas Freeman 41
B.R. Gates 96
Jon Gerik 59
Paula Gottlieb 43
Susan Harley 56
Ray Harrington 9
Katherine Haynes 72
Steven Hileman 71
Mark Hobson 94
Philip V. Hopkins 79
Jean-Jacques Houée 8
Robert Jennings 58
Steve Johnson 89

Mike Barret Kolasinski 29
Aili Kurtis 76
Rosemary Ladd 23
Lynne Farmer Lehman 97
Christopher Leeper 48
Hongmei Lu 30
Barry McCarthy 93
Andrew McDermott 83
Angus McEwan 51
Carol McKue 19
Kevin McNamara 18
Christa Malay 22
Mary S. Martin 24
Alan Morley 100
William Mowson 77
Torgesen Murdock 28
Paul Murray 42
Donald Neff 45
Christopher Osborne 17
Ravi Paranjape 69
Joan Parker 13
Virginia Peake 50
Jeremy Pearse 31
Rachel Pettit 11
J. Richard Plincke 15
Barron Postmus 32
John Pototschnik 27
Camille Przewodek 2
Barry John Raybould 55
Vladimir Ribatchok 34
Karin Richter 90
Marguerite Robins 63
Joanne Sibley 7
Michael Situ 66
Kathy Smoker 92
Hodges Soileau 39
Stuart G. Spencer 68
Pornparn Sridhanabutr 14
Shirley Straford 5
Charles Syvertsen 47
Jonathan Taylor 86
Peter Taylor 60
William Ternay 44
John R. Todd 10
Oleksiy Turkot 52
Jiri Ustohal 62
Clay F. Wagstaff 78
Kerry Wales 26
Michael Wood 35
Jeff Yeomans 88

With special thanks to David Badcock, whose painting appears on the front cover

Message from the Publisher

We have taken the "learn by observing" approach six huge steps further.

Welcome to the latest title in our innovative 6-volume series. Each volume contains 100 different interpretations of the subject by outstanding artists working in the world today — in all mediums.

There are five more Volumes in the series, each tackling a popular subject. Titles you can collect are:

100 Ways to paint Still Life & Florals

100 Ways to paint People & Figures

100 Ways to paint Flowers & Gardens

100 Ways to paint Favorite Subjects

100 Ways to paint Landscapes

Turn to page 128 for more details on how you can order each volume.

Studying the work of other artists is one of the best ways to learn, but in this series of Volumes the artists give much more information about a favorite painting. Here's what you can expect from each of the Volumes in the series.

- 100 different artists give 100 different interpretations of the subject category.
- Each one gives tips, instruction and insight.
- The range of paintings shows the variety of effects possible in every medium.
- A list of colors, supports used, brushes and other tools accompanies each picture.

- The artists reveal what they wanted to say when they painted the picture — the meaning behind the painting and its message.
- Each artist explains their inspiration, motivation and the working methodology for their painting.
- Artists say what they think is so special about their painting, telling how and why they arrived at the design, color and techniques in their composition.
- The artists describe the main challenges in painting their picture, and how they solved problems along the way.
- They offer suggestions and exercises that you can try yourself.
- They give their best advice on painting each subject based on their experience.
- Others explain why they work with their chosen medium and why they choose the supports and tools they do.
- The main learning point of each painting is identified in the headline.

Each of the explanations shown in **100 Ways to paint Seascapes, Rivers & Lakes** was generously provided by artists who want you to share their joy of painting. Take the time to read each description fully, because you never know which piece of advice will be the turning point in your own career.

Vincent Miller

Vincent Miller
Publisher

If you were standing beside Australian artist, David Badcock, who created this painting, the first thing you would ask is, "David, how did you paint that?"

Then a multitude of other questions would follow, fed by your insatiable hunger to know what it is that goes into making a masterpiece like this.

Our series of books is the next best thing to having direct access to exemplary artists like David Badcock. And on your behalf, we asked them the burning questions that you would ask if you met them face to face.

Here's the kind of information and insight you can expect to find on the following pages from other generous artists in this book.

How I found my nugget of gold

my inspiration

The interplay of light between the elements inspired me. It was the most amazing sight I'd seen. And it was painted for me by nature.

my design strategy

My design plan was to have the refraction and reflection of light pull the eye in from the vertical third on the right. I worked the rest of the composition from there.

my principles of design

Tonal value was the most important. Followed by color in relation to tone; the alternating high contrasts that balance the dominance of the feature rock face; and a balance between warm and cool hues for coherence.

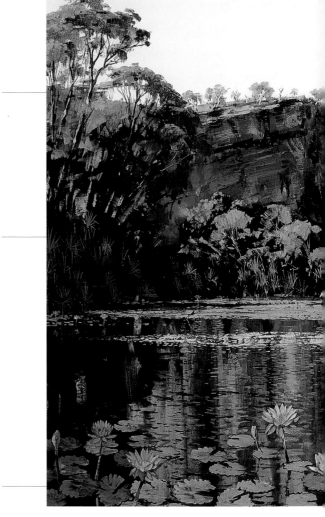

the eye-path

I used the sandstone outcrop to pull the eye in. Then, I used the reflections and lilies as a counterbalance to allow the eye to rest, linger and freely explore without being hooked in any one spot.

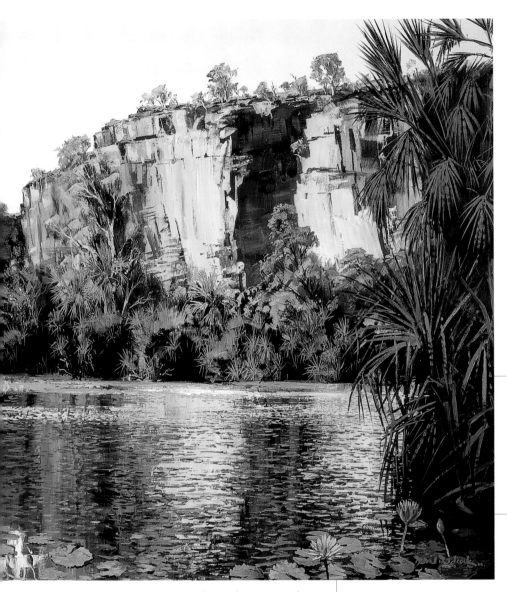

Colors of Another Day Passing, oil, 48½ x 73" (122 x 183cm)

the materials I used

support
Canvas

brushes
Hog-hair brushes

other materials
AS fat medium

Turps

oil colors

Cadmium Yellow	Yellow Ochre	Cadmium Red	Indian Red
Viridian Green	Cobalt Blue	Ultramarine Blue Deep	Lamp Black
Titanium White			

my working process

First I blocked in the skeleton of the subject quickly to cover the whole canvas. That was followed by the slow process of gathering information and collating. This is where my preliminary studies prove invaluable. (I only use photos for reference.)

my techniques

After blocking in the dark tones, I concentrate on the balance of the composition. I build a good, strong skeletal structure before introducing the mid-tones. Tone is the ultimate strength of a painting. Introducing color is the fun part: Bringing the painting to life.

my color plan

I use a primary palette because it gives me the control of how color is broken down tonally. It is easy to be carried away with pre-mixed colors, which can throw your whole palette out tonally. I do not rely on pre-mixes.

David Badcock lives in Port Douglas, Australia
Badcockdavid@hotmail.com

acrylic paint

Fast drying, waterproof, long lasting acrylic is an elastic paint that flexes and resists cracking.

Use it straight from the tube for intense color, dilute with water for transparent washes, or mix with an assortment of acrylic mediums to create texture. Available in tubes or jars, liquid or impasto, matte or gloss finish.
Binder: Acrylic resin emulsified with water.
Support: Flexible and inflexible, primed or unprimed.

alkyd

Looks similar to oil paints and can be mixed with them. Alkyds resist yellowing and they dry faster than oils.
Support: Prime flexible or inflexible surfaces first with oil or acrylic primer.
Binder: Alcohol and acid oil modified resin.

casein

This old medium, bound with skim milk curds, has mostly been overtaken by acrylic paints. However, casein is still available and many artists swear by it. The medium dries quickly to a velvety matte finish and is water-resistant when dry. It does become brittle, and if you apply too much, it can crack. Like acrylic paint, casein is versatile and can be applied as a thin wash or as an underpainting for oils and oil glazes. When it is varnished it looks like oil paint.

Support: Because casein does not flex like acrylics it is not suitable for canvas. Use watercolor paper or rigid surfaces, primed or unprimed.

egg tempera

This product uses egg yolk in oil emulsion as its binder. It dries quickly, doesn't yellow and can be used just as it is or diluted with water. Egg tempera will crack on canvas so only use rigid supports. Use as underpainting for oils and oil glazes.

gouache

This medium is opaque and can be rewetted and reworked. It comes in vivid colors.
Binder: gum arabic
Support: paper and paper boards. Dilute with water or use neat. Don't apply too thickly or it will crack.

acrylic gouache

This gouache uses water-soluble acrylic resin as the binder. Use it just like gouache, but notice that because it is water-resistant you can layer to intensify color.

oil

The classic painting medium. You can achieve everything from luminous glazes to opaque impasto. As the paintings from the Old Masters show, oil paintings can crack, yellow and darken with age. Oil paint dries slowly on its own, or the

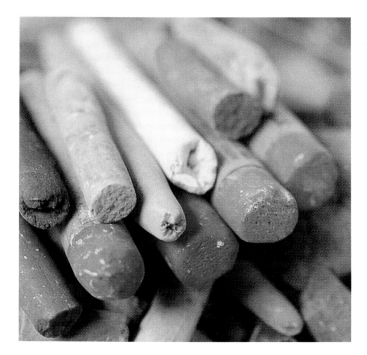

bud or soft brush. Hard pastels enable finer detail to be added as the work progresses or as a primary drawing medium for planning sketches and outdoor studies. Pastel pencils can be used for drawing and for extra fine detail on your pastel painting.

You can combine pastel with acrylic, gouache and watercolor. As long as the surface upon which you are working has a "tooth" (a textured surface that provides grip), then it is suitable for pastel.

Support: There is a variety of papers available in different grades and textures. Some have a different texture on each side. These days you can buy sandpaper type surfaces either already colored or you can prime them yourself with a colored pastel primer. Some artists prepaint watercolor paper with a wash and apply pastel over that.

water-soluble oil

A recent development. Looks like oil paint but cleans up in water instead of solvent. Dries like traditional oil. Use straight or modify with traditional oils and oil painting medium. Transparent or impasto.

Support: Canvas or wood.

watercolor

The pigments in this ancient medium are very finely ground so that when the watercolor paint is mixed with water the paint goes on evenly. Some pigments do retain a grainy appearance, but this can be used to advantage. Provided you let previous washes dry, you can apply other washes (glazes) on top without disturbing the color beneath. Know that watercolor dries lighter than it looks.

Watercolor is diluted with different ratios of pigment to water to achieve thin, transparent glazes or rich, intense accents of color. Watercolor pigments can be divided into transparent, semi-transparent and opaque. It is important to know which colors are opaque, because it is difficult to regain transparency once it is lost. Watercolor can be lifted out with a sponge, a damp brush or tissue.

Support: There are many different grade watercolor papers available from very rough, dimply surfaces to smooth and shiny. Different effects are achieved with each. Although a traditional method is to allow the white of the paper to show through, there are also colored watercolor papers available that allow warm or cool effects.

process can be accelerated using drying medium. There are many mediums that facilitate oil painting, including low odor types. Turps is widely used to thin oil paint in the early layers. Oils can be applied transparently in glazes or as thick impasto. You can blend totally or take advantage of brush marks, depending on your intention. Oil can be used on both flexible and inflexible surfaces. Prime these first with oil or acrylic primers. Many artists underpaint using flexible acrylic paint and then apply oil paint in layers. You can work oils all in one go (the alla prima method), or allow previous layers to dry before overpainting. Once the painting is finished allow as much time as possible before varnishing.

Binder: linseed, poppy, safflower, sunflower oil.
Support: Flexible and inflexible canvas or wood.

oil stick

This relatively new medium is artist quality oil paint in stick form. Dries faster than tube oils. Oil sticks allow calligraphic effects and they can be mixed with traditional oils and oil medium. Oil stick work can be varnished.

pastel

Use soft pastels to cover large areas of a painting. Use the side of the pastel to rapidly cover an area, either thickly or in a thin restrained manner. You can blend pastel with a finger, cotton

Find-it-Faster Directory

Color coded numbers let you quickly find the paintings you like,
all the methods and materials used and how each artist painted them

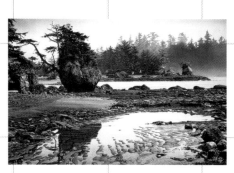

1 **Carol Evans**
Shaman's Rock
27 x 42" (69 x 107cm)
WATERCOLOR

Shape and direction

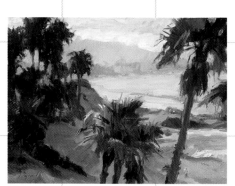

2 **Camille Przewodek**
The Jogger
12 x 16" (31 x 41cm)
OIL

Color and edges

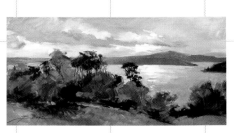

3 **Betty J Billups**
I Am the Sunlight
18 x 36" (46 x 91cm)
OIL

Balance

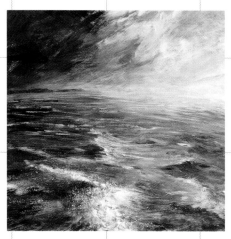

4 **Robert Dutton**
Distant Light Over Coastal Waters
20 x 20" (51 x 51cm)
ACRYLIC

Texture and contrast

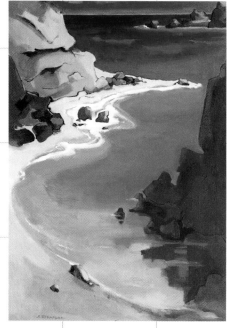

5 **Shirley Straford**
Coast Idyll
40 x 30" (102 x 76cm)
OIL

Complementary contrast and color

6 **Winsome Board**
Swimmers, Edith Falls, NT
17 x 8" (43 x 20cm)
PASTEL

Tonal contrast

7 **Joanne Sibley**
View Through Seagrape Trees
15 x 20" (38 x 51cm)
WATERCOLOR

Movement

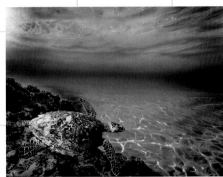

8 **Jean-Jacques Houée**
Blues des Mers
35 x 46" (89 x 117cm)
ACRYLIC

Message

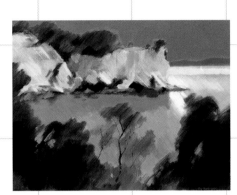

9 **Ray Harrington**
Gemstone Bay
14 x 18" (36 x 46cm)
OIL

Design

10 **John R Todd**
Flagstone & Shingle
22 x 17" (56 x 43cm)
OIL

Design

11 **Rachel Pettit**
Reflections on a Gray Day
18 x 24" (46 x 61cm)
OIL

Mood

12 **Martin Bashford**
Bay of Ghosts
10 x 15" (25 x 38cm)
ACRYLIC

Glazes

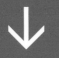

Find-it-Faster Directory

Color coded numbers let you quickly find the paintings you like,
all the methods and materials used and how each artist painted them

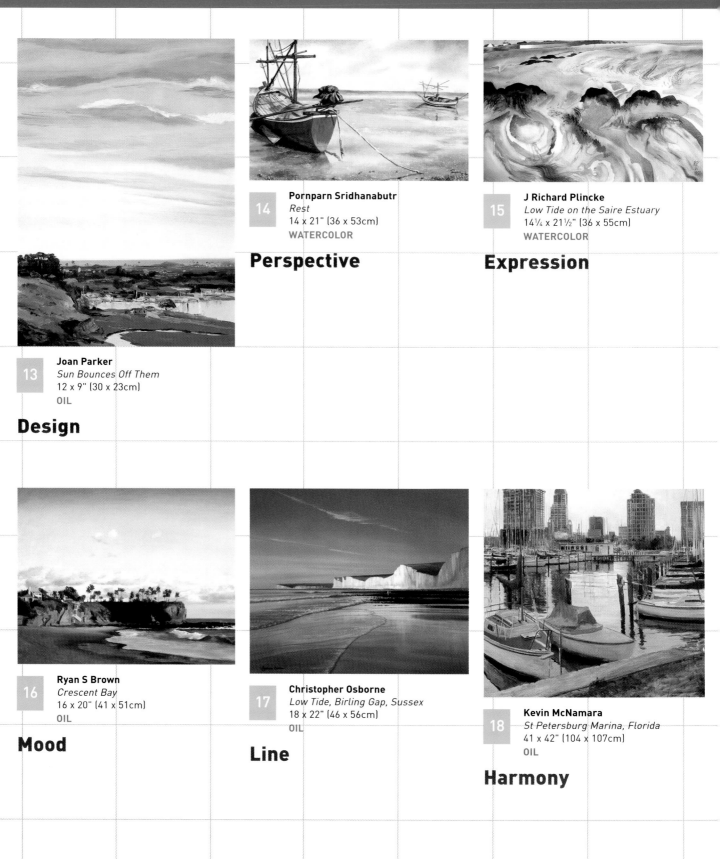

14 **Pornparn Sridhanabutr**
Rest
14 x 21" (36 x 53cm)
WATERCOLOR

Perspective

15 **J Richard Plincke**
Low Tide on the Saire Estuary
14¼ x 21½" (36 x 55cm)
WATERCOLOR

Expression

13 **Joan Parker**
Sun Bounces Off Them
12 x 9" (30 x 23cm)
OIL

Design

16 **Ryan S Brown**
Crescent Bay
16 x 20" (41 x 51cm)
OIL

Mood

17 **Christopher Osborne**
Low Tide, Birling Gap, Sussex
18 x 22" (46 x 56cm)
OIL

Line

18 **Kevin McNamara**
St Petersburg Marina, Florida
41 x 42" (104 x 107cm)
OIL

Harmony

You'll find all the information you want about how each painting was created by turning to the tab number indicated, in sequence from 1 to 100

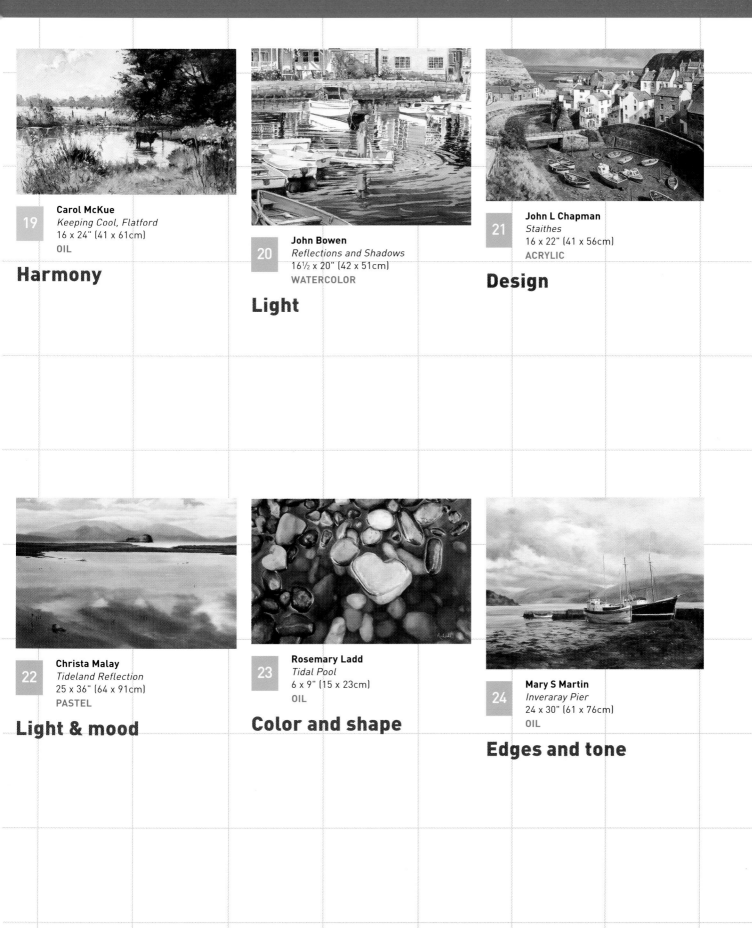

19 Carol McKue
Keeping Cool, Flatford
16 x 24" (41 x 61cm)
OIL

Harmony

20 John Bowen
Reflections and Shadows
16½ x 20" (42 x 51cm)
WATERCOLOR

Light

21 John L Chapman
Staithes
16 x 22" (41 x 56cm)
ACRYLIC

Design

22 Christa Malay
Tideland Reflection
25 x 36" (64 x 91cm)
PASTEL

Light & mood

23 Rosemary Ladd
Tidal Pool
6 x 9" (15 x 23cm)
OIL

Color and shape

24 Mary S Martin
Inveraray Pier
24 x 30" (61 x 76cm)
OIL

Edges and tone

↓

Find-it-Faster Directory
Color coded numbers let you quickly find the paintings you like, all the methods and materials used and how each artist painted them

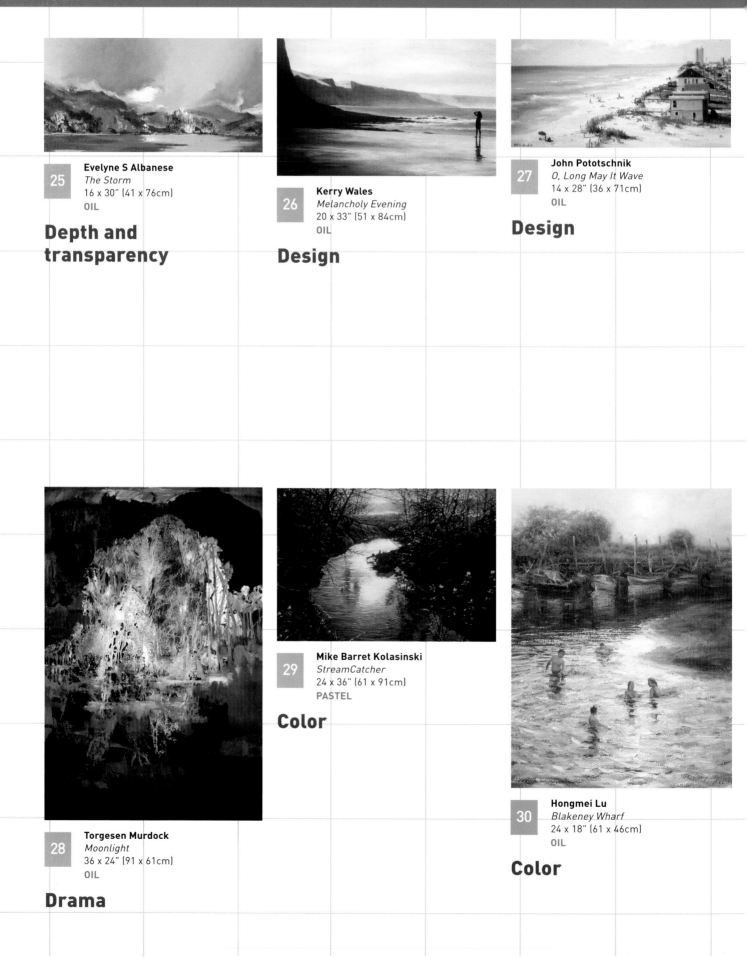

25 Evelyne S Albanese
The Storm
16 x 30" (41 x 76cm)
OIL

Depth and transparency

26 Kerry Wales
Melancholy Evening
20 x 33" (51 x 84cm)
OIL

Design

27 John Pototschnik
O, Long May It Wave
14 x 28" (36 x 71cm)
OIL

Design

28 Torgesen Murdock
Moonlight
36 x 24" (91 x 61cm)
OIL

Drama

29 Mike Barret Kolasinski
StreamCatcher
24 x 36" (61 x 91cm)
PASTEL

Color

30 Hongmei Lu
Blakeney Wharf
24 x 18" (61 x 46cm)
OIL

Color

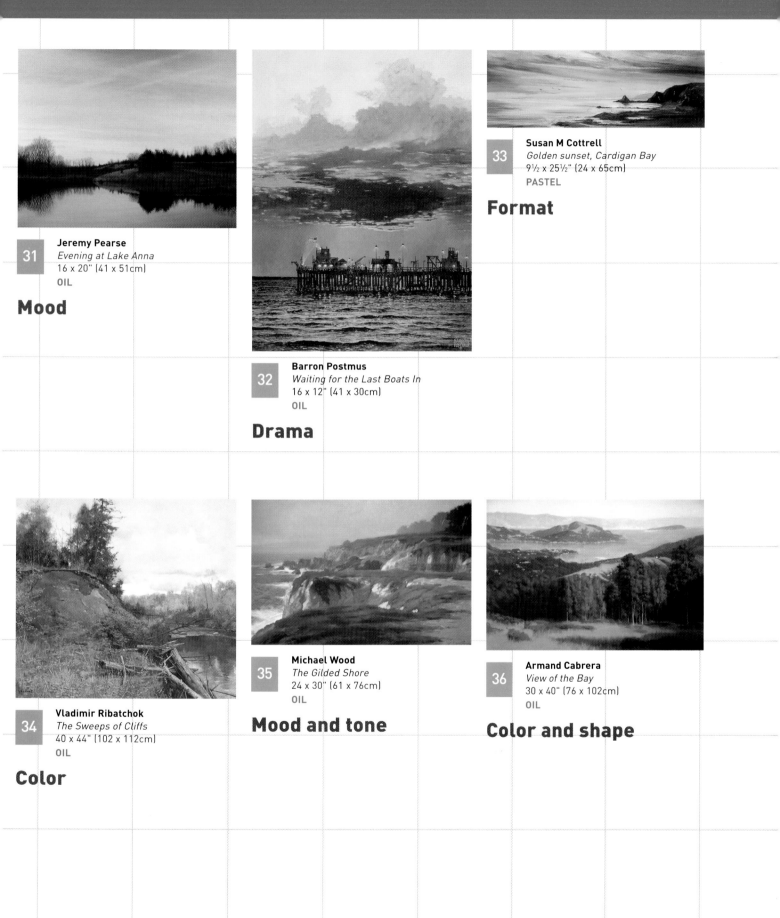

Jeremy Pearse
Evening at Lake Anna
16 x 20" (41 x 51cm)
OIL

31

Mood

Barron Postmus
Waiting for the Last Boats In
16 x 12" (41 x 30cm)
OIL

32

Drama

Susan M Cottrell
Golden sunset, Cardigan Bay
9½ x 25½" (24 x 65cm)
PASTEL

33

Format

Vladimir Ribatchok
The Sweeps of Cliffs
40 x 44" (102 x 112cm)
OIL

34

Color

Michael Wood
The Gilded Shore
24 x 30" (61 x 76cm)
OIL

35

Mood and tone

Armand Cabrera
View of the Bay
30 x 40" (76 x 102cm)
OIL

36

Color and shape

Find-it-Faster Directory

Color coded numbers let you quickly find the paintings you like,
all the methods and materials used and how each artist painted them

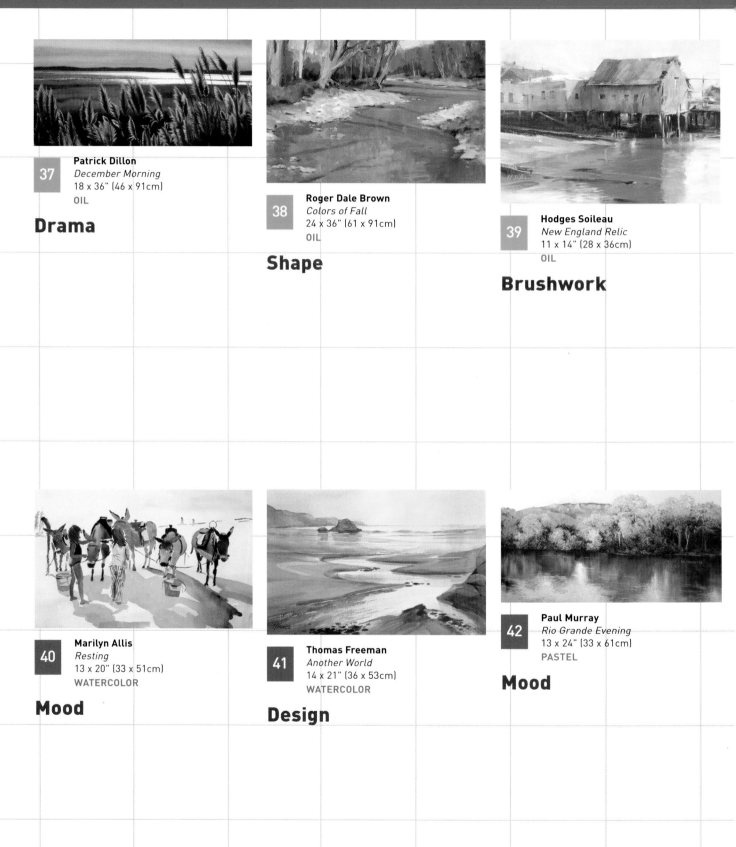

37 **Patrick Dillon**
December Morning
18 x 36" (46 x 91cm)
OIL

Drama

38 **Roger Dale Brown**
Colors of Fall
24 x 36" (61 x 91cm)
OIL

Shape

39 **Hodges Soileau**
New England Relic
11 x 14" (28 x 36cm)
OIL

Brushwork

40 **Marilyn Allis**
Resting
13 x 20" (33 x 51cm)
WATERCOLOR

Mood

41 **Thomas Freeman**
Another World
14 x 21" (36 x 53cm)
WATERCOLOR

Design

42 **Paul Murray**
Rio Grande Evening
13 x 24" (33 x 61cm)
PASTEL

Mood

You'll find all the information you want about how each painting was created by turning to the tab number indicated, in sequence from 1 to 100

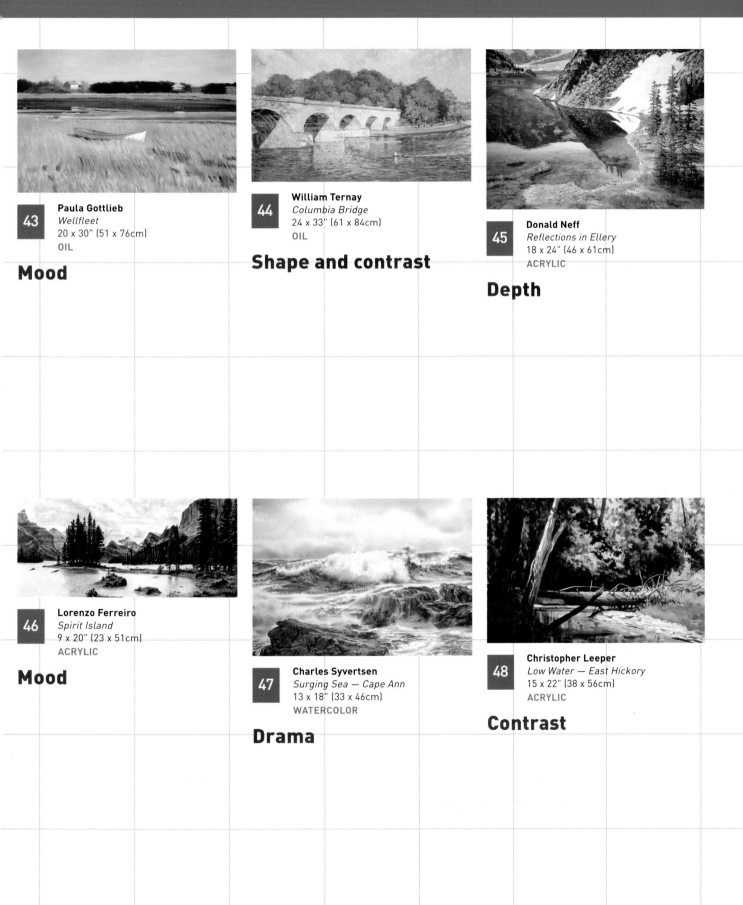

43 Paula Gottlieb
Wellfleet
20 x 30" (51 x 76cm)
OIL

Mood

44 William Ternay
Columbia Bridge
24 x 33" (61 x 84cm)
OIL

Shape and contrast

45 Donald Neff
Reflections in Ellery
18 x 24" (46 x 61cm)
ACRYLIC

Depth

46 Lorenzo Ferreiro
Spirit Island
9 x 20" (23 x 51cm)
ACRYLIC

Mood

47 Charles Syvertsen
Surging Sea — Cape Ann
13 x 18" (33 x 46cm)
WATERCOLOR

Drama

48 Christopher Leeper
Low Water — East Hickory
15 x 22" (38 x 56cm)
ACRYLIC

Contrast

↓ # Find-it-Faster Directory
Color coded numbers let you quickly find the paintings you like,
all the methods and materials used and how each artist painted them

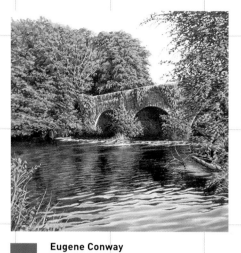

49 **Eugene Conway**
October Sunlight
30 x 30" (76 x 76cm)
OIL

Light

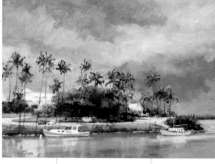

50 **Virginia Peake**
Safe Harbor
16 x 20" (41 x 51cm)
OIL

Color

51 **Angus McEwan**
Under the Boardwalk — Santa Monica, CA
33 x 26" (84 x 66cm)
WATERCOLOR

Contrast

53 **Willo Balfrey**
River's Magic Palette
11 x 19" (28 x 48cm)
PASTEL

Message

54 **Bill Fravel**
Past Ventana
20 x 28" (51 x 71cm)
WATERCOLOR

Design

52 **Oleksiy Turkot**
Sunrise On Icy Pond
36 x 24" (91 x 61cm)
OIL

Symbolism

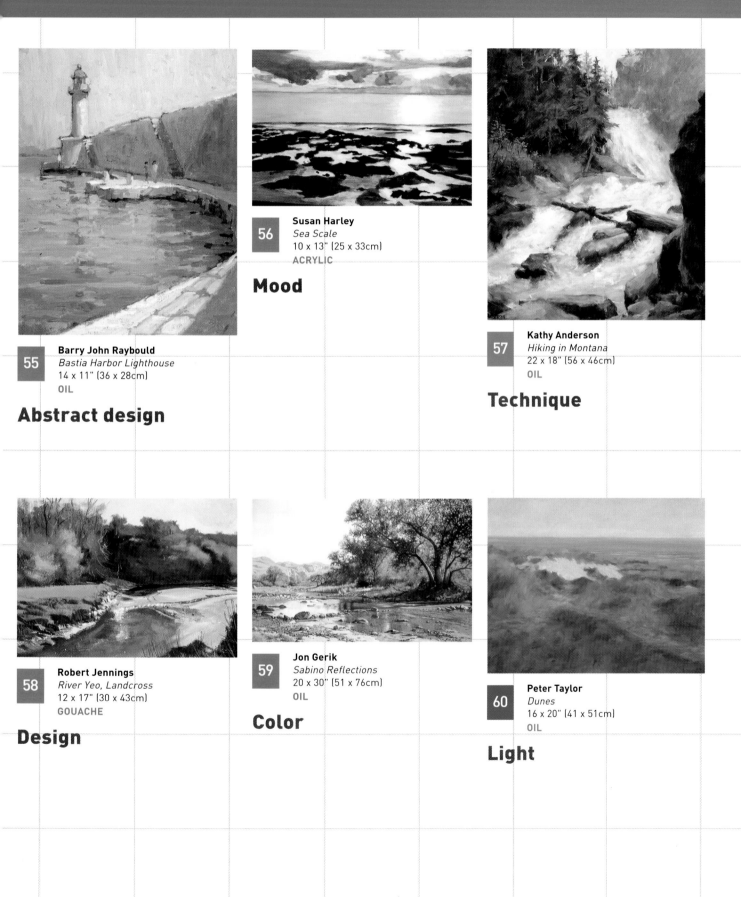

56 Susan Harley
Sea Scale
10 x 13" (25 x 33cm)
ACRYLIC

Mood

55 Barry John Raybould
Bastia Harbor Lighthouse
14 x 11" (36 x 28cm)
OIL

Abstract design

57 Kathy Anderson
Hiking in Montana
22 x 18" (56 x 46cm)
OIL

Technique

58 Robert Jennings
River Yeo, Landcross
12 x 17" (30 x 43cm)
GOUACHE

Design

59 Jon Gerik
Sabino Reflections
20 x 30" (51 x 76cm)
OIL

Color

60 Peter Taylor
Dunes
16 x 20" (41 x 51cm)
OIL

Light

Find-it-Faster Directory
Color coded numbers let you quickly find the paintings you like, all the methods and materials used and how each artist painted them

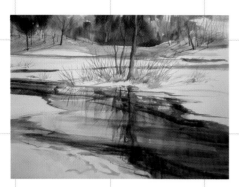

61 **Jane Flavell Collins**
Early Spring
18 x 24" (46 x 61cm)
WATERCOLOR

Mood

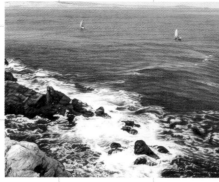

62 **Jiri Ustohal**
Sozopol, Black Sea
20 x 26" (51 x 66cm)
WATERCOLOR

Design

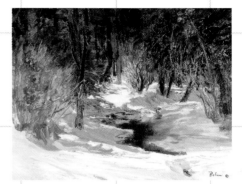

63 **Marguerite Robins**
River In December
16 x 20" (41 x 51cm)
OIL

Shape and tone

64 **Bob Brandt**
Near Huelgoat
18 x 26" (46 x 66cm)
OIL

Mood

65 **Nikolo Balkanski**
Chicago Creek, Colorado
30 x 40" (76 x 102cm)
OIL

Contrast

66 **Michael Situ**
Evening Light
18 x 24" (46 x 61cm)
OIL

Mood

You'll find all the information you want about how each painting was created by turning to the tab number indicated, in sequence from 1 to 100

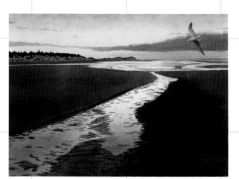

67 **Andrew Dibben**
Marauder — Thornham Beach
21½ x 29½" (55 x 75cm)
WATERCOLOR

Scale

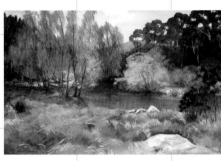

68 **Stuart G Spencer**
Fossickers Upper Hunter River Region
24 x 36" (61 x 91cm)
OIL

Color and mood

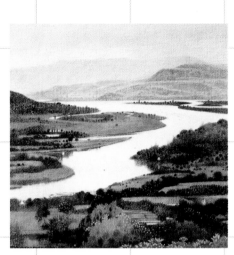

69 **Ravi Paranjape**
River Vasishthi
14½ x 14½" (37 x 37cm)
OIL

Symbolism

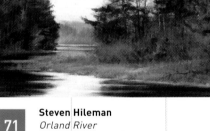

71 **Steven Hileman**
Orland River
8 x 16" (20 x 41cm)
OIL

Depth and mood

72 **Katherine Haynes**
A Rushing Torrent
15 x 22" (38 x 56cm)
WATERCOLOR

Design and tone

70 **Bruno Capolongo**
Water Snakes
17½ x 18¾" (44 x 48cm)
ENCAUSTIC

Technique

Find-it-Faster Directory
Color coded numbers let you quickly find the paintings you like,
all the methods and materials used and how each artist painted them

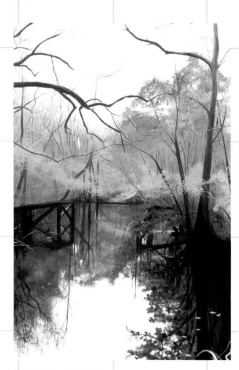

74 **Kay Cornell**
Morning Light
30 x 44" (76 x 112cm)
OIL

Tone

75 **Lori Beringer**
Cleansing
16 x 20" (41 x 51cm)
OIL

Design and color

73 **Debi Davis**
Reflections in a Blackwater Creek
28 x 22" (71 x 56cm)
OIL

Glazes

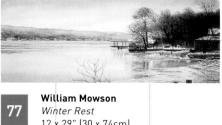

77 **William Mowson**
Winter Rest
12 x 29" (30 x 74cm)
WATERCOLOR

Color

76 **Aili Kurtis**
Killarney Dusk
18 x 24" (46 x 61cm)
PASTEL

Mood

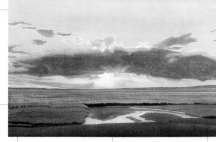
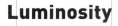

78 **Clay F Wagstaff**
Daybreak
44 x 36" (112 x 91cm)
OIL

Luminosity

You'll find all the information you want about how each painting was created by turning to the tab number indicated, in sequence from 1 to 100

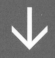

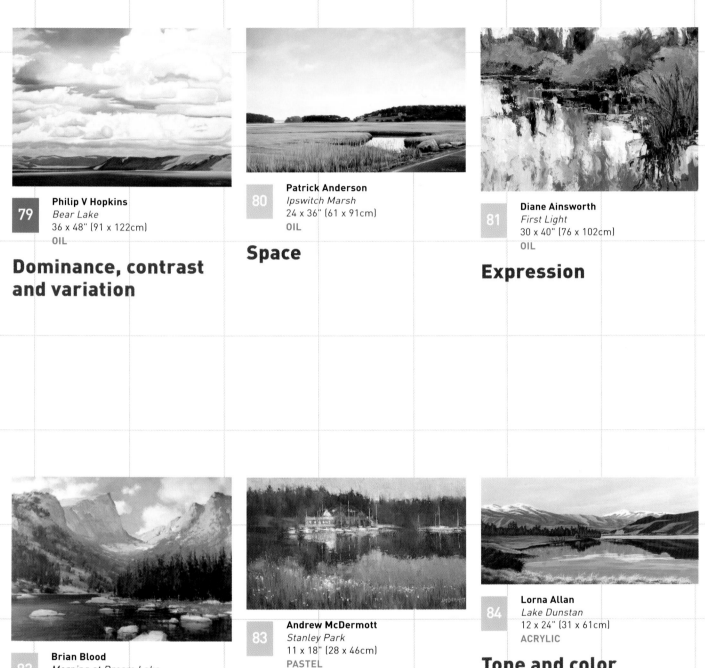

79 **Philip V Hopkins**
Bear Lake
36 x 48" (91 x 122cm)
OIL

Dominance, contrast and variation

80 **Patrick Anderson**
Ipswitch Marsh
24 x 36" (61 x 91cm)
OIL

Space

81 **Diane Ainsworth**
First Light
30 x 40" (76 x 102cm)
OIL

Expression

82 **Brian Blood**
Morning at Dream Lake
30 x 40" (76 x 102cm)
OIL

Design

83 **Andrew McDermott**
Stanley Park
11 x 18" (28 x 46cm)
PASTEL

Aerial perspective

84 **Lorna Allan**
Lake Dunstan
12 x 24" (31 x 61cm)
ACRYLIC

Tone and color

Find-it-Faster Directory

**Color coded numbers let you quickly find the paintings you like,
all the methods and materials used and how each artist painted them**

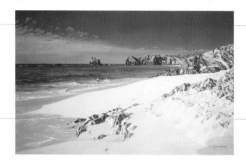

85 **Carolyn Finch**
Footprints
16 x 24" (41 x 61cm)
OIL

Eyepath

86 **Jonathan Taylor**
Boy Playing in the Shallows
15 x 22" (38 x 56cm)
PASTEL

Contrast

87 **Alun Edwards**
The Rocky Shore
11 x 14" (28 x 36cm)
WATERCOLOR

Shape and depth

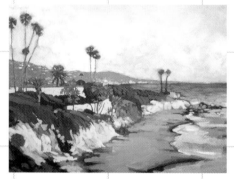

88 **Jeff Yeomans**
View of Diver's Cove
18 x 24" (46 x 61cm)
ACRYLIC

Tone and color

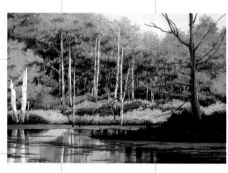

89 **Steve Johnson**
And the Greatest of These is Love...
18½ x 27" (47 x 69cm)
WATERCOLOR

Contrast

90 **Karin Richter**
Lake Louise Mood
22 x 30" (56 x 76cm)
WATERCOLOR/COLLAGE

Texture

91 **Keith G Cardnell**
Mid-Morning Cliché
24 x 36" (61 x 91cm)
OIL

Design

92 **Kathy Smoker**
Gold Coast Sunrise 1
22 x 15" (56 x 38cm)
PASTEL

Color

93 **Barry McCarthy**
The Frozen Grand
42 x 71" (107 x 180cm)
OIL

Color

94 **Mark Hobson**
Columbia River Flats
22 x 18" (56 x 46cm)
ACRYLIC

Color

95 **Gail Boyle**
Stillwater — A Touch of Heaven
20 x 30" (51 x 76cm)
OIL

Mood

96 **BR Gates**
Rocky Mountain Summer
18 x 24" (46 x 61cm)
OIL

Technique

Find-it-Faster Directory

Color coded numbers let you quickly find the paintings you like, all the methods and materials used and how each artist painted them

98 **Harold V Coop**
Mist and Light, Rakaia River, New Zealand
30 x 40" (76 x 102cm)
ACRYLIC

Technique

You'll find all the information you want about how each painting was created by turning to the tab number indicated, in sequence from 1 to 100

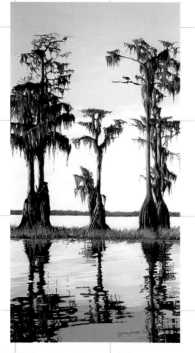

97 **Lynne Farmer Lehman**
Evening Cypress
48 x 24" (122 x 61cm)
ACRYLIC

Design

99 **Tom Bond**
Dune Shadows
22x 30" (56 x 76cm)
WATERCOLOR

Tone and color

100 **Alan Morley**
Where the Moors Meet the Sea
24 x 24" (61 x 61cm)
OIL

Technique

Softening my background made the sharper, darker important rock stand out.

Shaman's Rock, watercolor, 27 x 42" (69 x 107cm)

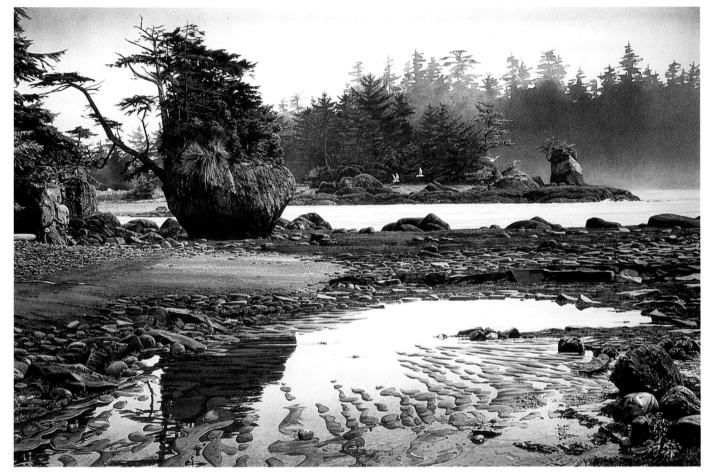

my inspiration

I was inspired by the bold shape of the rock with all its interesting growth and how it contrasted with the horizontal planes of the beach. It seemed like an unlikely quirk of nature, first, that such a massive boulder should be sitting out on the beach and, second, that it could support so much life.

The shape of the rock and the angle of the trees somehow reminded me of the brush strokes on a piece of Japanese raku pottery. It was such a striking scene in a very remote place. I wanted to paint it so others could see it. I learned that centuries ago, a Haida Shaman was buried at the summit and that the Haida people still call the rock by his name.

my design strategy

The main design strategy I used was to emphasize the horizontal bands in the painting of the background, mid-ground and

foreground. I wanted the bold vertical shape of the rock to stand out, so I made every effort to soften the background and sharpen and darken the rock. I found the island in the middle very interesting, so I included some of the details but muted it back so it wouldn't take away form the subject. I used the fanning fingers of sand in the foreground tidepool, as well as the reflection, to draw the eye into the painting.

my working process

• I made a rough sketch, then masked out the areas I wanted to keep light (the water, birds, foreground and mid-ground rocks) with art masking fluid.

• Then I did the washes for the sky, background island and, next, the water. I painted the mid-ground island and finally worked on the foreground.

• The rock itself was the last thing I painted.

• When that was completed, I went back and softened the background where needed to give the necessary contrast with the boldness of the rock.

special technique

The presence of sun is indicated in the foreground rocks and in streaks across the beach. Although it is minimal, without that suggestion of sunlight, the painting would have been too drab and dull, no matter how interesting the scene was.

what I used

300lb rag watercolor paper

other materials
paper stretcher
watercolor brushes
art masking fluid

watercolors

CADMIUM YELLOW

CADMIUM RED

PHTHALO BLUE

ULTRAMARINE BLUE

Carol Evans lives in British Columbia, Canada → www.carolevans.com

Camille Przewodek

I used intense color and hard edges in the foreground, and simple light shapes in the background.

The Jogger, oil, 12 x 16" (31 x 41cm)

my inspiration

The cool morning mists and softly sunlit surf are what attracted me to this scene along Laguna Beach's Heisler Park —probably the same factors that motivated the figure (who serendipitously showed up towards the end of the painting!) to take an early morning run.

my design strategy

The large foreground area of trees and sand, predominantly in shadow, provided a cool, clear contrast to the brightly illuminated palm fronds that have caught a few early rays of the rising sun. Using the placement of these sunlit areas, I tried to create a path of focal points which would direct the viewer's eye through the middle of the trees to the distant hills. There is an animated interplay between the not-quite verticals of the trees and the diagonals of the shoreline.

my working process

I started this study by attending to the big shapes, and to organizing my lights and darks. I made sure all my sunlit areas were light enough in value to stay within the sunlight, and all the shadow areas dark enough to stay within the shadow. The distant hills and water were blocked in with simplified shapes. These background area colors had to be neutral enough so they would stay in the distance, but still have enough relative brilliance of hue to indicate the sunlight passing through the moisture-laden atmosphere. If they were too pure, however, they would come too far forward. I tried to work quickly because everything was related, and I wouldn't know if my start was successful until I had covered the entire canvas. I intended to go back and add some hard edges and detail to finish off the painting later. It is always critical to think about the entire painting throughout the process and not just focus on small areas.

adding scale

Notice how the jogger in the lower corner gives scale to the trees. Also, I want the viewer to notice how simple the shapes are in the distance, and how they stay together in a color key. Note how the distant color stays back in the distance and how the foreground trees with their intense color and hard edges come forward.

what I used

Linen canvas
Palette knife
Painting medium

oil colors

Titanium White	Permanent Rose	Cobalt Green
Cadmium Lemon	Cadmium Red	Cadmium Green
Cadmium Yellow	Permanent Alizarin Crimson	Oxide of Chromium
Indian Yellow	Permanent Magenta	Ultramarine Blue
Yellow Ochre Pale	Permanent Green Light	Sevres Blue
Cadmium Orange	Viridian	Dioxazine Purple
Burnt Sienna	Emerald Green	

Camille Przewodek lives in California, USA → przewodek.com

I created a "yin-yang" balance of strong values and subtle, beautiful color and values of the sky and water.

I Am the Sunlight, oil, 18 x 36" (46 x 92cm)

my inspiration

I was on a five-week tour of southwest Ireland. Seeing this scene, I decided to capture the vastness of the field and sky. As I finished an 8 x 12" study, a small robin perched on the cattle gate I was standing next to, and looked at my painting, then at me, back at the painting, and at me again as if giving me its approval! That day was the anniversary of my father's passing, two years prior.

my design

When I got back to my room, the study looked rather boring, so I added the light in the sky, and brought it down into the water… creating a nice vertical.

Verticals create a sense of spiritual or intellectual emotions (thus, the great cathedrals, tall stately redwoods, spires that ascend into the sky all create a sense of awe). The added emphasis of the long horizontal of trees adds to the implied vertical of the light.

This piece was a studio piece, taken from an 8 x12" study, and was created for a show in Butte, Montana (one of the largest Irish communities outside of Ireland).

developing the plein air study

With this piece, since I love clouds, I allowed my colors to push what my plein air painting barely suggested: a feeling of space and added drama, with the addition of the warm reflections in the clouds themselves.

Also, by pushing the land mass down lower on the right, I created a flow earthward, thus opening the lake area, and allowing the sky to have a greater feeling of space and scale. The darkness of the trees created more luminosity with the sky and water, thus allowing those two areas to remain jewel-like in their values and colors.

horizontal versus vertical lines

In this piece, the distant mountains, along with the base of the tree line, create long horizontal lines. Horizontal lines create a feeling of earthiness. Vertical lines create a feeling of intelligence and spiritual connections. Diagonal lines create movement.

what I used

support
Linen canvas

brushes
Filberts and round bristle brushes

oil colors

other materials
Palette knife

Betty J Billups lives in Idaho, USA → www.billupsfineart.com

A journey across the sea created with analogous colors and my vigorous painting approach.

Distant Light over Coastal Waters, acrylic, 20 x 20" (51 x 51cm)

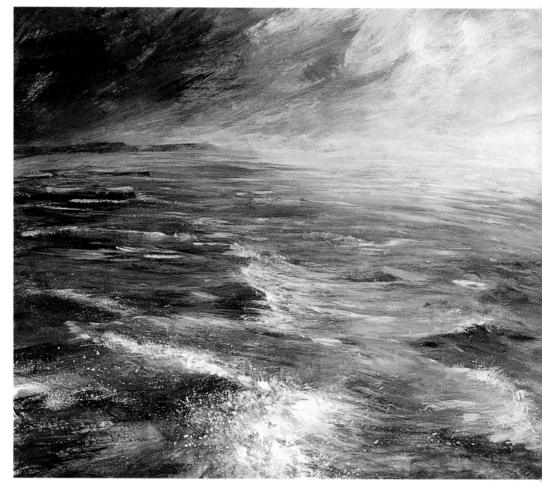

my inspiration

The inspiration behind this painting was the sea itself and my need to express this very elemental form and its ever-changing spirit that I find so compelling to paint.

my design strategy

Working from sketches, photographs and memory, I decided to give this expressive studio painting somewhat of a high curving horizon to suggest the global sphere of the earth, an added abstract element. The eye path was re-enforced through the waves and breakers with the low horizon light casting a shimmer over the ocean, naturally drawing the eye.

my working process

- I prepare my own painting surfaces from machined timber and cut MDF board. I coat this with several applications of gesso primer applied with large decorator's brushes. This gesso surface is manipulated with old rags, cloths, plastic scraper, torn card — in fact, anything that will ultimately make an interesting mark. Such textures add extra depth and an almost physical element to the finished painting's visual effects.

- Using predominantly analogous colors of the indicated and selected blues, at first I worked the mixes of paint with broad brushes, covering the surface in loose washes intermixed with thicker applications of paint, allowing all sorts of interactions to occur as the colors ran into one another.

- Working with acrylics has its advantages: The quick drying time is ideal for my painting methods of vigorous application, which is like a push and pull effect throughout the creative process, with paint being rubbed off, scraped back, manipulated, assessed, painted out then back in — all of which adds to the physical effect of working into a painting rather than simply painting onto a surface.

- Offering somewhat of an exotic touch, both acrylic Blue Interference Medium and Pearlescent Tinting Mediums were added to various mixes and layers of paint with stunning results, as yet more unusual subtle yet colorful effects were added to the painting.

- Depth of tone was created using mixes of Purple, Burnt Umber and Ultramarine Blue in various strengths to support the highlights and various subtle mid-tones. Mixes of Light Blue, Lemon Yellow and Emerald were added throughout the painting to create the turquoise effects of the sea. The land mass areas were created using mixes of Alizarin Crimson, Burnt Umber, Emerald and Lemon Yellow in various percentages to one another to build up and add hints of warm tones to an otherwise cold and stark painting.

- Final effects to the foreground waves were added using stiff old worn hog-bristle brushes "spattering" the paint between thumb and forefinger to express the ozone spray. This device was particularly effective as it offered a great deal of contrast, being light paint over dark.

what I used

support
6mm MDF board panel primed as described

brushes
Hog hair and acrylic, long handle flats, round and chisel brushes: #10, 12 18, 20, 24

acrylic colors
Titanium White
Pearlescent Tinting Medium
Light Blue Permanent
Brilliant Blue
Cobalt Blue (hue)
Interference Medium Blue

other materials
Old rags
Cloths
Canvas
Cut and torn card
Sponges
Scraper cling film
Decorator's brushes 10",8", 6", 4",1",½

Violet
Burnt Umber
Alizarin Crimson (hue) Permanent
Emerald
Lemon Yellow
Ultramarine Blue

Robert Dutton lives in West Yorkshire, UK → rdcreative@ntlworld.com

To achieve my goal I used strong contrast and complementary color.

Coast Idyll, oil, 40 x 30" (102 x 76cm)

my inspiration

Coastal views have always inspired me, with their crashing waves, rocky cliffs, inlets and beaches. My seascape was painted by combining two different locations and by introducing shapes and motifs to the scene to enhance the composition. I wanted to convey an atmosphere of a quiet beach, calm and deep sea, and the grandeur of rocky cliffs. To this end, I used strong contrasts of cool and warm complementary colors.

my working process

- After completing a few thumbnail sketches from my reference material, I roughly outlined the main shapes on my canvas with a #6 brush using Ivory Black paint.

- Keeping my paint thin, I roughly placed colors with one of my largest brushes so as to keep the image loosely suggested and simple at this stage.

- I next began the building up process of shapes and colors, using my paint a little thicker as I progressed. Some of the original shapes remained, some were changed.

- While working with large brushes, thickening the paint all the time, I aimed to keep color harmony throughout the painting; a little warmth in cool areas and a few cool accents in the warm areas.

- A few white areas were picked up more strongly at the edge of the beach, around the rocks and around the distant rock.

my color scheme

Because I frequently work with complementary colors, the choice I made with this subject was to balance the blue areas with warm orange-based colors, thus gaining maximum color vibrancey.

my advice to you

1. Keep your message simply stated.

2. Find the dominant shapes and work around these with the less important ones.

3. The balance of composition, color and good design form the foundation of all good paintings.

what I used

support
Oil-primed stretched linen canvas of medium texture

brushes
Flat #6, #8, #10 and #12

medium
Stand-oil based medium

oil colors

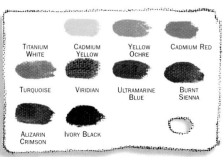

TITANIUM WHITE · CADMIUM YELLOW · YELLOW OCHRE · CADMIUM RED
TURQUOISE · VIRIDIAN · ULTRAMARINE BLUE · BURNT SIENNA
ALIZARIN CRIMSON · IVORY BLACK

Shirley Straford lives in Melbourne, Victoria, Australia → shirley_straford@iprimus.com.au

I chose pastels to capture the interplay of contrasting colors and the precise shape of the ripples.

Swimmers, Edith Falls, NT, pastel, 17 x 8" (43 x 20cm)

my inspiration

I wanted to share my amazement at the color of the plunge pool; the swimmers seemed to be immersed in liquid gold.

my design strategy

Because I wanted to focus on the subtle patterns in the water, I severely cropped several of my reference photos and studied the patterns in the water.

I cropped the top of the hill, wanting just enough of the hillside so the water patterns made sense.

This is predominantly a mid-tone painting, with small dark accents and no full light accents (even the waterfall is in shadow); this gives a feeling of serenity and peace.

The swimmers' heads are tiny but significant points in the composition, so I positioned them carefully.

The two bluish pathways lead the viewer into the painting to the swimmers, and the line of the dark shadow on the rocks cuts across the angled water shadows to give an implicit X, an integration symbol.

my working process

- Once I had visualised the structure and tonal balance, I selected a pinky-cream sanded pastel paper and painted the skeleton of the design in watercolor.
- The watercolor sepia tint underpainting had no strong darks, but enough to serve as a guide. I then applied soft pastels

working from the top down. Because I did not want a sharp tonal contrast against the sky to distract the eye from the swimmers, I broke the rocky silhouette with some small sunlit trees to reduce the tonal contrast of the rock against the sky.

On the rock face I kept a close tonal range for the detail of the rocks, except for a few critical dark shadows. The water was my main interest, so the tonal contrasts had to be most pronounced there.

- The only place I intentionally blended the pastel a little was in the distant water; for the most part I apply the pastel in distinct strokes, sharpening edges when necessary.
- After completing the water I surveyed the patterns which had evolved; they were not right. Because sanded paper can take several layers of pastel, I was able to adjust the colors to bring out the tonal patterns in my original concept.

using photographs

This was painted from photographs and my memory of the sensation. The light was changing so fast that as I scrambled to find a new viewpoint, the shadows had already changed. The color of the water intensified by the minute and only the camera was capable of capturing these changes. Because I had several photos, I could consider the various patterns at my leisure.

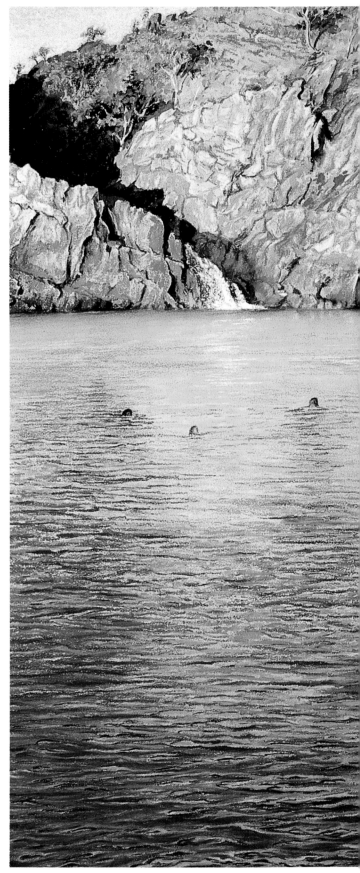

Winsome Board lives in Ravenshoe, Australia → winsomeboard@winsart.com

By creating its movement through color and design I shared my passion for the sea.

View through Seagrape Trees, watercolor, 15 x 20" (38 x 51cm)

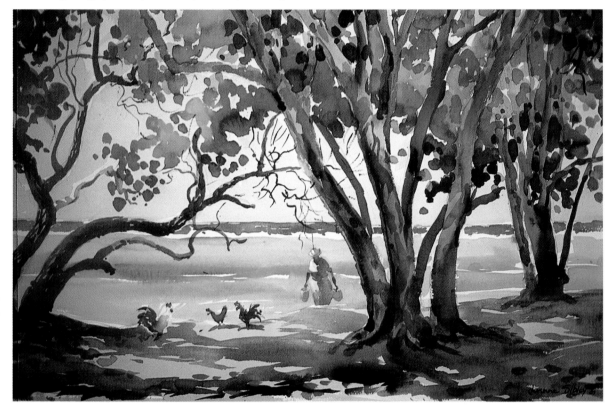

my inspiration

It was one of those days when the clarity of the light was just perfect. The color of the sea was breathtaking, a brilliant emerald green, turquoise and rich deep blue. The white of the large breakers was dazzling.

my design strategy

I decided on a horizontal format to enhance the sculptural forms of the trees framed against the broad expanse of the sea.

I planned to lead the eye into the painting and out to the sea through the trees via the hens silhouetted against the sea. I later added the figure to reinforce the focal point of the painting.

my working process

- I quickly set up my standing easel quickly with my stretched watercolor paper and paints.

- After deciding on my composition, I made a loose sketch on the paper, being careful to indicate the trunks and negative spaces of the foliage.

- I began with the sky trying to match the value and colors, usually cool at the top and warming to the horizon. While this area dried, I loaded the brush with a rich Raw Sienna and Alizarin Crimson mix, stronger than I thought was wise but that with luck would be right when dry.

- I laid In a mix of Ultramarine Blue and Alizarin Crimson along the horizon, observing the shape and position of the breakers. Leaving some white paper, I loaded my brush with Phthalo Blue and Phthalo Green for the distant water. Then I dropped Raw Sienna into this wet wash to suggest the shallow water at the shoreline.

- The tree trunks were painted with medium values of cool and warm colors.

- At the base of the tree trunks I added water and let the rich color dissolve into the lighter Sienna.

- I began the foliage, my brush loaded with dark green values, hoping to catch the tops of the tree trunks before they dried so that they blended together. I added Gamboge to the wash for the sunlit leaves, always following the original pencil lines that outline the pattern of negative spaces and worked as quickly as I could to complete the area. Before the wash dried, I dropped some Cadmium in for the turning leaves, a complementary color giving sparkle to this area.

- The foreground shadows were planned to help the composition and to indicate the undulating ground. I used a variation in values of cool and warm colors. To retain the luminosity of the shadow, it was very important to paint all the shadows in one go using transparent colors.

- Cool and warm shadows were added to the tree trunks giving them shape and solidity against the light sea.

- Finally I added the hens (in a loose manner), dried branches and leaves. I placed a few dark leaves in the mass of foliage where I felt it needed strengthening. The painting took about two hours to complete.

what I used

support
Cold press 140lb paper stretched on plywood

brushes
1" flat, a 9" round sable, rigger.

other materials
Easel
Heavy plastic palette
Two water jars
Paper towels

watercolors
Cadmium Yellow Light
Gamboge Genuine
Raw Sienna
Cadmium Orange
Burnt Sienna
Cadmium Red

Alizarin Crimson
Ultramarine Blue
Cobalt Blue
Phthalo Blue
Phthalo Green
Burnt Umber

Joanne Sibley lives in the British West Indies → Fax: 345-947-7273

Jean-Jacques Houée

My goal was to share my awareness of our planet's beauty and fragility.

Blues des Mers, acrylic, 35 x 46" (89 x 117cm)

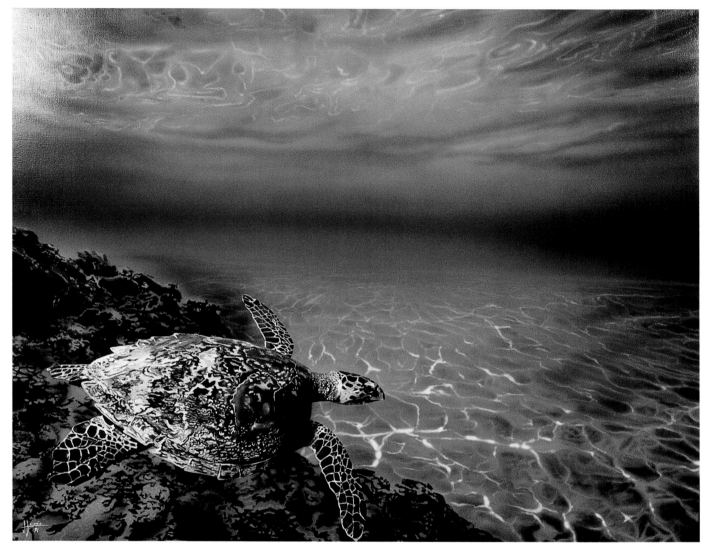

my inspiration

I wanted to make a self-portrait of my state of mind using an animal in its natural surroundings. I chose water, which makes up around 80% of the human body, and I chose a turtle to show nature's strength and fragility. The painting shows the turtle leaving its past (represented by the coral reef) and moving towards a serene future (represented by the horizontal depth). This movement explains the title *Blues des Mers*, a quest for peace.

my design strategy

I used different photos to define my composition. There are five basic elements in the painting: the surface of the ocean seen from below, the sea-bed, the immensity of the ocean, the coral reef and the turtle. They communicate together: the surface of the ocean caresses and lights up the sea-bed, the turtle caresses the coral reef… everything is serene. The turtle gives the composition movement.

my working process

I made several drawings before finding the final composition which expressed what I wanted to say. I experimented with the turtle's position, because the symbolic meaning changed with each attempt.

my color scheme

The dominating color in this painting is naturally blue… the blue of the sea, of the sky, of the universe. Everything is linked in blue, even a part of the turtle is blue. For me the blue in this picture represents serenity.

my advice

First, you have to define a composition which corresponds best with what you want to say.

Second, you have to keep your heart and mind open, and never consider that you have reached your destination. You must continue working to evolve. Last, if you want to paint water landscapes, you have to "breathe" water, and you must "go to the water." Looking at photos is not enough.

what I used

paint
The material used was acrylic paint. I always use the primary colors: red, yellow and blue, along with black and white, and I mix my own colors from those.

brushes
For this painting I used essentially mongoose-hair and martre brushes. For certain parts I used an airbrush. For the final touches, I brushed on a glossy acrylic varnish, which gives more depth to the dull colors.

Jean-Jacques Houée lives in France → www.atelier-houee.com

Too much sky would have killed my painting.

Gemstone Bay, oil, 14 x 18" (36 x 46cm)

my inspiration

The inspiration was immediate. The incredible green water caused by the reflection of pale cliffs was very seductive. I could have stayed all day, just looking.

my design strategy

Design was a priority here. Too much sky would have killed it. The balance of shapes within the painting was so important. The placement of the cliffs in the top third of the canvas was crucial, also the amount of distant space beyond the extremity of the cliffs on the right. The cliffs themselves have a warm stain which prevents the painting from becoming too cool. The painting is very tonal with the dark foreground foliage helping to accentuate the glowing colors in the water and the sky, which I deliberately deepened to contrast the highlights of cliffs and water.

There are many tonal changes, from deep sky to distant hills to pale water to cliffs to deeper water to deep foliage. The central foreground tree is also important in the design: It implies that you can see through it. It doesn't dominate, but it also helps tie some components together. It is significant that it is the only tree with any detail of trunk and branches.

my working process

I first gave the canvas a thin wash of blue which I rubbed in with a paper towel just to hide the white.

I then roughly blocked in the basic shapes of the composition, spending time here to get that all important design in a comfortable balance. Starting with the dark areas I blocked in the deep tones of trees using a flat bristle brush, about a #10 brush. Because of the brilliant colors of the subject,

I used Phthalo Blue as a major hue because of its powerful pigment.

Blocking in the sky and water gave me the overall shapes needed to satisfy me about the composition. I had a strong feeling that if I concentrated too much on detail, the painting would lose the freshness of the scene, so I stayed

with the larger brush for most of the work. Using strong directional strokes gave a crisp effect which I liked.

advice on technique

If you find your painting ends up looking overworked, try limiting yourself to using larger brushes.

what I used

support
Canvas board

oil colors

LEMON YELLOW · INDIAN YELLOW · CADMIUM SCARLET · PERMANENT ROSE

ALIZARIN CRIMSON · BURNT SIENNA · CERULEAN BLUE · PHTHALO BLUE

ULTRAMARINE BLUE · TITANIUM WHITE

Ray Harrington lives in Mount Irvine, New South Wales, Australia → raykat@lisp.com.au

My design gently lures the viewer's eye into the depths of the river.

my inspiration

Inspiration for this painting came while standing on a bridge spanning a river in the Scottish Highlands and peering down through the water at the color and formation of the rocks below the surface.

Wanting to explore the subject matter further, I found a more suitable viewpoint that allowed me to take in the far bank and still use the submerged rocks as the main focal point for the painting.

my design strategy

The strategy I used was to have a line of rocks emerging from the far bank directing the eye down into the center of the painting to investigate the colours and shapes on the riverbed.

my working process

I prepared a suitably proportioned board by applying three coats of acrylic primer. To this I added a patchwork of greens and earth colours blended with a rag to give me a varied base. This was then left to dry.

Starting at the top of the painting, a dense body of muted green was applied, gradually increasing the clarity of the rocks as the eye moves down to the foreground.

Small passages of shingle were then added to give slight variations of color and form to the riverbed.

At this stage the rocks emerging from the top of the painting were completed, and final highlights added to the foliage.

To complete the painting and add to the illusion of flowing water, I included the reflection of a line of trees against the sky.

the choice of medium

I chose to work with alkyds because of their rapid drying time and the need for me to capture this particular subject quickly while it was still fresh in my mind.

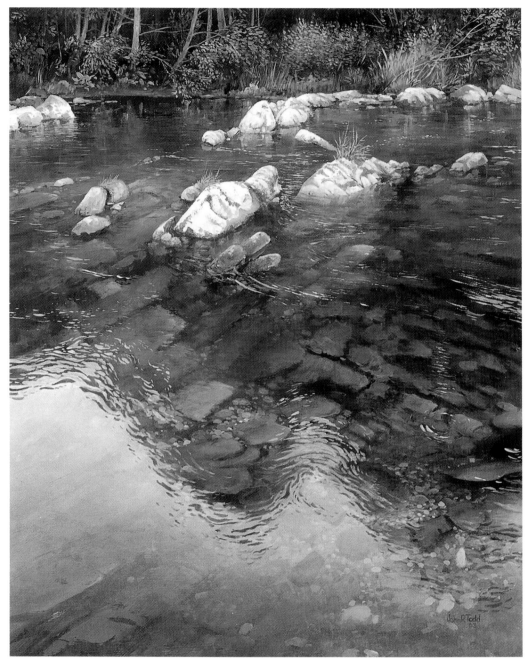

Flagstone & Shingle, alkyd, 22 x 17" (56 x 44cm)

what I used

medium
Alkyd painting medium
Artists turpentine

Brushes
Sable/Synthetic Mix
#4, #8 Round series
6, 12 Flat

alkyd colors

OLIVE GREEN VANDYKE BROWN BURNT SIENNA RAW SIENNA

COBALT BLUE TITANIUM WHITE

John R Todd lives in Moray, UK → todd@milnet.uk.net

I hope you can feel the quiet, reflective stillness that was created with subdued color and soft edges.

Reflections on a Gray Day, oil, 18 x 24" (46 x 61cm)

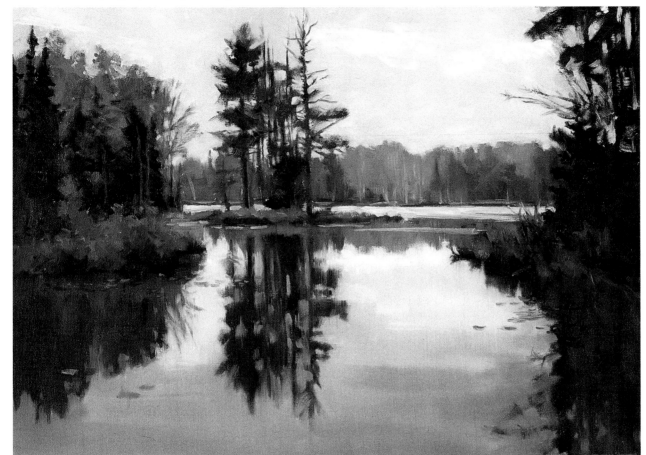

my inspiration

I'm usually not as inspired to paint landscapes on sunless days, but this lake, with its subdued color, high value contrast and still, quiet reflections enticed me to capture the essence of a peaceful day in the wilderness. I wanted the viewer to experience the same feeling of solitude and thoughtfulness that is present when there are no nearby manmade distractions.

my design strategy

The strategy in designing this painting was to draw the viewer past the foreground, deep into the depths of the far shore, after pausing to examine the island trees.

The element of light behind the darker foreground is key to creating the illusion of three dimensions (on a two-dimensional surface). This effect is also created by keeping the distant trees lighter in value and cooler in temperature than the darker foreground.

my working process

- I started painting directly on a white 18 x 24" stretched canvas. Using a #8 filbert bristle brush with a very dilute mixture of turpentine and Burnt Sienna, I roughly outlined the larger masses, making sure that no two were identical in size or shape. I also indicated the placement of individual larger trees, being careful to keep the composition balanced.

- Then, working dark to light, I started blocking in the darkest areas with broad, loose strokes. This was done to anchor the land and was achieved using a dark green mixture of oil colors (Phthalo Green, Burnt Sienna, and Alizarin Crimson).

- To make the farthest band of trees look more distant, I created atmospheric perspective by painting them lighter in value and cooler in temperature than the foreground.

- A small palette knife was used

to add detail and thicker paint in some areas, creating a variety of texture and line. The reflection of the sky was painted next, with deeper tones toward the bottom, being careful to "mirror" the trees above by painting around their reflections. The foreground brushstrokes of the water surface were softened, or blurred, by gently dragging a large, dry, flat bristle brush from the top edge of the reflection

to the bottom of the canvas, with the brush handle almost parallel to the surface of the canvas, repeating from left to right.

- I painted the sky last with a lighter version of the lake colors. The low clouds were added last with a large palette knife and a good amount of undiluted paint. The edges of this were then softened and defined with a large brush.

what I used

support
Acrylic primed canvas, stretched

brushes
#2, #4, #8 filbert bristle

#22 flat bristle

#00 synthetic

Palette knives, large and small

other materials
Odorless turpentine

oil colors

Rachel Pettit lives in Minnesota, USA → www.rachelpettit.com

Martin Bashford

Multiple glazes and fine brushwork made my painting come alive.

Bay of Ghosts, acrylic, 10 x 15" (25 x 38cm)

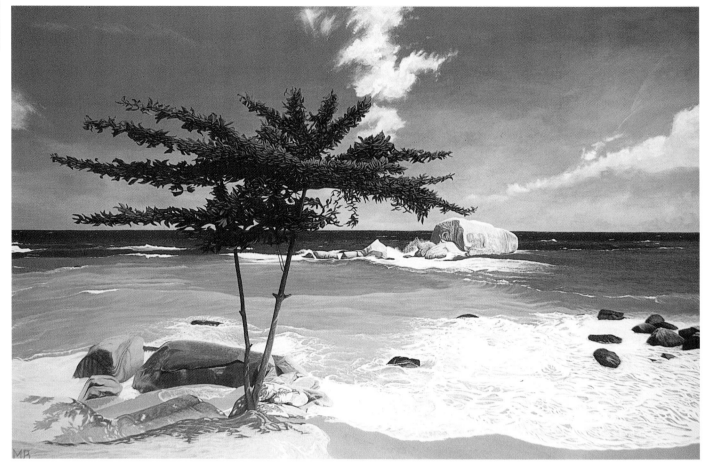

my inspiration

The rock in this bay in Thailand was so distinct that I felt I had to paint it. After a heavy thunderstorm the previous night, the tropical light and rough sea conditions brought it alive. I simply wanted to paint a realistic seascape with lots of detail which was pleasing to the eye.

my design strategy

The large rock in the bay is the focal point. The surf, rocks and tree all lead the eye towards the large rock, then leave the eye free to scan. This scene is completely natural. I walked around the bay until I found the view I wanted. The variation of color and movement of the sea was of primary importance to create a convincing scene.

my working process

- I worked directly from my own photographs and completed the painting during a long stay in Asia. The entire painting was created by glazing with transparent acrylics. The horizon and large rock were sketched and I began painting the sky, glazing to capture the brilliance and depth, carefully blending for a soft gradation of tone toward the horizon and light source using a medium filbert brush.

- The rest of the rocks and beach were laid out and underpainted, to be finished after the sea. The horizon was the starting point of the sea with the darkest tones and I worked toward the beach adding lighter and darker tones to create movement.

- The foam took most of the time as I added glaze upon glaze. The rocks and beach were finished off and the tree was sketched out and painted with glazes as the foam. The shadow of the tree was the last to be painted.

freezing the moment

This was painted from a series of reference photographs, that I managed to capture the whole scene. My biggest emphasis was on detail and the time it took to build up the glazes.

what I used

support
Cartridge paper

acrylic colours
Cobalt Blue
Cerulean Blue
Quinacridone Violet
Phthalo Turquoise
Dioxazine Purple
Raw Umber

brushes
Filbert # 4 and #2, #0, #000 Rounds

Cadmium Yellow Medium
Titanium White
Payne's Gray
Cadmium Yellow Light
Phthalo Green Yellow Shade
Alizarin Crimson

Martin Bashford lives in Sussex, UK → natthecat@tiscali.co.uk

The natural S-shape pulls the eye toward the ships and their reflections.

Sun Bounces Off Them, oil, 12 x 9" (30 x 23cm)

my inspiration

I live in the Midwest, but returned to my native California for three intensive weeks of plein air painting. It was a homecoming of sorts, but also new because my intent was very specific, in no way casual. The immediacy of the light on water drew me in. I painted over a two-hour period in the late afternoon light as the colors along the coast washed out to pale warms and cools.

my design strategy

Composition is always my first decision, approached initially through drawing. The estuary formed a natural "S" that pulled my eye to the ships and their reflections. I intentionally cast them as my focus and made sure other elements were less detailed, essential, but supportive.

my working process

- I paint exclusively from life, primarily plein air (outdoors). With this piece, I began by drawing three sketch book layouts. After choosing from the three, I drew it to scale on the canvas.

- I laid in the dark and middle values. My French easel supported a large palette of oils with plenty of room to mix a wide array of value and color temperature. I utilized no medium or turpentine in order to keep the color brilliant.

- Secondly, I captured the lightest colors throughout the painting, employing a broad range of brush sizes. Their application was varied in order to create atmosphere and depth.

- As important as my brushes were, my straight edge and palette knife were also essential. The straight edge allowed me to control edges in varying degrees from soft to hard. The palette knife was applied to smooth areas and also for mixing paint.

- After refining my edges, I reinforced the direction of the sunlight as it struck the skyline, water, ships, their reflections, and the edge between land and water.

- I reviewed the piece as a whole, re-connecting with the intuitive spark that initially drew me to the spot. I used different tricks to help suspend my literal tendencies. I viewed the piece from different points of view, upside down, from a distance, through a mirror, etc. Satisfied, I stopped, deliberately allowing viewers to have their own interpretation.

what I used

support
Canvas

oil colours
Cadmium Orange
Indian Yellow
Red Violet
Blue Violet

Ultramarine Blue
Cerulean Blue
Green Earth
Golden Green

brushes
#1, #4, #10, #20 Bright
#4, #6 Flat, #4, #6 Fan
#1, #3 Round

other materials
Mirror
Straight edge
palette knife

Warm Gray
Indigo
White

Joan Parker lives in Kansas, USA → www.joanparkerfineart.com

Pornparn Sridhanabutr

Dimension and depth combine as a design strategy for this sunlit fishing boat painting.

Rest, watercolor, 14 x 21" (36 x 53cm)

my inspiration

Prachuab Bay is one of the many tourist attractions in the south of Thailand. It is also one of the main fishing areas. After having been out to sea, fishermen rest their boats on the sandy beach. On a bright sunny afternoon when the tide was low, there were pools of sea water left on the sand. The reflection of the golden color of the sand contrasting beautifully with the blue sky was so impressive that I took several pictures of it.

my design strategy

I chose the red boat as the main subject of the painting. The contrasting colors of the red boat and blue sky would be quite an attractive composition. I also added texture on the sand in the lower part of painting, showing the sand grain and seashell bits. The rope serves as an eyepath to the boat, and the distant blue boat adds depth to the painting.

my working process

- I painted the sky with a wet-on-wet technique, then the sea and the patches of water on the sand. Then I flicked masking fluid to make seashell bits and sand grain. The far away sand ground was painted wet-on-dry with quick brush strokes.
- Lastly, I painted the reflection of the boats and shadow.

photography tip

I used a wide-angle lens to take a number of photographs from various angles to create this effect. The camera can keep the exact condition of light and shadow at the moment so that I can choose the best photograph to sketch later.

what I used

support
300gsm rough watercolor paper

brushes
#2, #6, #8 Rounds and smaller brushes for details

watercolors

other materials
Masking fluid and old brush
Rubber eraser to remove the masking

Pornparn Sridhanabutr lives in Bangkok, Thailand → pornparn_sri@yahoo.com

For me, expressiveness counts for more than photographic accuracy.

Low Tide on the Saire Estuary, watercolor, 14¼ x 21½" (36 x 55cm)

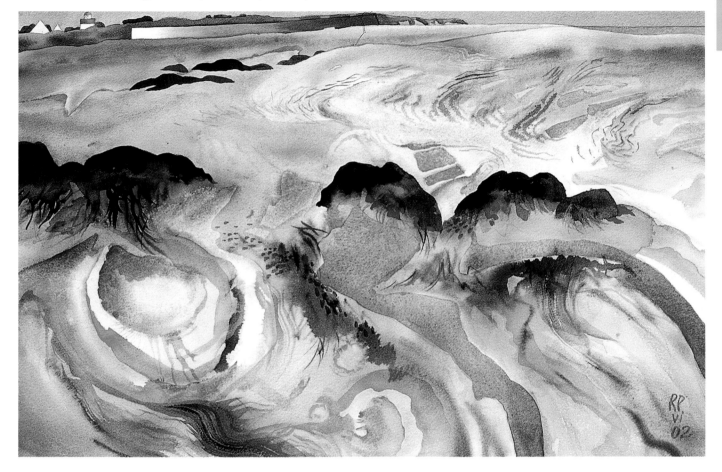

my inspiration

The Saire Estuary edges a two-mile stretch of sand at low tide, with the mussel beds of St. Vaast-la-Hougue at the far end. I hoped that with this painting I might perhaps capture the quality and visual interest of pools of water amongst rocks and ribbed sand rising away to a far horizon.

my design strategy

The first step, as so often, lies in my sketchbook, the start of my thinking processes. Most ideas evolve naturally and instinctively from those first outlines.

my working process

In the painting process, minor exaggerations take a more finite form as the work proceeds, emphasizing the qualities of the scene that attracted my attention in the first place. It is important, too, to keep the skyline thin, thus increasing the feeling of great distance.

For the purpose of this painting, considerable use was made of a two-inch flat brush in rapidly laid washes with plenty of well-pigmented water. Some effects have been added using a fan-brush, particularly at the rock pools.

Main colors were made up in Raw Sienna, varied by touches of Cadmium Yellow and Naples Yellow. Areas of water vary from Cobalt to Manganese Blue, with touches of Violet for deepened effect. Keeping hard outlines at a minimum, much care was taken with tonal gradation in the distant wall.

my sketchbook philosophy

The preliminary sketches, at least three in number, are contained within the pages of my sketchbook (which I always have with me when out and about.) Vestigial ideas in those sketches are developed into the final

image, which is more easily arrived at if alternatives have been tried and discarded. Color notes are sometimes written into the earlier sketches; more often, colors arrived at are instinctive, drawn from memory or experience.

my advice

- Use your imagination to the full; vary and change what you see in the original view. Expressiveness counts far more than photographic accuracy.

- Watercolor reacts best to vigorous use; timid touches lead nowhere.

- There is color in the world. Use it.

what I used

support
140lb handmade cold press (not) finish watercolor paper

watercolors

J Richard Plincke lives in Hampshire, UK

I wanted to capture the feeling of light and the mood.

Crescent Bay, oil, 16 x 20" (41 x 51cm)

my inspiration

This picture captured one of those perfect moments for me at sunset along the California coastline, with the sun peeking through the clouds, touching parts of the landscape. I wanted to capture the feeling of light and the mood it created for me that evening.

my design strategy

I love the shape of these cliffs and the way light plays on them. I pushed the warmth and contrast in the cliffs to really explain the warm light of the sunset. I also wanted to give a clear feeling of the cool, damp ocean breeze. I did this by pushing the cools in the sand and sky. I held back the contrast in the area of the homes on the left to make that space seem less busy and direct the viewer's eye more towards the jutting cliffs.

my working process

- I did a few quick thumbnail sketches to work out the composition on this one. I had the idea to have more foreground and cut out a lot of the sky, but it became apparent to me in this simple beginning stage that the sky held much more interest for me. I drew it out on the canvas with loose washes of Asphaltum and Ultramarine Blue.

- I was most concerned about getting the horizon line in place and then placing the trees. The trees add so much interest to the cliffs and cut into the sky beautifully, so I made sure to get them right.

- The shapes between the trees were very important. After a simple but careful lay-in, I went

directly into painting the sky to key the painting.

- I then painted the dark of the cliffs to give scale to my overall values. The painting went quickly from there, the most time being spent on finding ways to push color and soften edges.

- The foreground and ocean were left relatively loose, with just a general color and value idea quickly placed down. They were the last to be painted in.

my main challenge

The main challenge in this painting for me was overcoming the photo reference. I was unable to make a study from life and photos never tell the story that a from-life study will. I did a lot of work on the photo to get it to feel right before I even started to sketch a thumbnail drawing for the painting. I try to solve this problem by painting and drawing from life as much as possible, any and every subject.

what I used

support
Belgian linen canvas mounted on foam core board

brushes
Hog-hair bristle brushes

oil colors
Flake White
Yellow Ochre
Cadmium Red Light
Alizarin Crimson
Sap Green
Asphaltum
Ultramarine Blue

Ryan S Brown lives in Utah, USA → www.ryansbrownart.com

Here, I used line to direct the eyes to the off-center focal point.

Low Tide, Birling Gap, Sussex, oil, 18 x 22" (46 x 56cm)

my inspiration

The white chalk cliffs of the Sussex coast seem to come alive when there is bright sunlight and cloud shadow. When, in addition, there is a very low tide, the wet sands are exposed and this adds a new dimension.

my design strategy

All the main compositional lines in this painting lead, and give strength, to the focal area, which is just to the right of the center. Here there is the lightest part of the painting; the darkest, the change in light on the cliffs and the two figures.

The line of the waves neatly leads the viewer's eye and the cloud lines provide some balance. I wanted roughly equal areas of sea and sky, but to avoid symmetry, I put the horizon just below center. I deepened the tone of sea and sky to emphasize the whiteness of the cliff.

my working process

• I had photographs of the low tide scene and wanted to work with the reflections in the wet sand. A black gel pen sketch established the proportions and lines of the composition. I then painted a thumbnail oil sketch purely as a painting aid, which I find invaluable.

• I started the painting in acrylic with a blue sky, a neutral warm tone over the cliff area, and a warm red tone over the foreground.

• When this was dry, I started in oils, painting in the sky, though not the clouds yet. Focusing on the coastline I built to a highlight of pure white paint applied quite thickly with the rising cliff just right of center.

• I added texture, with the painting knife, to the waves in the central area. The foreground is mostly glazed on without any distracting detail. Then back to the sky, I put in the clouds quite quickly, relying on the simplicity in my thumbnail sketch.

what I used

support
Acrylic primed canvas

brushes
Flat, filbert hog, round synthetic (for finishing touches)

oil colors
Phthalo Blue	Naples Yellow
Cerulean Blue	Vermilion
Cobalt Blue	Cobalt Blue (Hue)
Yellow Ochre	Raw Umber

other materials
Painting knife

medium
Turpentine
Oil painting medium

Cadmium Yellow Light
Titanium White

Christopher Osborne lives In East Sussex, UK → www.christopherosborne.co.uk

I am a painter of light and atmosphere; the way the scene made me feel is what I was trying to give to the viewer.

St Petersburg Marina, Florida, oil, 41 x 42" (104 x 107cm)

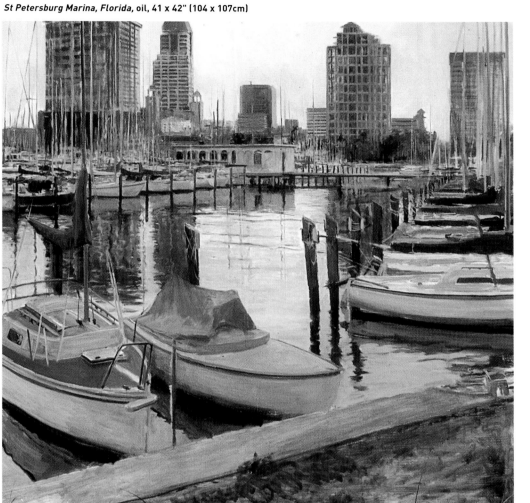

my inspiration

I chose this scene because of its strong perspective and bold shapes. Also, the evening light attracted me because it created atmosphere, and the reflecting water enhanced the mood of the late summer evening calmness. The color suggested that this place had been hot in the day and had cooled down with an echo of that heat still in the air.

my design strategy

In my design, I wanted to create something that was dynamic and balanced compositionally. This scene had strong lines of perspective running in many directions. The strongest perspective device is achieved as the eye moves in through the gap between the group of two foreground boats and the line of boats on the right; it then follows the lit reflection of the water to the pier house. This movement of the eye toward the pier house is aided by the posts in the water, which lead the eye in that direction. The light behind the city and high-rise buildings attracts the eye and creates a little mystery about what lies beyond. The masts on the boats and the posts in the water provide plenty of vertical lines that add interest to the composition. The silhouetted high-rise buildings touch the top edge of the canvas, which gives height to the composition, and the darkness of their shapes against the sky creates more of an illusion of light.

my working process

- I made preliminary sketches of the scene and some color notes in the form of small quickly executed paintings. These helped me design the painting and discover that an off-square format was best. I find it better to familiarize myself with a scene and start off with a plan rather than making drastic changes halfway through, although, that would be fine too. Being familiar frees you up to concentrate on more creative aspects of painting.

- I am a plein air painter and I do not use photos. Sometimes I kill the white of the canvas with a turpentine wash of color and sometimes I do not. I begin by blocking in the painting with loose paint mixed with turpentine and I tighten up the work and introduce thicker paint with more medium mixed into it as I go along. I always keep control over tonal values. If the values are right you are on the way to something good.

- I visited the scene about four times to finish the work, which was painted at the same time each day. The last session I use to really just improve carefully what is already finished.

what I used

support
Pre-primed canvas

brushes
#2, #4, #6, #8, #12 Filberts

oil colors

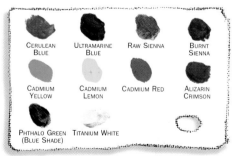

CERULEAN BLUE ULTRAMARINE BLUE RAW SIENNA BURNT SIENNA

CADMIUM YELLOW CADMIUM LEMON CADMIUM RED ALIZARIN CRIMSON

PHTHALO GREEN (BLUE SHADE) TITANIUM WHITE

other materials
Turpentine
Refined linseed oil

Kevin McNamara lives in Florida, USA → kevinthepainter@bellsouth.net

The secret of painting the serenity and timeless beauty of England is to make the colors harmonious.

Keeping Cool, Flatford, oil, 16 x 24" (41 x 61cm)

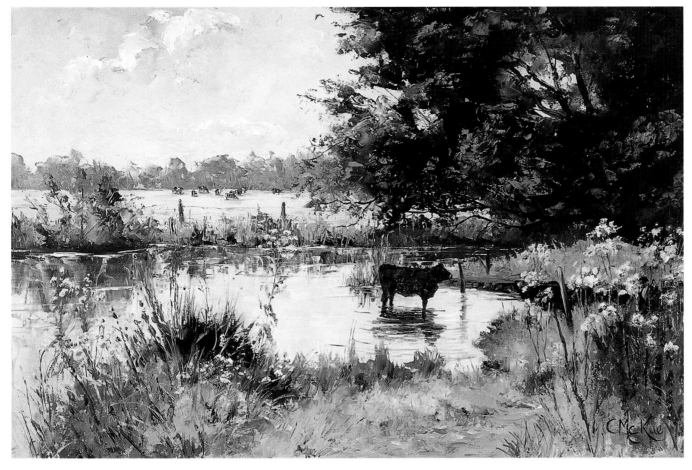

my inspiration

Flatford is a constant source of inspiration to me. It was a hot August day and I was walking the banks of the river armed with sketch book and camera when I saw a herd of cattle under the trees on the opposite bank. By the time I had crossed Fen bridge to reach this spot, most of the herd had meandered back into the adjacent field, leaving this one young bullock standing knee deep in the river, shaded by the large oak tree on the bank. Utter bliss on such a hot day. It was a scene I just had to capture.

my design strategy

I chose an L-shaped format with an underlying circular movement through the painting, with the river path as a natural lead into the scene. There was a great variation in the tonal values in the scene and I decided to use a fairly limited palette to accentuate this aspect, but also to create harmony throughout the painting. The circular design of the painting also encouraged the correct placing of the bull.

my working process

- My gessoed 24 x 16" panel was prepared by large swatches of acrylic in blue, Raw Sienna and purple to approximately correspond with sky, water, foreground and foliage.

- Using sketches and photographs for reference, I made a drawing of the composition to use as a basis for the painting.

- Using a large painting knife, I laid in the sky with a warm blue, (Ultramarine), mixing it with white and a little Indian Red at times to give variety to the sky. I changed to Cadmium Yellow and white towards the tree line to suggest the heat of the day. These same colors were carried through to the river in broad vertical strokes of the knife to give a sense of depth to the water.

- The distant trees and field were painted loosely and softly to keep the distance. The far river bank was also painted quite loosely using a smaller knife and the tree on the bank was heightened slightly to break through the horizontals of the background.

- Next, I established the dark tones of the oak tree and added a little of the same to base of the far tree. This was also included in the reflections in the water. Although it was the strength of the oak tree that first attracted my attention to the scene I needed to use some dark tones else where to balance the painting and to define the circular design through the painting.

- I finished the water by adding small amounts of weed and a few horizontal lines to suggest the slight movement in the water. Strong highlights were added to the foreground grasses, which were painted upwards movement with the knife, and a few branches were added to the oak tree trailing towards the river. These were the only brush marks on the painting.

what I used

support
24 x 16" panel prepared with 2 coats of gesso.

brushes
Round brush

2 painting knives

oil colors
Titanium White
Cadmium Yellow Pale
Cadmium Yellow
Raw Sienna
Indian Red

Burnt Sienna
Burnt Umber
Ultramarine Blue
Prussian Blue

Carol McKue lives in Essex, UK → www.carolarte.co.uk

Plenty of bright white areas throughout the painting emphasized the incredible light.

Reflections and Shadows, watercolor, 16½ x 20" (42 x 51cm)

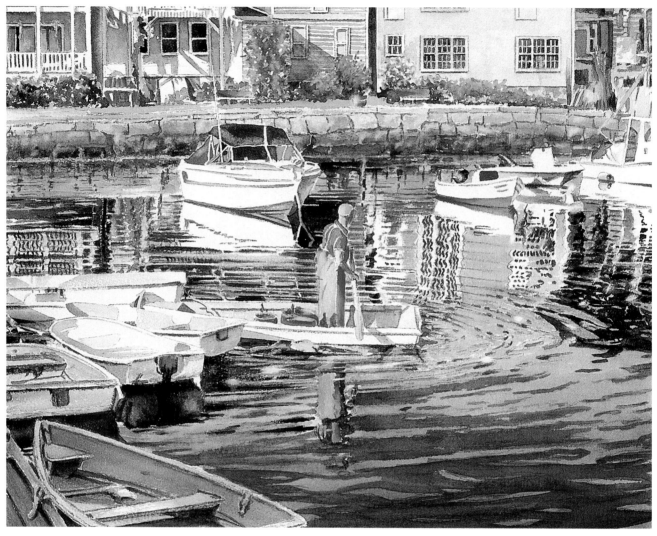

my inspiration

There were two things that inspired me in this picture. First, the incredible light and shadows which gave it such a wonderful warm, peaceful mood. Second, the challenge of the reflections, and how they worked to move the viewer's eye around the painting.

my design strategy

The fisherman with his strong colors and location is obviously my center of interest. I had everything leading to him. The ripples moving out away from the boat are in actuality pulling in all the shapes and colors surrounding it. The cool blue water and the warm wall and houses hold the eye in the painting while everything else pulls you in to the focal point.

my working process

- I started with a very tight drawing. I studied both a photo and a drawing, trying to save my whites. This is a totally transparent watercolor painting.
- I started at the top right, working across the top to put in each of the houses, including foliage. I worked them up in light washes until I was satisfied with the results.
- Next came the wall and the wall's reflection. This was done with a number of washes to build up the color. The background boats came next, being careful to save the whites. The reflections followed. Here again, I had to be extremely careful to save the whites. To me, the whites were the

backbone of this painting, and helped to direct the eye around this painting.

- Once all was dry, I carefully painted in the vivid colors of the man and his reflection while remembering to make the reflection a little darker.
- Next came the boats closest to us. I then began laying in the colors and sculpting the shadows to give them subtle

shaping and creating a sunlight effect.

- Lastly, I put in the cool blue of the clear water going light to dark with successive washes. I was careful not to overwork it. During the course of painting I would stop from time to time to analyze what I had done so far. Take notes, make changes and continue on. I repeated this process all the way through.

what I used

support
300lb. rough watercolor paper

brushes
½", 1" and 2" Flat
#2, #4, #6, #8, #12, #18 Round

other materials
Cotton swabs
Sandpaper
Razor blades

watercolors
Cadmium Yellow
Cadmium Orange
Chinese Orange
Alizarin Crimson
Burnt Umber
Olive Green

Sap Green
LightCobalt Blue
Ultramarine Blue
Cobalt Violet
Payne's Gray
Sepia

John Bowen lives in Florida, USA → www.johnbowenwatercolorist.com

Careful observation and planning were the keys to mastering this complex scene.

Staithes, acrylic, 16 x 22" (41 x 56cm)

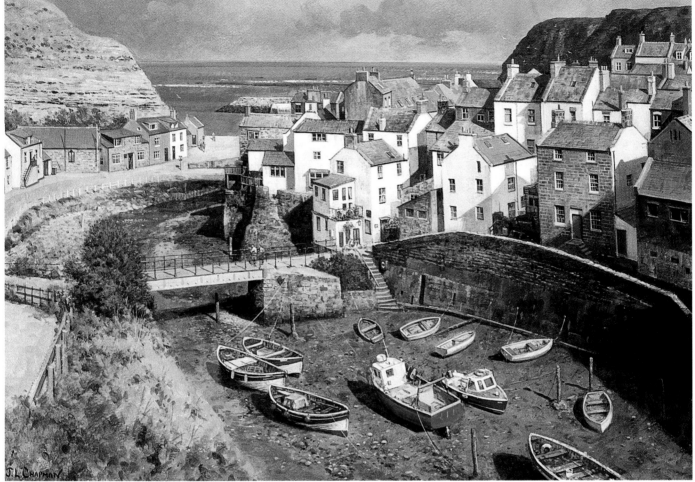

ARTIST
21

John L Chapman

my inspiration

Staithes on the Yorkshire Coast is a gift for the seascape artist. Everywhere one looks there is subject matter. I could not resist climbing up a track to get a bird's eye view of the village.

my design strategy

You don't really need to be an artist to appreciate this scene. It's a ready-made view enjoyed by most visitors to Staithes. But I did want to show both headlands and keep the horizon high in order for your eye to wander over the rooftops across the bridge to the boats in the foreground.

my working process

This is a complex subject. In the time it would take to sketch this scene not only the light on the buildings would have changed, but the tide would have come in, completely changing the foreground. So I took photos and worked in my studio from these. I took care penciling out the scene on to watercolor board. Then, with thin acrylics, I blocked in the sky. I painted in the sea and headlands on the left and right. This jumble of houses was almost abstract. But adding windows and chimneys, and so on, brought reality to the scene. I left the red boat until the end. It acted like a full stop.

point of view

From my viewpoint right on the edge of a cliff, it was quite impractical to set up an easel, particularly in the wind. There was so much to consider in this subject. The shadows on the building were slowly changing and the tide was coming in. The photo froze all this, enabling me to take my time and bring it all to a successful conclusion.

my main challenge

This certainly was a challenging subject. To do justice to the scene, a feeling for atmosphere and particularly the play of light on the buildings was essential. My photos helped with this. I rearranged the boats in the foreground to form an interesting counterpoint to the white-washed cottages. The red boat was not invented. It actually was there. I also used a little impasto medium on the shore and on some highlights, but on the whole I kept the brushstrokes flat and the paint thin.

what I used

support
Watercolor board primed with gesso

brushes
Flat and round nylon brushes

other material
Impasto medium

acrylic colors

Titanium White	Burnt Umber
Naples Yellow	Cobalt Blue
Orange Yellow	Neutral Gray
Vermilion	Ultramarine Blue
Yellow Ochre	Sap Green
Burnt Sienna	Black

John L Chapman lives in Blackburn, UK → www.johnchapman.co.uk

I wanted to shout: "Look, the sky fell into the water!"

Tideland Reflection, pastel, 25 x 36" (64 x 91cm)

ARTIST
22

Christa Malay

my inspiration

My inspiration for this painting was the dramatic evening light with its reflection on the bay. I wanted to shout:"Look, the sky fell into the water!"

my design strategy

The mood of this painting would be best expressed in pastels, with a lot of blending to get that soft look of the sky and the reflection. I chose to stay with the natural colors seen that day: warm and cool grays and blues with only the strip of land in warm earth tones. The eye will travel from the strongest blues in the foreground to the left, guided by the detail of the land on the left side. The small island hit by the glancing light will be the focal point. The soft blues in the background echo the strong blues in the foregrounds and invite you further into the composition.

my working process

Because of the large format I planned, I used watercolor paper (H.P. 300gsm from a roll). After soaking it in a tray of water for three minutes, I stapled it onto a large drawing board. I brushed two layers of gesso mixed with marble dust onto the paper and let it dry overnight on a flat surface. I sketched a few lines for the clouds, islands and land shapes with a hard, light gray pastel and started filling in shapes in medium values with medium soft pastels.

I started refining the edges, sharpening some and softening others by blending and generally painting with my fingers. Adding the strip of land and the island that anchors the whole composition, I finished off with the lightest blues and pinks, making sure to retain the flatness of the water and making it softer than the sky.

my color scheme

The color scheme is very low key and muted. With only blues and pinks to work with it was a challenge to not make it look too sweet and sentimental. The earth tones in the middle distance and the harder edges on the island shapes anchor it down successfully.

The placement of the horizon line was critical in this painting to convey my first impression: nothing but water and sky.

Christa Malay lives in Washington, USA → m2arts@centurytel.net

I strived to create a harmonious design while drawing the viewer into the fascination of small detail.

Tidal Pool, oil, 6 x 9" (15 x 23cm)

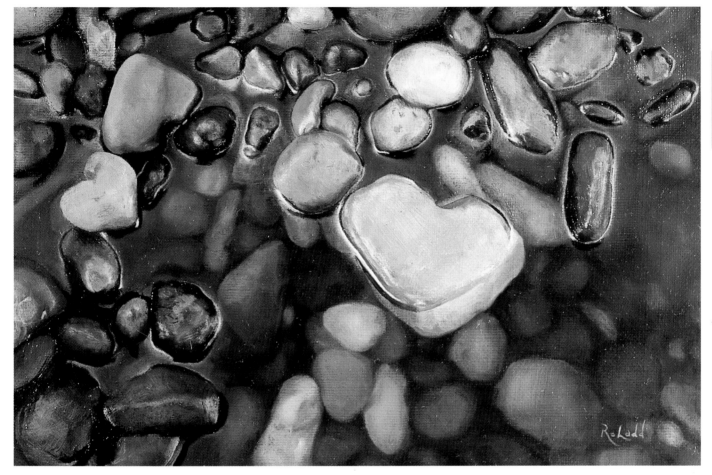

my inspiration

I am drawn to the transcendent beauty of small treasures found in nature; feathers, shells, leaves, and so on. Pebbles on the beach have always been a delight to me — and finding a heart-shaped one? I want others to stop and be delighted, too!

my design strategy

My goal was to create a harmonious pattern of color and shape made up of finely-detailed parts, with the focal point being the "heart" stone. I also wanted to play with the application of thick and thin paint to create surface texture.

my working process

I started with a strong blue black (Ultramarine Blue Deep and Transparent Oxide Red) underpainting. This is the point where I applied the texture: each surfaced stone painted thickly, the water thin and smooth. This initial block-in color shows throughout the painting (in many places never painted over) to create an overall harmony. When the underpainting was completely dry, I direct painted (not glazing) each area, keeping it painterly but also detailed and realistic. I used every color on my palette and had fun!

my approach to moving water

I like painting from life best, but when the scene is likely to change (tides), I will rely on photos for my follow-up work. The drawing, values, and color harmonies can be captured with a strong block-in from life, then I go back to the studio with a good photo taken at the time of the block-in for more layers and final touches.

borrow from my philosophy

Paint what you love ... what you are intuitively drawn to. Never stop learning. And proceed with confidence.

what I used

support
Canvas

brushes
A variety of #0 - #6 small brushes

underpainting medium
Fast-drying linseed oil

oil colors

Cadmium Lemon · Cadmium Yellow Pale · Cadmium Yellow Deep · Cadmium Red · Yellow Ochre Pale · Terra Rosa · Alizarin Crimson · Transparent Oxide Red · Ultramarine Blue Deep · Viridian · Titanium White

Rosemary Ladd lives in Vermont, USA → roladd@sover.net

To catch the light of Western Scotland and the romance of these old boats, I focused on edges and tone.

Inveraray Pier, oil, 24 x 30" (61 x 76cm)

Mary S Martin

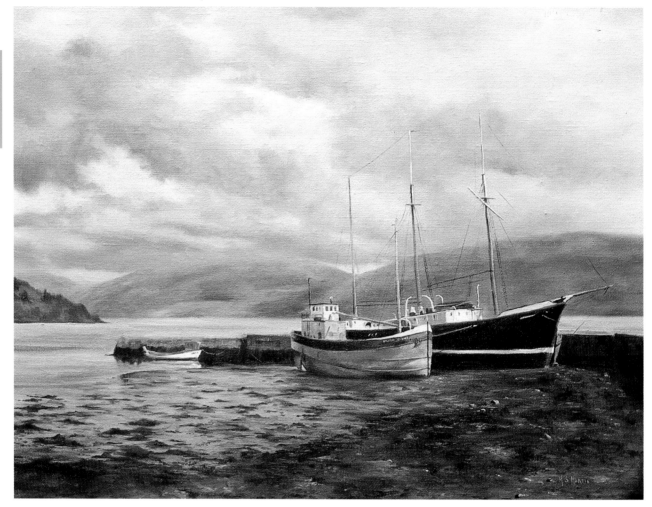

my inspiration

This was a scene that just cried out to be painted. The fitful sunshine, the immense Scottish sky, the sturdy yet elegant shapes of the boats, the reflections, the rich and somber color harmonies — all made this a compelling subject.

my design strategy

The composition was "ready-made" and very few adjustments were required. The triangular shape of the dark foreshore and pier lead the eye to the focal point of the boats. The dominant horizontals are linked by the vertical masts and enlivened by the diagonals of foreshore and clouds. My main concern was to divide the horizontals into pleasing proportions. I played up the contrast between the hull of the Clyde Puffer and that of the three-masted schooner behind

and made the hardest edges there to reinforce the center of interest. The recession was enhanced by making the nearest clouds larger and warmer in color than those at the horizon.

my working process

- I prefer to work alla prima (all in one session).
- I made a series of thumbnail sketches to establish shape placement and tonal values.
- I blocked in a tonal complementary underpainting with Cadmium Orange and Burnt Sienna. It is at this stage that I refine the "drawing," working with bristle brights and filberts, wiping out where necessary with mineral spirits.
- Starting at the horizon, I painted the sky first since the sky determines the mood of the painting. Then I work forward

from background to foreground, keeping edges and tonal contrasts subordinate to those at the focal point.

try this yourself

A warm underpainting allowed to show through creates a special vibrancy, particularly in a predominantly cool water painting.

what I used

support
Stretched linen canvas

brushes
Hog-bristle filberts

Brights

medium
Liquin medium

oil colors

CADMIUM YELLOW	YELLOW OCHRE	CADMIUM ORANGE	BURNT SIENNA
CADMIUM RED	ALIZARIN CRIMSON	COBALT BLUE	ULTRAMARINE BLUE
TRANSPARENT OXIDE RED	TITANIUM WHITE		

three pieces of advice

1. Do thumbnails: The small investment in time and effort is more than repaid in full.
2. A tonal map is the best route to success.
3. Be aware of edge quality.

Mary S Martin lives in Quebec, Canada 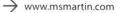 www.msmartin.com

My layering technique creates depth and transparency.

The Storm, oil, 16 x 30" (41 x 76cm)

my inspiration

My inspiration for this painting came from an unusual stormy day. The colors were so different that they became the main focus for this painting. I wanted to show how nature's colors can create unexpected spectacles.

my design strategy

My primary objective was to make the viewer feel as if they were on the lake anticipating the storm's arrival. I therefore created the composition in a horizontal format with the water being the foreground, and used color reflections to pull the viewer's eye from the foreground into the background. My palette was monochromatic to create harmony, but I also took some liberty with my own contrasting colors to create interest throughout the painting.

my working process

- When I consider a new painting I begin with deciding whether a vertical or horizontal format will best show my subject. I then stretch my own canvases so that I can best control the shape.

I prime the canvas with rabbit skin glue to firm and protect the canvas and then put two layers of acrylic medium to seal the canvas. This leaves the natural color of the cotton canvas, unlike gesso that leaves a white surface.

- I then draw in my basic composition in charcoal. Here, I chose areas in the sky and water that I wanted to leave "natural," allowing the canvas to "breathe." The negative space adds a lot to the overall effect. I then rub on oil washes with rags until I get a good build up of color, usually 10 to 15 layers. I use cotton rags to blend rather then brushes because I get better blending results.

- I then gradually add more color with palette knives until I get the results I'm looking for. The layering technique really helps to create a lot of depth and transparency that adds a true feeling of atmosphere.

To draw attention to the focal point, I chose to reflect the light area of the sky in the water, which helps move the eye from the foreground to the background and sky.

- The dark areas were reflections of the hills and added a nice contrast. The hills were created by adding color with palette knives over the washes.

try this technique

I have found that using very thin washes in either oils or acrylics layered over and over gives the greatest depth. Using rags instead of brushes for blending has made all the difference for me.

what I used

support
Raw cotton canvas, primed with rabbit skin glue and acrylic medium

medium
Turpentine

Oil medium

Linseed oil

oil colors

TITANIUM WHITE YELLOW OCHRE ALIZARIN CRIMSON COBALT BLUE

PRUSSIAN BLUE SAP GREEN BURNT UMBER

Evelyne S Albanese lives in New York, USA → Evelyne5007@aol.com

Extreme tonal contrast helped get the mood I was after.

Melancholy Evening, oil, 20 x 33" (51 x 84cm)

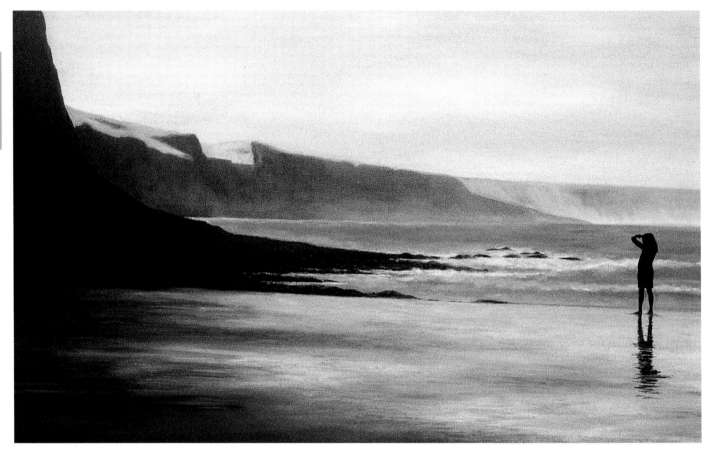

my inspiration

The cliffs along this part of the west coast of New Zealand's North Island are constantly crumbling and changing due to the relentless battering of the Tasman Sea.

On this particular evening, the last sunlight on the distant hills, contrasted with the deep shadows of the cliffs in the foreground, and created such a feeling of distance and melancholy that I couldn't resist painting the scene.

my design strategy

This scene, just as it was, required little from my imagination, so my challenge was to capture the sense of isolation I felt at the onset of a chilly evening on this seldom frequented stretch of coastline. The extreme tonal contrast helped with this, as did the striking effect of the oranges against the purples and blues.

To further accentuate the mood, I decided to add the solitary figure of the girl gazing into the distance. Following her line of vision also helps to carry the viewer's eye up the shadow line on the cliffs and back around into the painting.

my working process

Having found this place, the first step was to be there at the right time. There was, even so, only time for one color sketch due to the rapidly changing light, so I took a number of photographs. Then back in my studio, with plenty of material to work with, I built up the painting over a number of days. If possible, I like to finish a painting at the scene, so on a suitable evening when this one was dry enough, I returned for the final touches and to get my wife to stand at the water's edge so I could get the reflections right.

my approach

In changing light it is often necessary to paint from photographs, but it can be really helpful to get back to the scene at least once or twice.

Practice is what it all comes down to, so my advice is: Paint, paint, paint.

what I used

support
Board

brushes
#2 - #11 Filberts

oil colors

ZINC WHITE CADMIUM YELLOW YELLOW OCHRE ALIZARIN CRIMSON

RAW UMBER COBALT BLUE CERULEAN BLUE

Kerry Wales lives in Otaki Beach, New Zealand → www.kerrywales.com

An unconventional diagonal composition gives my painting scale.

O, Long May It Wave, oil, 14 x 28" (36 x 71cm)

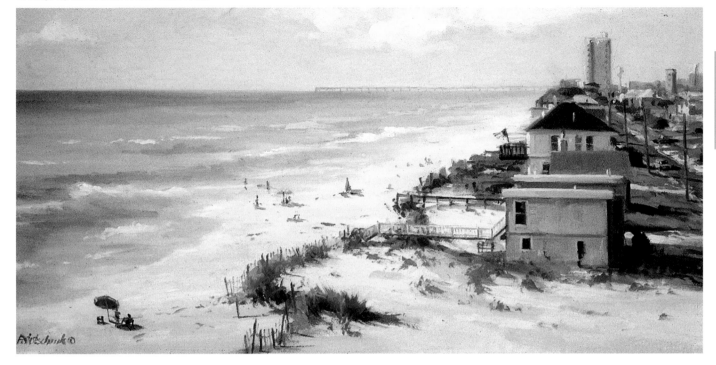

my inspiration
I've never painted such white beaches in sunlight. I wanted to capture the brilliance of the light and vastness of the scene.

my design strategy
In order to capture the vastness of the scene, I chose a long, narrow, horizontal proportion. What excited me was the challenge of dividing the painting in half diagonally with all of the weight of the composition in the upper right corner. It's an unconventional composition and placement of the focal point and that's what I found very stimulating. In order to balance all that weight on the upper right, it was necessary to counterbalance with a lot of length on the left.

my working process
- This painting began as a small oil study on paper done from the balcony of a condo along the beach in Pensacola, Florida.
- Back home in the studio, the sketch was used as the guide for an enlarged and more refined painting, all the while being very conscious of maintaining the colors and values achieved on location. The only change made to my palette was to add Permanent Green Deep in order to better achieve the color reflected in the water.
- The painting was done on a ¼" masonite panel, which was sanded and coated with acrylic gesso.

- Without toning the surface, I began to draw the scene directly on the panel using a round bristle brush and thinned paint.
- After the establishment of the composition, values and approximate color, I refined and completed the sky, working forward from the horizon line until the painting was completed.

my important field studies
I greatly value my on-location work. I work small (generally 4½ x 6") with oil on gessoed paper from an 8"x 10" pochade box. I consider my field studies as educational visual note taking of the scene before me. Hundreds of studies done in this way are filed in notebooks and often referred to later for information, inspiration or enlargement. Noted on each sketch is the location, as well as the date, time of day and the colors used. My on-location study was invaluable when I began this painting.

what I used
support
Masonite panel

brushes
Flat bristle brushes
Synthetic rounds

oil colors

TITANIUM WHITE | COBALT BLUE | ULTRAMARINE BLUE | ALIZARIN CRIMSON
CADMIUM RED | CADMIUM YELLOW PALE | CADMIUM LEMON | PERMANENT GREEN DEEP

John Pototschnik lives in Texas, USA → www.pototschnik.com

My intent was to create the drama that occurs as the full moon sets trees alight and shimmers across the water.

Moonlight, oil, 36 x 24" (91 x 61cm)

my inspiration

My inspiration for this painting was the intensity of the moonlight as it backlit the trees and shimmered across the water.

Every summer for many years we have made it a point to raft various rivers. These trips and my studio location have been the inspiration for a whole series of moonlight paintings.

my design strategy

Design has always been my forte. My methods start with shape hunting.

- I look for interesting shapes in the subject and how I can place them for full impact.
- I use value to move the eye around and within the shapes.
- I use color to create mood.

In this particular painting, the shape and value of the moonlit trees pulls the eye into the painting as the intensity of the colors and value of the dark water pulls the viewer's eye down into the water. The eye wants to escape and goes back to the safety of the sky and the contrast of the dark mountain, from where it begins again returning to the trees.

my working process

This painting began on triple-primed canvas. I did a monoprint to create texture and shape. I used plastic sheets, and any material that promotes the texture that I think will add appropriate detail to the finished painting.

I protect certain areas from the oil paint with masking material. I seldom use a palette knife except for scraping, but use glazes and thick brushstrokes to clarify shapes and value and to subdue the built-up texture, if necessary.

I use a full palette, seldom restricting myself, but I do mix up a mother color that goes into all the other colors used in the painting. This is an easy way to force a color harmony. In this painting I added a Burnt Sienna/Yellow Ochre mother color to everything.

what I used

support
Canvas

brushes
Bristle filberts

Bristle brights

Sable brights for glazing

medium
Linseed oil

oil colors

CADMIUM YELLOW MEDIUM YELLOW OCHRE BURNT SIENNA PHTHALO BLUE

CERULEAN BLUE VIRIDIAN ALIZARIN CRIMSON MARS BLACK

PEMALBA WHITE

Torgesen Murdock lives in Idaho, USA → www.livvnart.com

Controlled saturation created a bright, warm feeling in my pastel painting.

StreamCatcher, pastel, 24 x 36" (61 x 91cm)

Mike Barret Kolasinski

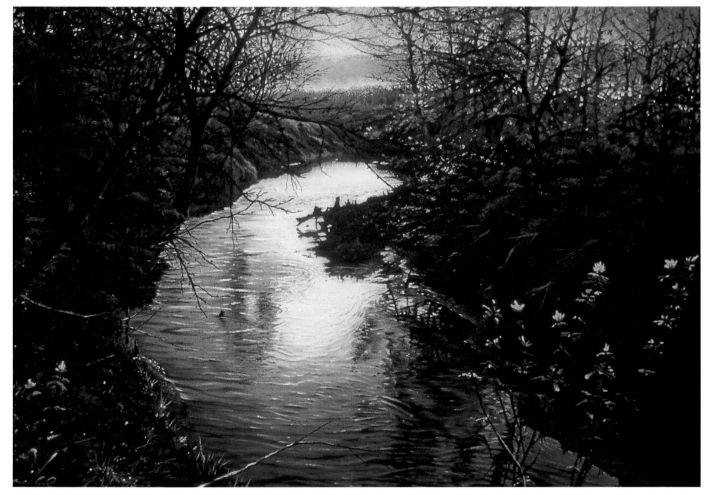

my inspiration

While hiking along a creek in northwestern Illinois exploring for painting possibilities, I was attracted by the warmth of the early morning light reflecting off the waters of the creek, splashing that same warmth up on the creekside spring blossoms.

my design strategy

Designing a curved ribbon of bright color that contrasted with the deep, dark, rich shapes of early spring foliage, I hoped to lead the eye into and around the image by using the same radiant color to depict the luminous light of the wildflowers.

my working process

- When I came upon this scene, I spent a long time just observing; making mental notes. I may sketch a small drawing in pastel, but if the light is fleeting as it

was in this case, I snap a couple of slides, bracketing the film settings to achieve details in the shadows.

- Back in the studio, I scanned those slides into my computer and played with the images to create a cropped version that had an exciting visual impact.

- Using a fast print as a study, I sketched my image with a dark purple pastel pencil on an archival foam-core board that had been prepared with a mixture of Terra Cotta and Burnt Umber-toned acrylic pastel primer containing a fine-tooth pumice.

I established the main, big shapes and then used the side of a cool, dark purple and a warm, light umber pastel to quickly create a value painting.

- Once satisfied with the balance of lights and darks, I slowly

added local color, generally working from background to foreground, broad shapes to fine detail, dark to light, hard to soft pastel. By building up layers of intensely bright and pure color, I proceeded to add emotional and visual excitement. I gave the shadows rich details of complementary shape and the highlights the glowing warmth of saturated tints.

- Finally, I made some adjustments to ensure proper color exaggeration through controlled saturation to create a bright, warm overall feeling against a dark, rich detailed environment.

my medium of choice

I prefer to work with pastel, because of its immediacy. Even as a child, I always enjoyed using dry mediums, from pencil to dry pigment. It's pure color!

my advice to others

Even if you don't paint plein air, get out and train your mind's eye to really observe, study and retain the many qualities and characteristics of the various aspects of water in all its light and shadow.

Mike Barret Kolasinski lives in Illinois, USA → mbkolasinski@earthlink.net

Once I found the dominant color and its complementary color, I was on my way to creating mood and drama.

Blakeney Wharf, oil, 24 x 18" (61 x 46cm)

my inspiration

I saw this beautiful sunset view in Blakeny, a small village in Norfork, UK. Earlier in the day, I was not particularly attracted by it because the scene was too bright and noisy, but then the colors of sky and water made it a totally different scene. The reddish light united everything, and the kids in the water added sound and movement. It was peaceful yet joyful

my design strategy

I wanted to give the water the most space because that's where the excitement was going on: The boats, the reflections and the activities. For that reason, I used a vertical format rather than horizontal, and raised the horizon high. By including the small bank on the left, I lent curves to the water and thus to the painting. Choice of color is very important in creating mood and drama. In this painting, orange is the dominant color, thus I needed to find places for purple, the accent color which would relieve the hotness of orange and make the whole painting sing.

my working process

- My digital photo came out a little dark, which made it difficult to read the colors in the dark parts, so I lightened it up. By having two references of different values, I could see colors better. That's one of the great things about using a digital camera.

- In order to achieve the golden harmonies, I made a color sketch through which I decided how much Orange, and its complementary color, purple, I should use and where.

- I started with the sky and then gradually worked down. I paid attention to edge control. Too many hard edges would spoil the harmonies and poetic effect I wanted to achieve. So I made a special effort to soften the edge between the sky and trees and also made sure the boats in the shadow didn't stand out too much.

- Thicker paint is effective when we paint highlights, and very often palette knives are great for that job. That's how I painted the sun and the highlights on the water.

- After the painting dried, I went back and adjusted the colors of the sky and the dark part of the water by using transparent glazing techniques. I was happy with the upper half of the painting, but I did have trouble painting the water, as you might see from the print. It appears a little dry, and that's mainly because I did it wet-on-dry and I realize now that wet-on-wet would make the job easier and the result would be better.

Hongmei Lu lives in California, USA → www.hongmeilu.com

what I used

support
Canvas

brushes
#4, #6, #8, #10 brushes

Palette knives

oil colors

| Titanium White | Cadmium Lemon | Yellow Ochre | Cadmium Red Light |
| Alizarin Crimson | Ultramarine Blue | Ultramarine Violet | |

I wanted to recreate the last light fading from a cool evening sky.

Evening at Lake Anna, oil, 16 x 20" (41 x 51cm)

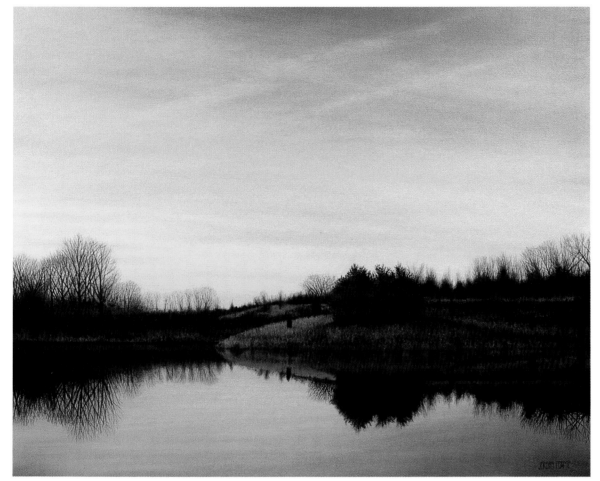

my inspiration

This is a scene of a nearby lake that I visit often. On this particular evening, I was moved by the quality of the light and the reflections in the water contrasting with a much darker landscape. The sky was still full of color but the landscape was muted with evening light catching some of the grasses. Almost everything else was basically in silhouette. I wanted the painting to be mostly about the wonderful light still left in the sky during the dying moments of a day when most of the color had gone out of the landscape.

my design strategy

I wanted the darker mass of the landscape to be a strong band across the lower part of the painting, giving the sky above a sense of light and space. The slightly darker reflections in the water would bring the colors of the sky down and into the foreground, harmonizing the painting. I chose a slightly squarer canvas so that I could give prominence to the sky.

my working process

- Since I know the area well, I painted the scene mostly from memory aided with a few sketches and photos. As is usual for me, I did a smaller oil study first, then used it as a basis for the larger painting.

- Working on an acrylic-primed canvas, I first laid in the lighter areas of the sky, followed by gradated blue from the top downwards.

- When this had dried somewhat, I worked over it with lighter and warmer grays to create diffused clouds. I then intensified the orange at the horizon. Some of the same colors were used in the water but darkened slightly.

It was very important at the start to get the tone of the sky correct, as this would set the mood for the entire painting.

- The next day, I started on the grasses and trees using much darker tones and building up texture and interest throughout. The finer branches of the trees and their reflections were carefully put in when the sky and water were dry.

my main challenge

The main challenge with this painting was getting the tonal values correct. The sky had to be light enough to suggest the intensity of the setting sun and the landscape dark enough to create strong contrasts. The easiest way for me to solve this was with small pre-studies.

what I used

support
Canvas

brushes
Bristle brushes
#4 Synthetic round

oil colors

Jeremy Pearse lives in Maryland, USA → www.jeremypearse.com

I hoped a strong, dramatic sky would convey my feelings about a favorite place.

ARTIST 32

Barron Postmus

my inspiration

Thinking the Santa Barbara pier was going to be torn down after a damaging fire, I painted this reminiscence from sketches and snapshots gathered on previous trips there. The pier has since been reconstructed, but I still like to remember the old pier in this more sentimental manner.

my design strategy

Since this was to be a nostalgic work, I decided to use a dramatic sunset. This enabled the introduction of more color, as the subject itself was quite dark. Also, having rather strong feelings about the pier and times shared there, I hoped the strong sky and lighting would add the drama and emotion I was looking for.

my working process

- Several pencil sketches on vellum were done to establish shape, light direction and particular details.

- Then a tight drawing on gessoed canvas with magic marker pens and Burnt Umber was followed by an overall undercoating of the colors chosen with very thin turpentine-washed paint. This was allowed to dry while work was continued on other paintings in progress.

- The final layers included the addition of details and the highlighting of color areas. As the paint was somewhat thin, the drying time was not too long.

- A final coat of straight Liquin medium was applied and the project was done — provided I can keep from fussing with it.

preliminary sketches

Generally, I will sketch on location with soft pencils on vellum pads, supplemented by snapshots for detail. Photography was of particular value here as a great deal of the original structure had been lost in the fire.

my favorite medium

Oil is my favorite medium. I like to work in thin layers, which allow an application of an almost watercolor-like wash to be built on. With a mania for detail, the turpentine allows a control for working small spaces (a holdover from illustration days). Also, the drying time is shortened.

Waiting for the Last Boats In, oil, 16 x 12" (41 x 30cm)

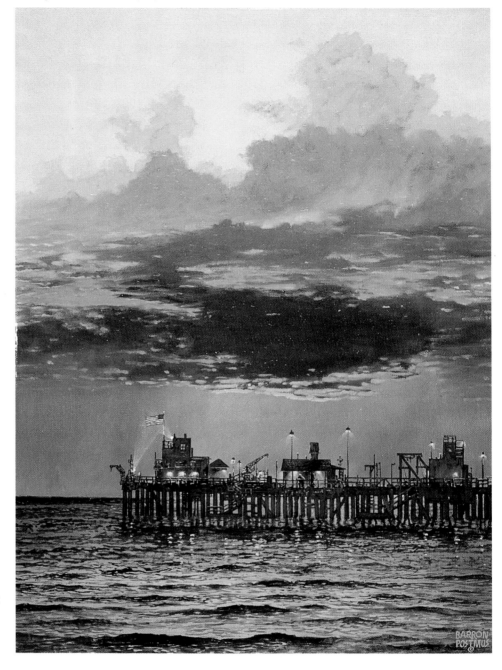

what I used

support
Canvas

oil colors

Titanium White · Cadmium Yellow Pale · Juane Brilliant · Cadmium Orange · Alizarin Crimson · Burnt Sienna · Burnt Umber · Raw Umber · Cerulean Blue · Cobalt Blue

Barron Postmus lives in California, USA → barronpostmus.com

A panoramic format helped to convey the wide expanse of the sea at the moment when sky and sea turned to gold.

Golden Sunset, Cardigan Bay, pastel, 9½ x 25½" (24 x 65cm)

ARTIST
33

Susan M Cottrell

my inspiration

In this part of West Wales, on Cardigan Bay, the light effects over the sea are often amazing. Facing due west, there are spectacular sunsets at all times of the year and I wanted to try to portray this particular evening. Because these effects are so fleeting, I took several photographs over a period of about 10 minutes.

my design strategy

I decided to use this panoramic format to convey the wide expanse of sea across the bay. I aimed to lead the eye around the painting by using the rock formations and by the cloud directions and their reflections in the sea.

my working process

- The composition evolved through reference to the photographs (for color) and also from memory, trying various formats before deciding on this.

- As I wanted to convey the tremendous glow and luminosity of this sunset, I selected a yellow-gold surface as a base and then chose my selection of pastels in yellows, golds, reds and brown. To give some contrast I added complementary blues and grays to suit the design.

- The basic design of the rocks and headland was first drawn in with pastel pencil. The main areas of light and dark were stated and then I worked very freely, adding layers of pastel, blending with my fingers as I aimed for an "impressionistic" approach. Fixative was used only sparingly to avoid dulling the colors and never on the final pastel strokes.

- Highlights were added, sometimes using hard pastels for a clear clean line. Finally the three birds, homeward bound at sunset, were added.

my advice to other artists

- Always plan your painting before making a final decision. It saves tempers and materials.

- Select your colors carefully, aiming for harmony and unity.

- If the inspiration is there, go for it! Who knows what you might achieve.

what I used

support
Toothed (abrasive) pastel paper in a yellow-gold color

other materials
Fixative

pastels
Soft pastels for main body

Hard pastels for highlights

Susan M Cottrell lives in Ceredigion, UK → susancottrellcal@yahoo.co.uk

Using a limited range of natural colors emphasizes the mood of my Ontario landscape.

ARTIST
34

Vladimir Ribatchok

The Sweeps of Cliffs, oil, 40 x 44" (102 x 112cm)

my inspiration

I am always seeking inspirational landscapes to paint, and from the first glance, this scene of the Rouge River, in Ontario, inspired me. It appeared simple at first, but it awakened my creativity.

my design strategy

The composition is quite simple. First, the area of grass on the left moves your eye across the scene to an obstacle — the fallen trees and branches on the edge of the water. To the right of the obstacle is the Rouge River — an area of calm. It draws you into the deep, inviting you to wonder what is at the end of the river. Both the composition and the colors reflect the mood of this painting, and the near-square shape of the canvas helps focus your attention.

my working process

• Like all my paintings, I created this one in the open air. I used several layers to develop a melody of color and tone.

• The first layer is imprimatura with a brown-silver color for areas of soil. It's important to get this layer right because it can be seen through other layers.

• In the second layer, I added the harmonious colors, such as Burnt Sienna and Ultramarine, and I also used Indigo to define certain elements, such as the fallen logs.

preliminary sketches

I made some quick sketches of both the composition — to get the balance right — and the color scheme. The sketches, along with my actual observations, helped me to see that I should use a limited range to complement the meditational theme.

my color scheme

I used a limited range of natural colors to emphasize the mood and colors of the landscape in Ontario during November.

my approach

My advice to you is to embrace everything about landscape:

• Educate your eyes; teach them to look on the world of nature.

• Create your drawings and paintings outside in the open air. Draw anything that inspires you: the water, fields, forests.

• Read as many books about landscape art as possible.

what I used

oil colors

TITANIUM WHITE CADMIUM YELLOW PALE HUE NAPLES YELLOW YELLOW OCHRE

RAW SIENNA BURNT SIENNA ALIZARIN CRIMSON VIRIDIAN

ULTRAMARINE BLUE INDIGO BLACK

Vladimir Ribatchok lives in Ontario, Canada → www.vrstudio1.com

My primary challenge was to merge two moods.

The Gilded Shore, oil, 24 x 30" (61 x 76cm)

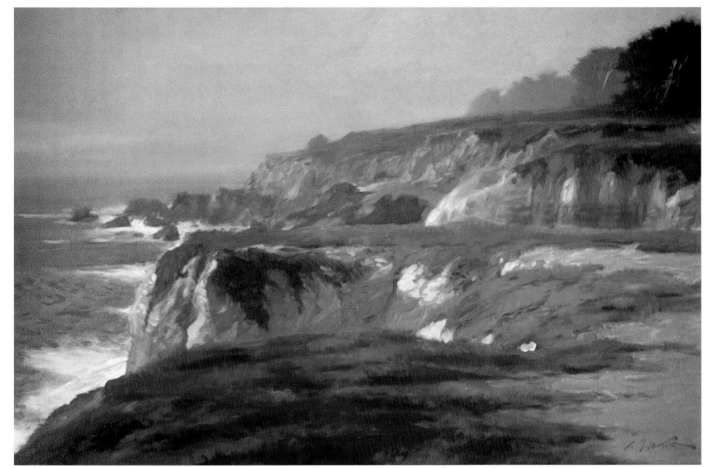

my inspiration

This stretch of coastline at Moss Beach, California, is an inexhaustible source of inspiration, from the brightly colored wildflowers and kuarly cypress stands which adorn these golden cliffs, to the mossy rocks and gem-like tide pools below, hemmed by a shore whose moods can change quickly and dramatically.

my design strategy

I enjoy creating competing moods within a painting. In this scene, the brightly lit foreground was gradually transformed by the incoming mist beyond. This was accomplished by establishing multiple gradations of tonal value from the stark and well-defined lights and shadows of the foreground to the more vague and mysterious shapes in the distance as colors merge with the sky.

my working process

- I first toned the entire canvas with a thin wash of Yellow Ochre using a #12 flat brush. This tone established the overall underlying mood of the work.

- Over this wash, still using the #12 bush, I began to block in the shapes of cliffs, trees, and sea in a rough composition using Dioxazine Purple and Burnt Sienna.

- Continuing with the #13 and a #8 flat, I began to emphasize light and shadow, almost sculpting the heavy-textured mixture of Titanium White and Cadmium Yellows over the crevices of Dioxazine Purple.

- The harsh areas between these two extremes were then softened with a heavy-bodied application of Titanium White and Burnt Sienna using a #8

and #3 flat. The ground cover was layered on using Cadmium Orange, Phthalo Green, Cadmium Yellow, Raw Sienna, Burnt Sienna, and Cadmium Red, again employing a #3 flat.

- The dark, prominent cypress tree was painted using a flat brush, mixing Phthalo Green and Cadmium Red.

- The sky was then completed in a blend of Titanium White, Burnt Sienna and Ultramarine Blue with the broad #12 flat, and blended down into the distant forms to obscure them with a warm enveloping mist.

what I used

support
Canvas

brushes
#3, #8, #12 Flats

oil colors

CADMIUM YELLOW MEDIUM
CADMIUM YELLOW DEEP
CADMIUM ORANGE
YELLOW OCHRE
RAW SIENNA
CADMIUM RED
BURNT SIENNA
PHTHALO GREEN
ULTRAMARINE BLUE
DIOXAZINE PURPLE

Michael Wood lives in California, USA → fmwood@msn.com

Using only four colors, I was able to capture the grandeur of this bay in one late afternoon session.

View of the Bay, oil, 30 x 40" (76 x 102cm)

Armand Cabrera

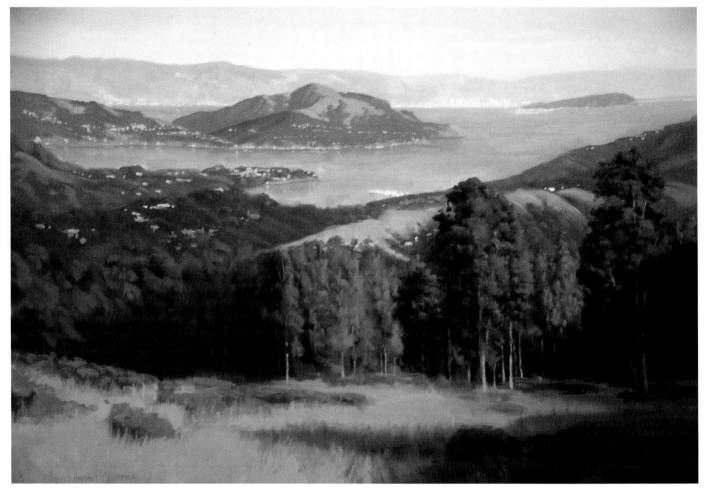

my inspiration

My inspiration came from this spectacular view of the bay from Mount Tamalpais in Marin County, California. I wanted to convey the beauty and grandeur of this breathtaking location that I have enjoyed for many years.

my design strategy

This scene was rather complex. I wished to communicate the vast area of the bay and the scale of the surrounding landmasses. Designing the middle ground as the main focus, the foreground became the lead-in to the painting.

The trees growing along the hillside helped to set the scale.

In order to keep a strong composition, I focused on subtle changes in color temperature and simplified the shapes into four values.

my working process

- I observed this panorama at different times to help me decide the best time of day for my painting. I ultimately settled on the late afternoon.

- First, I drew my horizon line with my largest brush, using a neutral color I had mixed. A horizon line establishes eye level and supports the rest of the drawing process; all other placement lines relate to this line.

- Using a big brush, I completed the rest of the drawing. Next, checking for accuracy, I made any needed corrections.

- After the drawing stage was complete, I massed in flat, poster-like shapes of color in each tonal area, working from background to foreground. I used as big a brush as possible to avoid applying unnecessary detail at this stage. I was careful

to compare the color and values, making sure all elements in the scene were accurate. From start to finish, this part of the process took roughly forty minutes.

- I modeled the forms, preserving my original shapes and composition. To add interest to the piece, I worked from large to small shapes and created temperature and subtle value changes within the larger shapes. I also began to emphasize and

de-emphasize elements by modifying edges and varying paint thickness.

- Finally, I added accents to arrive at the finished painting. Total painting time: approximately 3½ hours. (If I don't like a painting, I think it's better to start from scratch, rather than endlessly noodle away at an idea that is fading and changing in my mind.)

what I used

support
30 x 40" pre-stretched canvas

brushes
#10, #12, #14, #16, #18 Hog-bristle flats

oil colors
Titanium White
Cadmium Yellow Light
Alizarin Crimson
Ultramarine Blue

Armand Cabrera lives in California, USA → www.armandcabrera.com

Dramatic lighting was the key to this painting's success.

December Morning, oil, 18 x 36" (46 x 91cm)

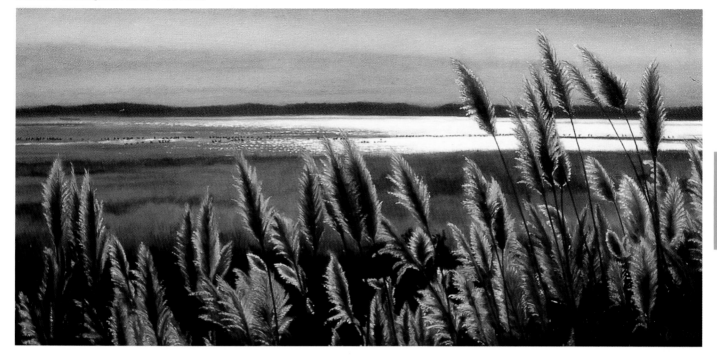

my inspiration

My goal was to capture the peaceful December morning light at the Blackwater National Wildlife Refuge in Maryland. I wanted the viewer to feel the chill in the air and hear the rustling of the grass.

my design strategy

I was drawn to the juxtaposition of the vertical grass against the horizontal bands of land, water and sky. I wanted the painting to invite the viewer to look into the distance but also be able to focus on the foreground and see the light shimmering on frosty grass.

my working process

I started by roughing in the drawing with Burnt Umber thinned with medium. I made an effort to keep the sky and Sienna-colored middle area thin and transparent. Too much paint in those areas would have been less effective in creating the atmospheric effect I was going for. The light areas (water and grass highlight) use much thicker paint. I wanted the painting to be peaceful but not boring. I tried to accomplish that goal by using contrast: light and dark, thick and thin paint, and warm and cool colors.

the advantages of digital photography

I started this painting process with photos from my digital camera. Discovering the advantages of using a digital camera has been a revelation for me. Because the cost of film and developing is no longer a consideration, I take many more photos and many more chances than I used to with a film camera. Sometimes the photos that I don't expect to work turn out to have something special. When I get the photos on the computer, I review what I shot (usually deleting about half) and begin to experiment with cropping the ones I like. With this painting, I played with the cropping until it felt right.

Dramatic lighting has always attracted me. I also love the serenity of this beautiful unspoiled land at the Blackwater National Wildlife Refuge.

what I used

support
Untoned canvas

brushes
Medium-sized bristle filberts

Fine-point sable

oil colors
Cadmium Yellow
Burnt Umber
Yellow Ochre
Ultramarine Blue
Cadmium Red Light

Prussian Blue
Alizarin Crimson
Ivory Black
Burnt Sienna
Flake White

Patrick Dillon lives in Maryland, USA → pld56@aol.com

It was extremely important to keep the shapes looking natural.

Colors of Fall, oil, 24 x 36" (61 x 91cm)

my inspiration

This river has been one of my favorite subjects for a long time. It is the many colors that intrigue me. Throughout most of the stream, the water is shallow except for a deep channel that runs along the side. This creates a multitude of color as the light refracts and reflects. Colors range from cerulean to amber to teal and everything in between.

my design strategy

In the foreground, I widened the water mass in order to give it dominance and give the painting distance. In the background, I angled the stream hard to the left, giving the painting a strong "S" composition and making the shape more pleasing. This also creates more interest as the water disappears behind the tree line. It

was extremely important to keep the shapes, masses, and patterns looking natural.

my working process

- I sketched the picture creating a design. Even at the beginning, I started working the edges and considering values.

- I put in the dark accents. This not only started to define the key areas in the painting but also acted as a reference for comparing values.

- I painted the shadow patterns. From this point on, I kept the values close until the very end. I determined the general color in the water and blocked in the whole mass. This helped me keep the water simple.

- From a solid starting point, I lightened the values and

added colors and shapes necessary to the water. Overworking water is the most common mistake I see. It doesn't take much detail to make water read well.

- Next, I concentrated on value relationships and massed in the uprights, which included the trees, and then the diagonals

(hills, mountains, etc.) and finally the sky. When I painted in the masses, I used a general color for the mid-tones and shadows. At this point, my canvas had nice abstract shapes to work from.

- Then I added the temperature shifts and the details of the trees, water ripples and rocks. Finally, I added the highlights.

what I used

brushes
#6 - #12 Flat bristle brushes

oil colors

CADMIUM YELLOW LIGHT CADMIUM RED MEDIUM CERULEAN BLUE ULTRAMARINE BLUE

ULTRAMARINE VIOLET

Roger Dale Brown lives in Tennessee, USA → www.rogerdalebrown.com

This boathouse was captured using painterly brushwork, edges and value to show texture, rather than detail.

New England Relic, oil, 11 x 14" (28 x 36cm)

my inspiration

The inspiration for this painting was the old boathouse itself. The character of this beautiful old building in failing health, but still standing, also suggested the title, "New England Relic." I wanted to capture the personality of this old relic in disrepair without rendering every weathered plank and broken window.

my design strategy

The design strategy for this painting was quite simple. The fortunate dark shadow of the building reflected in the water served as a natural device to bring the viewer to the main interest, the building. Everything else has supporting roles. The dark shadows under the boathouse anchors the composition and sets the stage for the light that plays

across the face of the building. Harmony is achieved by the complementary nature of the color in the painting.

my working process

- This painting was done basically in the direct, *alla prima* (all in one session) fashion. It is easier, and less risky, in my opinion to sneak up on a painting, but a spontaneous direct approach, if successful, is much more exciting and satisfying to me. The size of this painting (11x14") also allowed for completion in one sitting. I began this painting with a neutral wash, just to rid myself of the stark white of the canvas. This allows one to judge color and value more quickly. Painting on a white canvas can be problematic.

- Then I indicated roughly the darkest areas under the building.

- Next, I suggested very broadly the shape of the building and color notes without too much detail. The goal was to use paint quality, edges, and value to

indicate the texture of this old building, rather than render a lot of fussy detail. This was achieved by using bristle brushes (filberts and flats), and some palette knife work.

what I used

support
Linen canvas

brushes
Filberts

Flat bristle brushes

other materials
Two palette knives

Medium: 1 part stand oil, 1 part Damar varnish, 5 parts turpentine

oil colors

TITANIUM WHITE · CADMIUM YELLOW · CADMIUM YELLOW DEEP · YELLOW OCHRE

CADMIUM RED · VENETIAN RED · TRANSPARENT OXIDE RED · ULTRAMARINE BLUE DEEP

COBALT BLUE · VIRIDIAN

Hodges Soileau lives in Florida, USA → www.hodgessoileau.com

My painting is about reliving childhood memories and capturing moments of glorious, hazy summer days past.

Resting, watercolor, 13 x 20" (33 x 51cm)

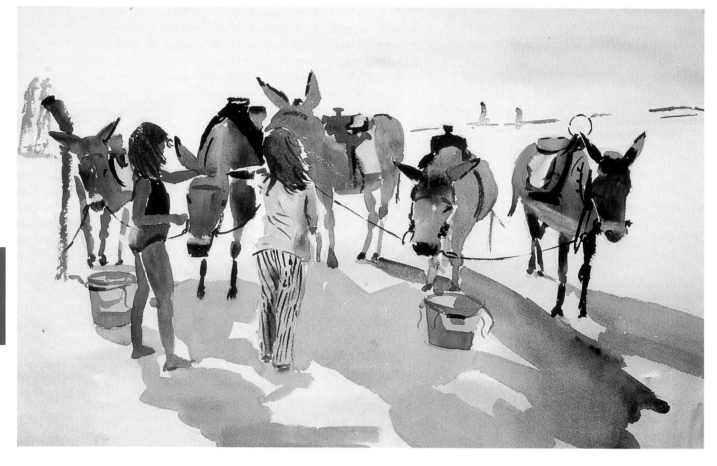

my inspiration

Whilst holidaying in Devon, my children were very excited to discover these beautiful donkeys on a beach at Exmouth. I decided to work from photographs and snapped numerous digital images for future reference.

my design strategy

The different postures of all the donkeys lent themselves well to the overall composition, with very little alteration. I wanted my daughter and her new friend to be upfront in the composition.

I made the wash for the sand considerably paler than the sand would appear in reality, and the donkeys and children's skin tones are slightly darker. I wanted to create that hot, steamy, summer heat atmosphere.

my working process

I applied a very pale wash of Prussian Blue to the sky with a very large brush. I then used a mix of Raw Sienna and Sepia, again well diluted, for the beach. Whilst this wash was still wet, I added some Raw Sienna and Burnt Umber to the very near foreground. This was done for two reasons: The warm colors added to the front would create the recession in the painting. The granulation that would occur from doing this would add interest to the painting and break up the sand to make it more interesting. (You need to let it dry naturally to let the granulation occur.)

I used a mix of Ultramarine Blue and Burnt Umber for the darker donkeys. I then used a clean damp brush to drag some of the color away from underneath the donkeys. For the legs, tips of the ears and noses, I used a fairly thick mix of Sepia. On the legs I tried to use dry-brush marks to create a feeling of looseness and the impression of the donkeys moving slightly, whilst refreshing themselves. To break up the composition I used a Cobalt Blue and Raw Sienna on two of the middle donkeys. The children's flesh tones were a light Red with a very small amount of Sepia added, slightly darker than reality.

There is a large area of shadow in the foreground. I decided to use a mix of Ultramarine Blue and Burnt Umber, hardly mixed at all in the palette. Doing it this way meant there would be a lot of variation within the shadow breaking up the large area.

what I used

support
Rough watercolor paper

brush
Large brush with a good point

watercolors

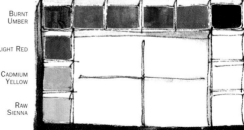

Marilyn Allis lives in Dorset, UK → www.marilyn.allis.btinternet.co.uk

The winding stream leads the viewer's eyes to the sunset and rocks.

Another World, watercolor, 14 x 21" (36 x 53cm)

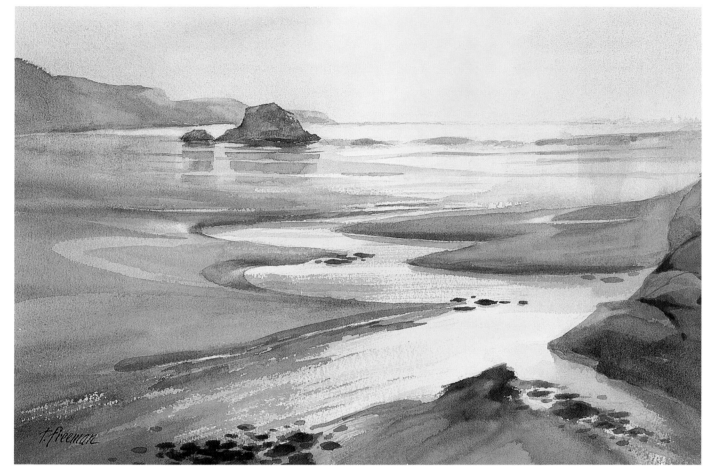

my inspiration

There are so many moods along the Pacific Coast. I wanted to show a very quiet, peaceful scene. The painting is imaginative, derived from so many walks along the shoreline.

my design strategy

I decided to illustrate this scene with the use of a winding stream leading the viewer's eyes toward the sunset and the outcropping of rocks. In order to show the brilliance of the sky, it was necessary to keep the land mass dark for contrast.

my working process

I started by doing a number of small 2 x 3" thumbnail sketches for value and design. After choosing one, I made a quick color thumbnail.

I then sketched the scene lightly onto the paper and brushed it with cold water to slow the drying time. While the paper was damp (not wet), I quickly brushed in the sky area, which set the mood, time of day and direction of light.

In this painting I then brushed in the yellow in the stream area to show the sun's reflection.

After this dried, I painted the ocean, rocks, and sand areas in that order.

why I chose watercolor

I chose transparent watercolor because I am able to portray landscapes and seascapes with a softness and luminosity that is difficult to achieve with opaque mediums.

what I used

support
300lb cold press watercolor paper

brushes
½", 1", 1½"
Flat brushes

other materials
Tissues
Mist sprayer

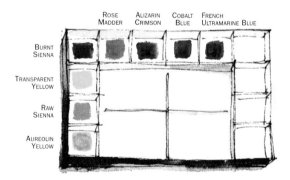

Thomas Freeman lives in California, USA → www.thomasbfreeman.com

I combined warm, late afternoon light with cool, flowing water to create a tranquil, emotional and soothing image.

Rio Grande Evening, pastel, 13 x 24" (33 x 61cm)

Paul Murray

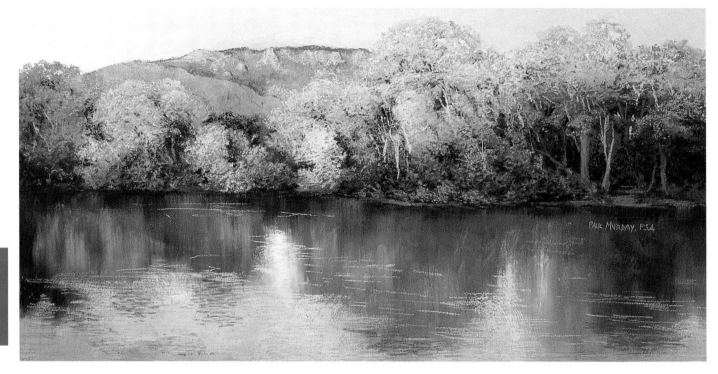

my inspiration

I liked the combination of colors: The dusty pinks of the mountain, the blue/periwinkle of the water and the bright green leaves illuminated by late afternoon light.

my design strategy

My first concern is always composition. That is the first thing which attracts me to an image. My strategy was to balance the color elements of the painting. I also liked the shadows falling on the trees on the right side of the painting. I made the pink/dusty rose mountains more prominent than in the original scene since I didn't want it to get lost in the trees and I wanted the viewer's eye to eventually travel there. I almost always want the viewer to visually travel through the painting, from the foreground to the background. I don't normally want the eye to stop in a certain area of the image.

my working process

- My first step is usually to do a thumbnail of the picture. It's a quick way to become familiar with the image and to quickly explore compositional possibilities or solve potential problems.

- Once this is done, I begin painting from the top down. I use a homemade surface using PVA size, clear gesso and pumice for the ground on hardboard. When I coat the hardboard, I always wet the backside to prevent warping. I also tone the hardboard a medium dark color, since it's helpful for me to work both darker and lighter in value. This makes a highly textured surface, which works great for my style of painting.

- For smooth blending, I use the inner foam core found in archival foam core board. This bubble-foam pushes the pastel into the valleys of the textured surface and blends it very well. For less intense blending, I use a sliver of plastic eraser. Both of these items can be trimmed to the size you need.

- Harder pastels are used for underpainting and broad areas and softer pastels for detail. I occasionally use harder pastels to blend softer pastels in order to mix colors and achieve some textural effects.

my advice to you

First: paint and paint some more. There is no substitute for actually painting. It is where you find yourself. Second: commit to your painting. Don't try to hurry or cut corners. If it goes quickly, great; if not, this is not a bad thing. Each painting has its own life. Nothing is more absurd to me than trying to finish paintings in a certain time frame. Give yourself time to do a good job. Third: Go to galleries and museums. It's really helpful to see original art and how artists do things.

Paul Murray lives in New Mexico, USA → www.murrayfineart.com

I chose oils for this piece because I wanted to build up the foreground surface through an impasto method of painting.

Wellfleet, water soluble oil, 20 x 30" (51 x 76cm)

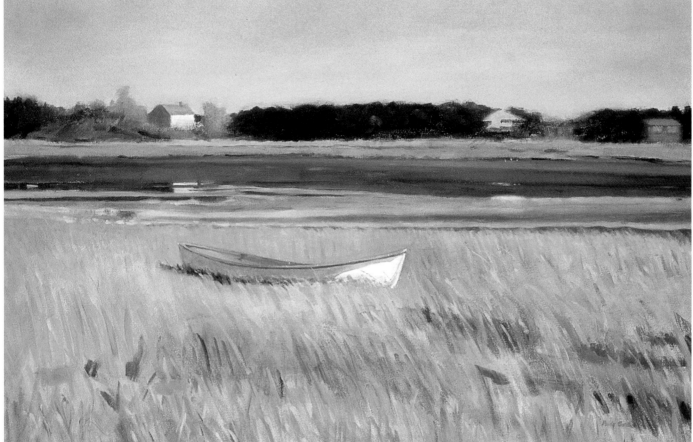

my inspiration

I wanted to capture the light quality at the marshes of Cape Cod Bay. I wanted to show a canoe which was beached in the tidal marshes in Wellfleet, strongly defined by the angle of light.

my design strategy

I used a long horizontal format to emphasize the long horizon which is omnipresent near the ocean. The design is divided into three basic horizontal sections, each a slightly different width. This provides a visual dynamic. The middle section is again divided into sections of slightly varying widths with these sections blending into one another in places. The canoe is placed slightly off center horizontally and vertically for a dynamic and non-static focal point. The canoe is dominant in the composition. This is achieved by utilizing sharp edges, clear bright color and the lightest white in the painting. The water area is

the next dominant area, using blurred edges to convey movement. The background area is softly blurred out to convey distance, especially at the edge where the tree line meets the sky.

my working process

• I explored this area until I found the perfect canoe for my painting. I knew that I wanted a strong angle of light which would make the colors appear as saturated as possible. I chose dawn because the tide was out at that hour. Dawn also gave me a slightly longer window of time than late afternoon, before the colors and edges begin to fade and lose intensity. I shot a roll of color film, showing the canoe at different angles.

• Back in my studio several weeks later, I chose the best photograph based on composition, clarity, perspective and color intensity. I then made preliminary pencil sketches to help me determine

the appropriate canvas size and format. The sketches also helped determine scale, composition, values and gave me a feel for the subject.

• Then I enlarged the photo onto the canvas with an opaque projector. I also enlarged the 4 x 6" photo to 11 x 17" for greater detail.

• I started painting by laying in washes of the darker values. Since there are not many darks in this painting, I immediately started laying on thicker paint in an alla prima (all in one session) style.

• The final stage of transparent glazing was done when the paint surface was dry.

what I used

support
Primed stretched canvas

brushes
#000 Round

#2 - #9 Rounds, Flats, Filberts

Synthetic sable brush

Fan brush

oil colors

TITANIUM WHITE, LEMON YELLOW, CADMIUM YELLOW LIGHT, CADMIUM RED, YELLOW OCHRE, RAW SIENNA, BURNT UMBER, SAP GREEN, VIRIDIAN, ULTRAMARINE BLUE

Paula Gottlieb lives in Massachusetts, USA → www.paulagottlieb.com

Diagonal shapes and contrast made my design work.

Columbia Bridge, oil, 24 x 33" (61 x 84cm)

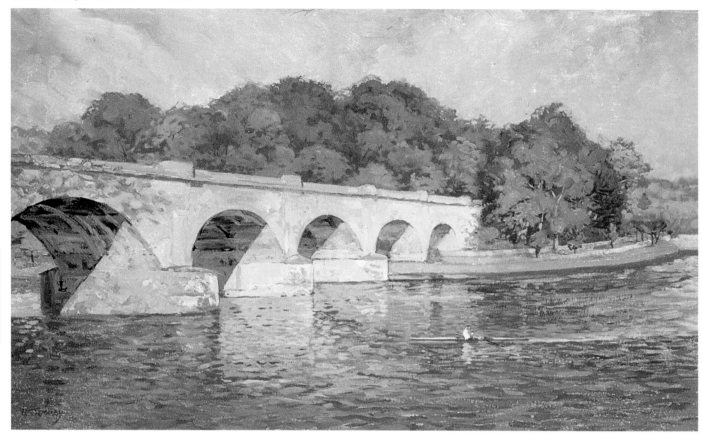

William Ternay

my inspiration
Contrasts inspired this painting: Bridge, sky and shoreline shapes contrasted by the elegant scull gliding through graceful arches. Late afternoon light illuminating the glowing ochre bridge, infusing the air and reflections with warmth, was complemented by the cool river, sky, and shadows.

my design strategy
Diagonal shapes and movement are the dominant theme. The eye enters the picture via the powerful bridge shape, from left middleground to right background. The eye lingers at the illuminated tree, then moves down to the rower and scull, which gently takes us back to left center, and up to the warm, colorful reflections, to repeat the clock-wise movement through the painting. More diagonals are on the crisp shadow edges under the arches, creating a staccato to emphasize the movement to the right. Quiet diagonals of the clouds echo this theme, but do not distract.

Although greater in area, the cool blues, greens, and violets act as foils for the higher-keyed warms in this complementary color scheme.

my working process
• A small, in-scale value drawing preceded this painting. Using a 2" flat hog-hair brush, I covered the canvas with a lightly-colored Burnt Sienna wash thinned with odorless turpentine.

• After about 10 minutes drying time, I roughly sketched the composition in a slightly darker Sienna line, using a # 8 filbert hog-hair brush. I purposely did not indicate values with this thin mixture because I wanted the luminous warm ground to enhance the final colors. With bigger filbert brushes, I painted the sky a Phthalo Blue tint; the clouds white, gently tinted with Raw Sienna. With these colors I went from a "lean" to a "fat" paint mixture for the rest of the painting, introducing an alkyd medium and heavier paint.

• With the value of the sky established, I then went to the yellow bridge, the lightest, warmest, and most powerful shape in the painting.

• Next came the dark cool blues and violets in the shadows of the arches. Note that the darkest darks start in the left arch, then get progressively lighter as the arches reach the far end of the bridge, creating atmospheric perspective.

• Mixing colors as much as possible on the canvas, I laid in the warm cool greens on the distant shore, then the water, and finally, back in the studio, the rower, from sketches.

• Working from 4pm to 6pm on three consecutive days, I built up impastos and refined colors and values until, finally, the painting told me we were done.

what I used
support
Acrylic-primed cotton canvas

brushes
#8, #10, #12 Filbert hog-hair

medium
Alkyd painting medium

Odorless turpentine

oil colors

TITANIUM WHITE · CADMIUM LEMON YELLOW · CADMIUM YELLOW DEEP · CADMIUM ORANGE · ROSE MADDER · CADMIUM RED DEEP · PHTHALO BLUE · FRENCH ULTRAMARINE BLUE · PHTHALO GREEN

William Ternay lives in Pennsylvania, USA → wternay@comcast.net

I painted many glazes of color over the same area to create a sense of depth in the water.

Reflections in Ellery, acrylic, 18 x 24" (46 x 61cm)

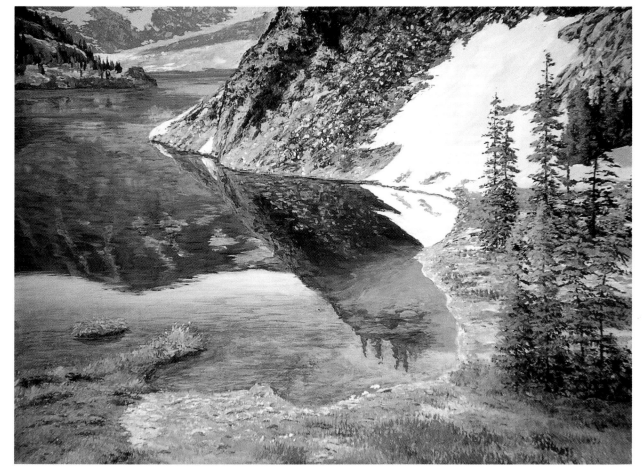

my inspiration

Embraced in the cradle of soaring granite peaks atop the Sierra mountain crest lies Ellery Lake. I saw this scene on one of my regular trips is to this California high country over Highway 120 and Tioga Pass.

my design strategy

I did several studies of Ellery Lake, but the exact angle and layout of this particular painting came from a photo. I was particularly intrigued by the "ghost image" of the reflection as it melds into the deep water. The curve of the shoreline was also interesting as it leads you into the painting.

my working process

• I first drew a rough sketch on the board, then blocked in the darks and shadows with a deep purple mixed from equal amounts of Ultramarine Blue and Quinacridone Red. I use this

mixed purple throughout the painting process. I also mix a gray (usually Phthalo Blue and Cadmium Red Medium) to use throughout the painting.

• I then blocked in the other areas with washes of the main local color to get rid of the white of the canvas so that I could judge the values better.

• To obtain a feeling of distance, I used primarily blues and grays for the background shore and gradually intensified the colors as they came to the foreground. The far shore was painted primarily of gray mixed with white, some Sienna and a touch of Cadmium Orange.

• The rocky point was first roughly sculpted in with a palette knife using the purple mixture. I then went back over it with various size brushes and the palette knife, adding in details to the rocks. I also used the splatter technique to define some of

the small rocks.

• To create a sense of depth in the water, I paint many glazes of color over the same area, gradually building up a feeling of depth. Between each glaze I will put on an extra coat of acrylic gloss medium to further separate the layers.

• The foreground was painted using many layers of color applied with a variety of brush sizes and the palette knife. A ruling pen and a script brush helped finish some of the details of the tree branches, grass, and other plants.

what I used

support
Gesso-primed board

brushes
#6, #8, #10 Bright
Script brush
Fan brush

other materials
Palette knife
Ruling pen

acrylic colors

Donald Neff lives in California, USA → www.donaldneff.com

Tranquility, beauty and majesty inspired this painting.

Spirit Island, acrylic, 9 x 20" (23 x 51cm)

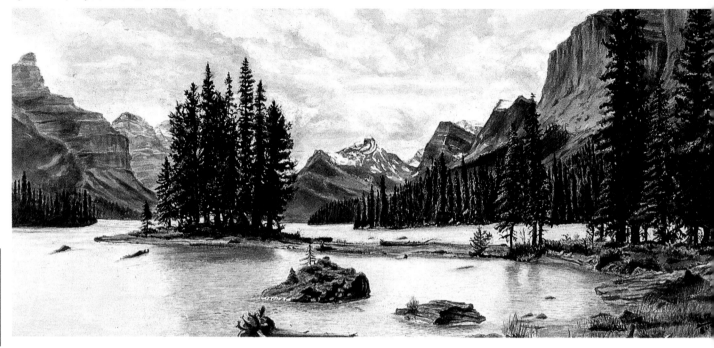

ARTIST 46

Lorenzo Ferreiro

my inspiration

Two summers ago my wife and I took a vacation to the Canadian Rockies. Spirit Island is located in the middle of Maligne Lake in Jasper National Park. While the entire lake was impressive, it was the tranquility, beauty and majesty of Spirit Island that inspired me to want to paint it.

my working process

- I made some quick thumbnail sketches on the spot, as well as written notes and photos.

- At home I made some pencil sketches to establish a composition, where Spirit Island could be the center point. Then I did a final and detailed but light pencil sketch on 140 lb. cold pressed watercolor paper.

- Beginning with the sky, I applied light washes of Ultramarine Blue with #4 and #5 round brushes. Starting at the left top corner of the paper, working to the right, I left the white of the paper for clouds. I also used touches of Payne's Gray for the gray clouds.

- I then worked on the mountains and rocks in the foreground in the water. I applied washes of Raw Sienna and Yellow Ochre. I applied some transparent glazes of Payne's Gray with a touch of Mars Black, working from light to dark over the dried mountains and rocks. I let the white of the paper become the snow on the mountains.

- The water was the result of laying a light wash of Cerulean Blue with a #5 flat brush. When it dried, using #1 and #2 round brushes, I rendered the wrinkles on the water using a mixture of Cerulean Blue and a touch of Payne's Gray.

- The pine trees were painted from light to dark using different mixtures of Sap Green, Forest Green, Hooker's Green, Burnt Umber and Mars Black.

- The grass on the bottom right and in the water was painted with Sap Green and some touches of Yellow Ochre.

what I used

support
140lb cold pressed watercolor paper

brushes
#0 - #5 Rounds

#5 Flat

acrylic colors

Lorenzo Ferreiro lives in New Jersey, USA → lferr31082@aol.com

I wanted to illustrate the power of the forces of nature and its effect upon the sea

Surging Sea - Cape Ann, watercolor, 13 x 18" (33 x 46cm)

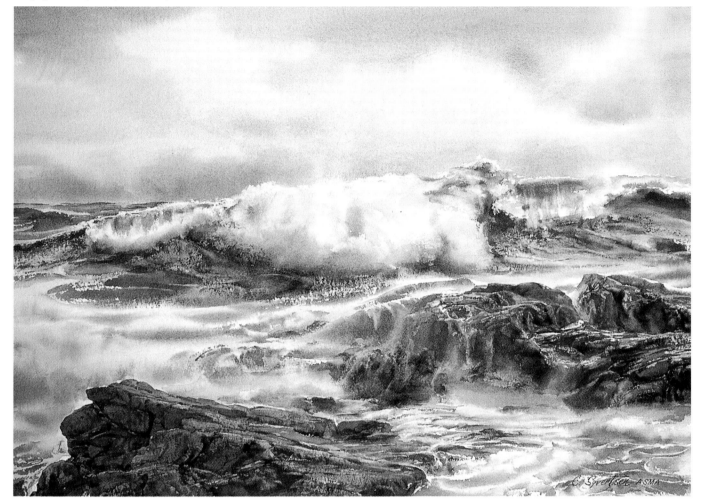

ARTIST
47

Charles Syvertsen

my inspiration

I have always enjoyed painting marine subjects. Bass Rocks is the location and lies between Gloucester and Rockport, Massachusetts, on Cape Ann. The breaking sea provided the drama and the inspiration. In the painting I wanted to illustrate the power that the forces of nature and the sea can generate.

my design strategy

The composition is simple and consists of three large shapes: The breaking wave and the two rock formations in the foreground. The warm sunlit area in the sky casts a strong light on the large wave. I emphasized this by painting a bluish-purple wash over the horizon line and the top of the wave on the left side of the painting. The rock formations tend to keep the eye in the picture and on the breaking wave.

Charles Syvertsen lives in New York, USA ➡ esyverts@optonline.net

my working process

- I took some photographs and made several quick thumbnail sketches. Conditions changed rapidly and I had to decide whether to paint the large wave before or after it broke against the rock. After studying the photos and sketches in my studio, I made a composite drawing on poster bond paper. I turned the sketch over and traced over the lines with a 5B pencil and transferred the drawing onto my watercolor paper. This process ensures a clean working surface with no erasures.

- Before painting, I used a little masking fluid on top of the wave to preserve the highlights. I wet the paper and painted a light wash of lemon yellow and a bit of orange. This wash was very light. While the paper was

still wet, I dropped in the blues and violets creating the diffused light in the sky.

- After removing the masking material I painted the large wave using the same colors reflected from the sky. To get a strong contrast I painted the area under and around the wave with strong dark color, primarily Ultramarine and Phthalo Blue tempered with violet and green. I used some dry brush strokes to

enhance the appearance of foam.

- I wet part of the paper in the misty areas of the water and rocks using Ultramarine Blue, Red and Burnt Sienna. I used these colors sparingly to create a luminous effect. The same colors, plus Raw Sienna, were used on the rocks. More pigment was used to obtain darker values. I used more dry brush techniques on the rocks to add some texture.

what I used

support
300lb Cold press watercolor paper

brushes
#2, #4, #6, #8, #12 Kolinsky sable rounds

Round show card lettering brushes

2" wash brush

Sable ½", 1" and riggers

watercolors
Cadmium Lemon
Cadmium Yellow Pale
Quinacridone Red
Raw Sienna
Burnt Sienna
Phthalo Blue
Ultramarine Blue

Dividing the composition into thirds strengthens the visual contrast.

Low Water - East Hickory, acrylic, 15 x 22" (38 x 56cm)

ARTIST
48

Christopher Leeper

my inspiration

This painting was inspired by the deep contrasts of sunlight and shadow and the textures of the exposed streambed and fallen tree.

my design strategy

The composition follows the classic ⅓ division. The fallen tree on the horizontal ⅓ and the leaning, dead tree falls along the vertical ⅓. The most visual contrast also exists along these lines.

my working process

• Working from a photograph, I made a light drawing on hot-pressed watercolor paper. A watery mix of Phthalo Blue and Burnt Umber was used first to establish the darkest shapes. This was done with #6 and #10 rounds.

• Once these washes were dry, local color was brushed on using a no. 12 round. At this

stage the painting resembled a traditional watercolor.

• Next, using a #8 round and a ½" flat, a variety of medium value greens were brushed into the background. This application of color was a bit more opaque. Once the background shapes were established, the fallen tree, shoreline, water and foreground were developed further with a mix of transparent and semi-transparent washes.

• The darkest values were put in using a semi-opaque mix of Phthalo Blue, Burnt Umber and a touch of Cadmium Red. Several thin washes of color were layered on the trees and shore. On top of these washes, opaque mixes of color and Titanium White were used to establish the light value details. The early application of color on the water was allowed to stay with a few opaque touches of yellows and pinks added.

I heightened the color by using mixes of Brilliant Blue and Acra Crimson to create the vibrant shades of blue and purple. The lightest values were done with opaque Titanium White.

• The leaves of the foreground

brush were then painted with a semi-opaque mix of Phthalo Blue, Cadmium Yellow Light and Brilliant Blue. Finally, a wash of Ultramarine Blue and Burnt Sienna was laid across the water to represent the cast shadow.

what I used

support
Hot-pressed
watercolor paper

brushes
#1, #2, #4, #6, #8, #10, #12 Synthetic watercolor rounds
½" Synthetic watercolor flat

acrylic colors

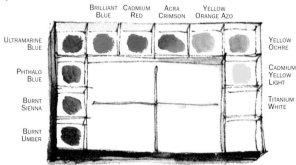

Christopher Leeper lives in Ohio, USA → christopherleeper.com

The light and reflections dominate this scene.

October Sunlight, oil, 30 x 30" (76 x 76cm)

my inspiration

The inspiration for this painting was the colors of the reflections in the water. The October sunlight is lower than it is in midsummer and this light picked up a lovely crisp autumn light from the trees and the bridge. There was a lovely contrast between the blue of the sky set against the warm autumn colors of the trees in the reflections of the river.

my design strategy

I was interested in the light and how the soft reflections in the water contrasted with the sharper edges in the reflected light on the bridge. I wanted the cool colors of the bridge and foreground reflections to contrast and complement the softer warmer colors of the trees in the middle of the painting. I tried to use the bridge as a focal point where the reflected colors in the water lead the viewer into the painting.

my working process

- For this painting I worked from sketches taken on site and from photographic references. I started the painting in the studio, drawing the main areas of the painting first. I worked out the overall design and composition of the painting by sketching.

- Then I blocked in the main areas of color, using very little painting medium. Once I had the main composition and colors painted in, I worked out the shadows on the bridge and the trees to establish the light pattern in the painting.

- Then I started to work on the reflected colors in the water, working from the bridge out to the foreground of the painting. I began with the darker colors in the water and gradually worked up to the lighter areas. I wanted to keep a strong contrast between the lights and darks in the water. I worked back into the main areas using more painting medium, refining and blending colors as I worked.

- Once this painting began to take shape, I worked on the lighter areas, adding a little more detail, for example, picking up areas where the light hit the arches on the bridge and the lighter colors in the water. Then I continued to refine the colors and the tones in the shaded areas until I was satisfied. I normally leave the painting for a few days, then come back and look at it fresh and maybe rework some areas, adding some final details as I finish.

ARTIST
49

Eugene Conway

what I used

support
Oil-primed linen canvas

brushes
#4, #6, #8 Flat
#2, #4, #6 Round
Fan brush

other materials
Palette knife
Painting medium
Linseed stand oil

oil colors

TITANIUM WHITE · NAPLES YELLOW · CADMIUM YELLOW PALE HUE · CHROME GREEN HUE
INDIAN YELLOW · RAW SIENNA · BURNT SIENNA · ULTRAMARINE BLUE
SAP GREEN · IVORY BLACK

Eugene Conway lives in Dublin, Ireland → carolink@indigo.ie

This scene was a color show-stopper for me.

Safe Harbor, oil, 16 x 20" (41 x 51cm)

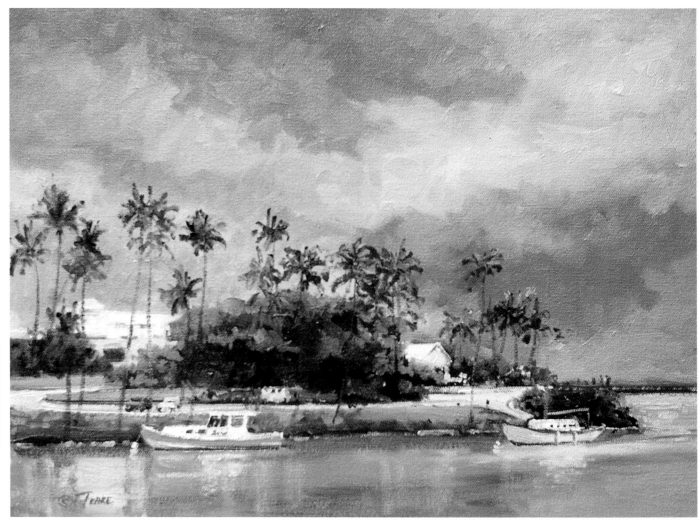

Virginia Peake

ARTIST
50

my inspiration

The beautiful colors of the water, set off by the glowering sky, and accented by the whites of the Bermudian roofs and boats, made the scene a color show-stopper for me.

my design strategy

I intuitively knew the painting would work. There were several light areas of interest within the painting, so I just made sure the eye had a "path" to follow from one to another, so the viewer wouldn't get bored and move on.

my working process

- I built this painting in layers. After spraying the drawing with a fixative, I put a bright orange mid-tone on the canvas to set up a vibration against the cool colors to follow.

- Next, I laid in and completed the sky, the water and the darkest areas of the land. I concentrated on getting a wide variation of colors within the grays and blues.
- When this dried, I put in the middle values of the greenery and the boats.
- Last: dessert. This consisted of the trees and the clean whites on the buildings and boats, and the reflections on the water. Then the painting sat and aged on the mantle for a couple of weeks so any mistakes would eventually become evident and could be fixed.

atmosphere sets the mood

The ominous atmosphere looming over the tranquil harbor scene provided a natural tension. There was also tension between the calm water's translucent blues, and the angry sky's opaque blues and grays.

what I used

support
Canvas

brushes
#4 - #10 Filberts
Small round for details

oil colors

CADMIUM YELLOW LIGHT	CADMIUM RED LIGHT	PHTHALO GREEN (BLUE SHADE)	PHTHALO BLUE
COBALT BLUE	ULTRAMARINE BLUE	PERMANENT GREEN LIGHT	YELLOW OCHRE
BURNT UMBER	TITANIUM WHITE		

Virginia Peake lives in Connecticut, USA → www.virginiapeake.com

Tonal contrast and rich, intense darks helped me suggest a feeling of strong sunlight.

Under the Boardwalk - Santa Monica, CA, watercolor, 33 x 26" (84 x 66cm)

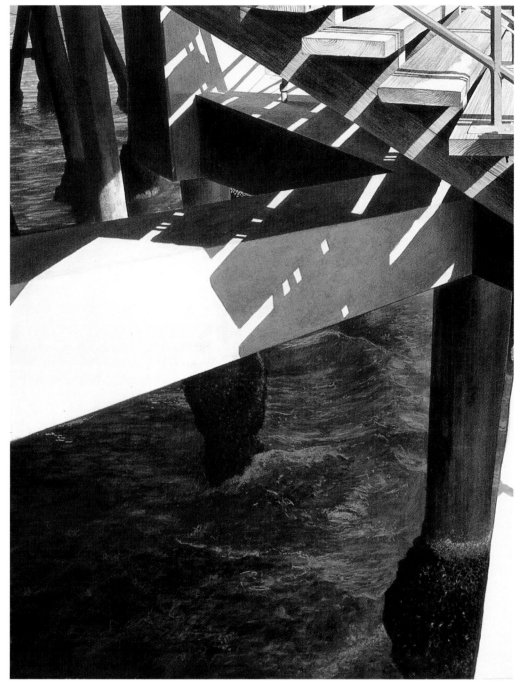

my inspiration

While visiting the pier at Santa Monica, I was struck by the quality of light playing across the sculptural forms of the pier and the depth of color and tone in the shadows cast on the water.

my design strategy

The structure of the pier is angular and I wanted to convey the monumental and rigid quality of the construction against the chaotic and free-flowing nature of the sea.

The painting itself is predominately blue/green, with some warmer orange in the wood and in the shadows; this helps the painting from becoming too cold. I left the large areas of bright sunlight as white paper to produce the effect of blinding Californian sun hitting concrete.

my working process

- I spent a while doing an accurate drawing in pencil (4B).
- I always start with an uncomplicated underpainting with simple, almost monochromatic washes.
- I began to work into the water with a squirrel-hair mop brush and tried to convey the jagged, choppy shapes of the water almost in a calligraphic manner.
- I enjoy using colored pencils with watercolor and especially find them useful when describing water and reflections.
- The steps on the right hand side were built up by dragging my brush on its side to pick up the texture of the paper, creating a wood grain effect in the process.
- I used mainly washes of pure color wet-on-dry, making sure not to agitate the surface. It meant I could build up a very rich and dark surface, which often surprises people as they don't expect watercolor to be so intense.
- The water's depth of tone was enhanced by splattering with a short-haired stipple brush and spraying with a plant spray gun.

Angus McEwan

ARTIST 51

what I used

support
Cold press watercolor paper

brushes
Squirrel mop brushes

#000 - #10 Sable watercolor rounds

¹/₄" - 1" Square-headed synthetic brushes

other materials
Watercolor pencils

Plant spray gun

Angus McEwan lives in Fife, Scotland → www.angusmcewan.com

watercolors

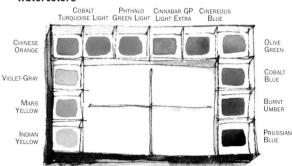

COBALT TURQUOISE LIGHT · PHTHALO GREEN LIGHT · CINNABAR GP LIGHT EXTRA · CINEREOUS BLUE

CHINESE ORANGE

VIOLET-GRAY

MARS YELLOW

INDIAN YELLOW

OLIVE GREEN

COBALT BLUE

BURNT UMBER

PRUSSIAN BLUE

This is a symbolic painting about the new dreams of imminent spring.

Oleksiy Turkot

Sunrise on Icy Pond, oil, 36 x 24" (91 x 61cm)

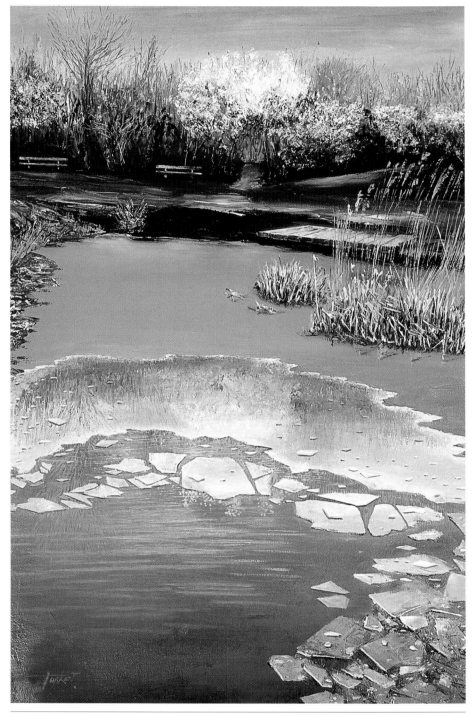

my inspiration

I came across a very rare moment on a pond, when at the very start of a sunny day in springtime there is a light frost. This phenomenon produces big contrasts: Under the rising flame-colored sun, the bare branches of the trees and the shore are empty after the long cold winter. The delicate frost on the wooden benches, on the dry reeds and on the bridge recalls the harshness of winter. All these things help to reveal the beauty of spring. The pond is covered in green all year round. On this occasion the ice, which was breaking up, revealed a dark reflective smooth surface with a large range of colors of the advancing spring.

my design strategy

The basis of the composition is the path leading to the park, where the rising sun, a symbol of vivid memories, is starting to blaze. In one color the matte frozen greenery on the pond calms and balances the strong contrasts of the different colors. The symmetry of the reflections has created the picture's vertical composition. The horizontal line of the shore and the frozen benches is a transition into the world of the coming spring and the hope of past meetings.

my work process

- For this kind of technique I chose the palette knife. It was easier for me to show the true color of the cold-warm sky with the flame-red trees of the park.

- I painted the shore in the background on the still-wet layer of black between sky and pond to make it stand out.

- After the paint dried, the main task was to show the frost. The white color on the blossoming trees is a symbol of spring, while the white of the frost symbolizes winter.

- I used a palette knife to make the dried out, almost transparent, reeds stand out.

- I used brushes for the difficult task of depicting the pond surface spreading like hot, molten volcanic rock, into the cold matte smooth surface of ice.

- The ice pieces that had formed on the lake were randomly placed, recalling the way in which the viewer is able to break up their old thoughts before their new dreams take shape.

what I used

oil colors

TITANIUM WHITE	CADMIUM YELLOW LIGHT	CADMIUM RED LIGHT	CADMIUM RED DEEP
ALIZARIN CRIMSON	VIRIDIAN	VIOLET PERMANENT	COBALT BLUE DEEP
ULTRAMARINE BLUE DEEP	IVORY BLACK		

Oleksiy Turkot lives in Lviv, Ukraine → www.artturkot.com

This was a glorious farewell to a stricken friend.

River's Magic Palette, pastel, 11 x 19" (28 x 48cm)

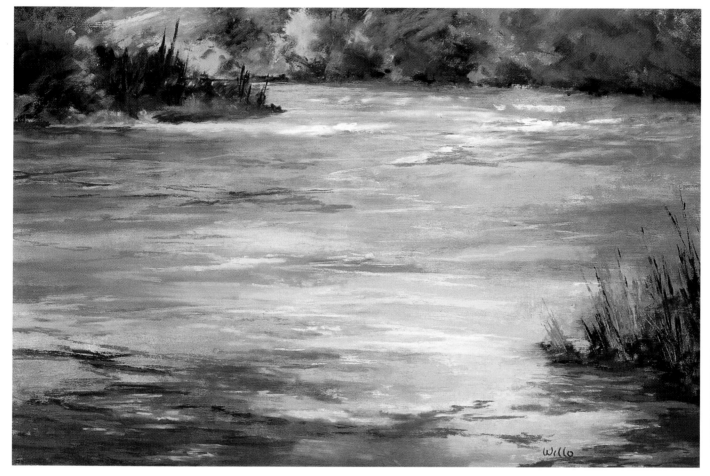

my inspiration

It was a late evening in August, and we were attending a "memory celebration" of a young 18-year-old man taken by cancer. His wish was to have friends celebrate life along the river and have fun. As the sun was setting beyond the river bend, it bathed the hillside in the salmon glow and reflected it back into the water. I knew I had to do this painting. It was a glorious farewell moment to all of us.

my design strategy

I wanted to create a high horizon line and let the viewer appreciate the reflections in the water without knowing for sure that the hillside created the reflected light. I wanted the viewer to walk into the dark of the water in the foreground and follow the salmon reflected light back to the curve of the river, and by using the middle blue of the river, to carry you back into the center of interest.

my work process

- I begin by making numerous thumbnail sketches from the 75 photos taken at the scene to determine the eye movement and the placement of the center of interest.

- Then I sketch this onto my textured paper (which has been mounted on mat board) with a #2 charcoal pencil.

- I then apply an underpainting stain with thinned oil paints by blocking in solid areas of color, at times using the family color or the complementary color. In the river I used both blue and a salmon stain because I wanted some of the stain to show through on the final piece.

- After the oil stain has dried (about 10 minutes), I apply the pastels. I start with my softer pastels, as the stain allows me to bypass the hard pastel stage. I establish most of the darks and then work at the center of interest to establish the lights. From this point on, I work on all parts of the paper, never staying in one area very long.

- As a final step, I add the accents and highlights. This sometimes creates changes throughout the piece to bring some color "up" and to weaken other colors. On this painting I found I needed to create stronger darks in the foreground to bring the eye back to the center of interest.

what I used

support
Textured paper mounted on archival mat board

pastels
Various brands from soft to hard

other materials
Paintbrush to remove excess pastel

Willo Balfrey lives California, USA → www.willobalfrey.com

In my painting, the directional patterns in the sky and ocean form a large arrow pointing at the headlands.

Past Ventana, watercolor, 20 x 28" (51 x 71cm)

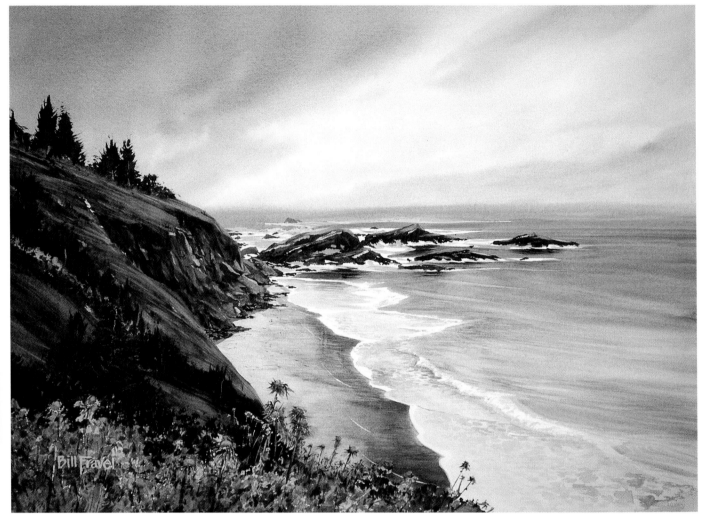

my inspiration

I might state that the inspiration for this painting was the current condition of our planet environmentally, politcally, and socially, and therefore a metaphor for man's quest for truth. The other reality is that it was done as a demonstration for a local watercolor group to illustrate how to paint from a bad snapshot.

my design strategy

When painting from a photograph, I use the photo only as a general reference or starting point. If you copy a bad photo exactly, at best you'll have a bad painting. The trick is to change shapes, colors, and values to give the painting your desired focus.

my working process

- I never sketch on my paper before painting. I do not want to know what is coming next. I want each mark or shape to be a response to the previous one, not just an isolated neighbor.

- In this painting, I painted the sky and ocean first as the largest shape. The directional patterns in them form a large arrow pointing at the headlands.

- The rocks and headlands were added to buttress the arrow and bring the eye down into the thistles, which in turn bring us to the beach and my focus.

try this approach

Try leaving lots of randomly placed white. This leaves you more options to go back and direct the viewer to a focus: thistles, waves and movement, shimmering cliffs and whitewater.

what I used

support
Unstretched 140lb. Cold press paper clamped to a masonite board

brushes
1", 2" Flat
1" Bristle
#4, #12 Round
#4 Rigger

watercolors

Bill Fravel lives in California, USA → www.whalehedge.com

I focused on the underlying abstract design and black/white harmony in this work.

Bastia Harbor Lighthouse, oil, 14 x 11" (36 x 28cm)

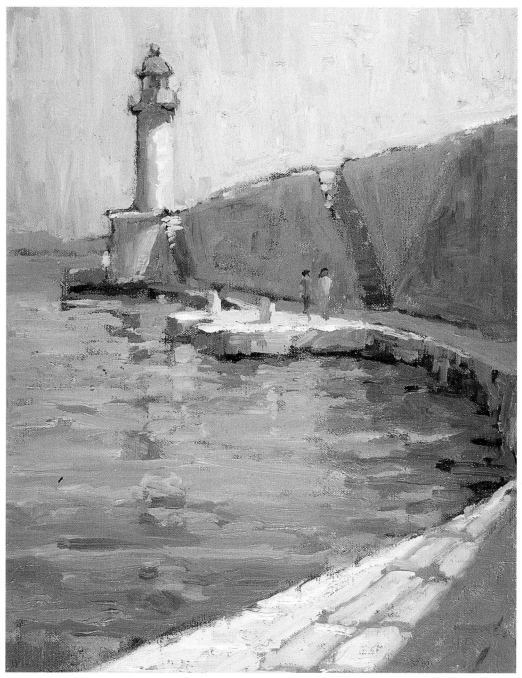

Barry John Raybould

ARTIST 55

my inspiration

I was struck by the mood created by the red top of this lighthouse set against the field of blue-violet, blue and blue-green-grays of the Mediterranean ocean and sky.

my main challenges

There were three main challenges in this painting:

- The first challenge was to create a strong dark/light harmony — one of the key abstract foundations of all successful paintings.

- The second challenge was to create interesting paths for the viewer's eye to move around the composition and so keep the viewer involved in the painting.

- Finally, I wanted to work in the close middle value ranges where grays are the most beautiful. If you go too dark or too light, you end up with lifeless color. At the same time, I needed to create visual interest and life in the three major flat gray shapes in the painting: the sky, the water and the outer harbor wall.

my working process

- I made several small (about 1 x 1½") studies of the light/dark pattern using brush pens of different values. The process I use for creating these studies is much quicker than using pencil or ink pens, so I can explore many more design options in a given time.

- I used two techniques for creating eye movement. First, I used the graceful curve of the quayside, the steps in the harbor wall, and the vertical reflections in the water to design a series of circular eye path movements. I also repeated the red of the lighthouse throughout the painting: in the figure, in the reflections, and more subtly, in small color variations in the harbor wall and in the sky.

- I used color vibrations to create visual interest in the wall by layering warm and cool complementary colors on top of each other, and by layering pinks into the blue-gray of the sky. These touches also helped unify the color in the painting.

what I used

support
Linen canvas

brushes
#4, #6, #8 Filberts

oil colors

CADMIUM YELLOW MEDIUM · CADMIUM ORANGE · VENETIAN RED · CADMIUM RED LIGHT · ALIZARIN CRIMSON · PLATINUM VIOLET · COBALT BLUE · BURNT UMBER · ULTRAMARINE BLUE · PHTHALO BLUE · TITANIUM WHITE

Barry John Raybould lives in California, USA → www.VirtualArtAcademy.com

This was a tussle between light and dark . . . even at sunset the sand shone like a mirror.

Sea Scale, acrylic, 10 x 13" (25 x 33cm)

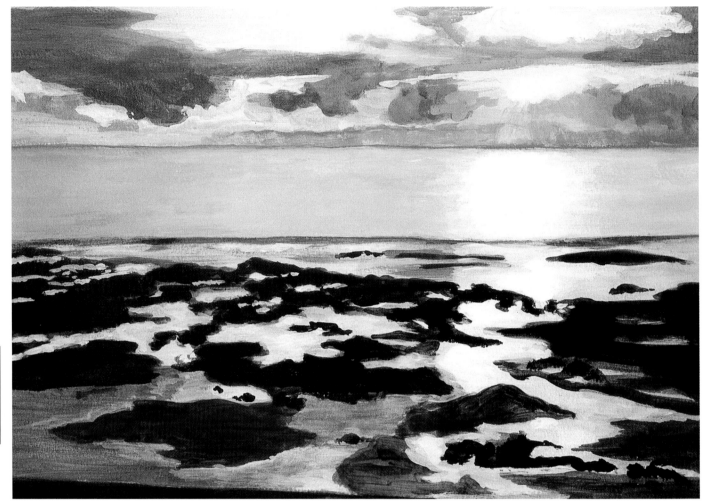

my inspiration

I was inspired to paint this while walking on the beach at sunset after a rainy day, when the weather cleared briefly to leave the sand shining like a mirror.

my design strategy

The rays of the partially obscured sun reflecting on the rain-soaked sand lead the eye towards the horizon.

my working process

I worked initially from dark to light, but then overpainted with whiter highlights when the paint was dry. I used flow enhancer to allow the paint to flow more easily. I also used acrylic gloss medium to seal the paint and to add a watery sheen. I used a rigger brush to form the horizon; with a wet brush I diluted the color below the horizon line.

my main challenge

The main challenge was to try and recapture the atmosphere. The subject matter was limited: sky, clouds, sea, puddles and sand. At no time was I tempted to place a figure, bird or animal in the painting, although there were people walking their dogs on the beach and plenty of birds. Rather the challenge was to create a feeling of solitude and immensity within the simplicity of the scene and to get the right balance between dark and light.

photography helped

This was painted from a photograph. I was on a walking holiday in the Lake District. The rain dampened the days but the evenings were clear, and the brightness of the reflections and the changing skies helped to lift the spirits. I took many photographs and this one inspired me to try to recapture that feeling.

what I used

support
Board

watercolors

Susan Harley lives in Notts, UK → sdh1@emidlands.wanadoo.co.uk

I tried to capture the force of the waterfall by not overworking the water.

Hiking in Montana, oil, 22 x 18" (56 x 46cm)

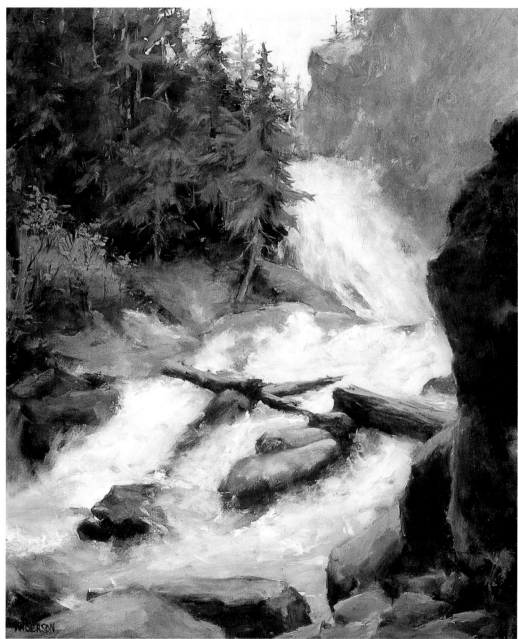

my inspiration

I was hiking with my family in Montana when we came upon this breathtaking spot. I immediately knew that I wanted to capture the force of the waterfall on canvas.

my design strategy

This piece hardly needed any help from me with the design. I think I have developed my eye as an artist to the point where it is the composition as much as the scenery that attracts me. The trees on the left and the dark cliffs on the right framed the waterfall beautifully – I only had to move a few rocks to make it work.

my working process

I started this painting from life with a small (8 x 10") canvas and laid it down in the "brown method" I use to begin a painting. I applied a deep Transparent Oxide Red, Ultramarine Blue, and Sap Green wash over the whole canvas and then "pulled out" my drawing with a paper towel dipped in some pale drying oil. I pulled the water out almost to white, then wiped the lights on the rocks and trees lightly. With a soft, round brush I drew in some trees — again dipping in the oil. I then took numerous digital photos to work on a larger painting back in my studio.

preliminary sketches

This painting was started from life as a small sketch and started over as an 18 x 22" in my studio using the sketch and photos as reference. I find that I need the feel of the landscape in person to inspire me to realistically convey what I am trying to say.

my main challenge

The main challenge in a waterfall is to keep it moving. I look for where the rocks form a crest and for the very lightest lights in the foam. Do it fast and trust yourself: It's better to wipe it out and start over than to fuss with each section. Look for the masses and where the turns are. Remember, there is very little pure white. The colors in the water will vary depending on many factors — geography, geology and the season, as well as the usual factors of sun or clouds and time of day.

what I used

support

Portrait linen canvas glued to masonite for field studies

Double-lead-primed stretched portrait canvas for larger paintings

medium

Odorless turpentine

Pale drying oil

oil colors

RAW SIENNA YELLOW OCHRE PALE VIRIDIAN SAP GREEN

TERRA ROSA TRANSPARENT OXIDE RED CADMIUM YELLOW DEEP OLIVE GREEN

COBALT BLUE CERULEAN BLUE

Kathy Anderson lives in Connecticut, USA → kathyandersonstudio.com

Even with a highlighted central feature, I made sure the picture was a balanced whole.

River Yeo, Landcross, gouache, 12 x 17" (30 x 43cm)

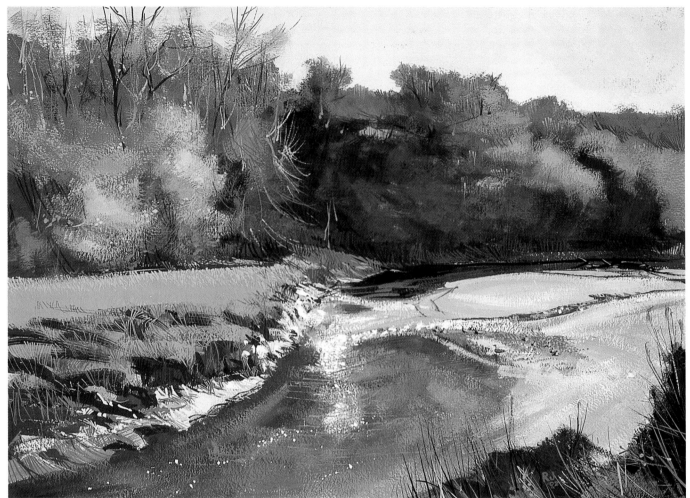

my inspiration

I am working on a series of British river paintings. I try to cover all the seasons in a year and all aspects of rivers that are affected by them. In this picture I am anxious to capture two elements: First, the autumn season with its fantastic color. Second, the fact that the river is tidal. This calls for a strengthening of the oranges and shadows and the indentations, caused by two tides a day, in the banks.

my design strategy

The strength of this picture is the balance of heavy shadow and rich coloring. Its vitality is the flow of water and flood of light, even the flock of birds on the mud. Critical to the overall design is the direction of the painting itself; from right to bottom left, increasing in intensity as it goes and establishing the flow of the river.

Robert Jennings lives in Devon, UK → www.river-paintings.co.uk

my working process

• I walk the river to decide the ideal viewpoint. This could be a long walk, with many opportunities but I usually know what I want to do before leaving the scene. If you don't know a river, it is difficult to guess what the next bend or a reverse journey along the same stretch will reveal. So it follows that I invariably paint from a photographic reference for detailed work. I must emphasize that outdoor sketching gives one an entirely different outlook on a subject. You know what you are leaving out, whereas from a photograph you have to guess. My outdoor work has more flourish and animation, and is usually in line and wash.

• The day of the painting was bright and dry, with deep shadows because of the late season and enough — but not too much — autumn color.

• I normally work on unstretched heavy handmade paper because it is less inclined to cockle. It is often colored, but the amount of gouache I apply tends to neutralize this factor.

• I start with a very rough soft-pencil outline to establish the main features and then block in major color shapes. From this point on, it is a question of working on the individual parts of the work to build up the effect desired. How long it takes depends on how successful one is.

what I used

support
Heavy unstretched handmade paper

watercolors

brushes
Flat sable brushes, from 6mm to 25mm
Riggers

I used the warm autumn colors to counteract the coolness of the water, mountains, and sky.

Sabino Reflections, oil, 20 x 30" (51 x 76cm)

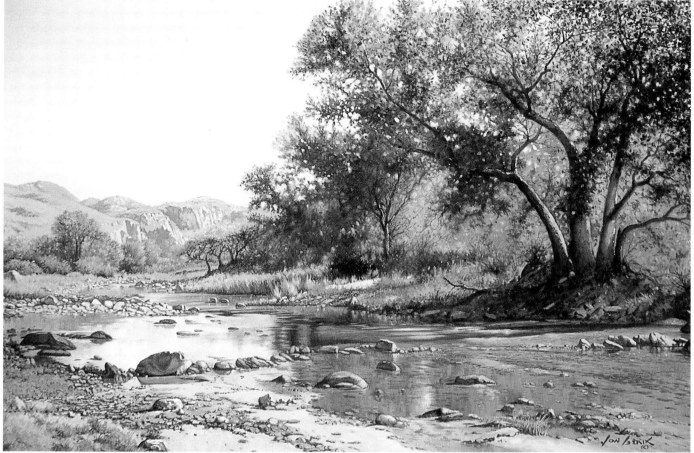

my inspiration

We had a lovely rain shower late one night in October. The next morning, I took my camera, a couple of 35mm rolls of 200 ASA slide film and my notebook, and took off in search of water-filled landscapes. I wanted to paint and enjoy the freshness and sparkle that the rain brought to the dry, dusty desert.

my design strategy

I decided to use the stream of water to lead the viewer's eye into the picture towards the distant Sabino Canyon Mountains; to follow the tree line back to the large tree in front and back to the water again. I used the warm autumn colors to counteract the coolness of the water, mountains, and sky.

my working process

- After viewing my slides, I decided on three that had the elements I needed for my picture, and had 8 x 10" color prints made.

- Guided by the color prints and notes I took down at the scene, I compiled 8 x 10" color compositions in thinned oil paint. I chose the best composition and used charcoal to copy it onto a 20 x 30" medium-textured cotton duck canvas.

- I then retraced the charcoal outlines with Cobalt Blue oil paint thinned with a mixture of painting medium and turpentine. I left it to dry and dusted off the charcoal.

- I proceeded to lay in all the main colors in a medium value. This made it easier to judge the lights and darks of the final colors and it also eliminated the white of the canvas.

- I started with the sky and completed every section of the painting, leaving the details until the end. Leaving the details for last prevented me from getting carried away with unnecessary detail.

what I used

support
Medium-textured cotton duck canvas

other materials
Palette knife
Painting medium
Turpentine

oil colors

brushes
1" Flat bristle house painting brush
#2, #10 Filberts
#6, #8 Short flat/brights
#4 Round bristle brush
#0, #2 Nylon liners

Titanium Opaque White	Cadmium Yellow Pale	Yellow Ochre	Cadmium Red Light
Alizarin Crimson	Cobalt Blue	Phthalo Blue	Brown Madder Alizarin
Ivory Black			

Jon Gerik lives in Arizona, USA

I was enchanted by a flash of warm sunlight on the sand dunes.

Dunes, oil, 16 x 20" (41 x 51cm)

my inspiration

I love the beach, foreshore and sand hills, in particular when the evening sun is low and warm, casting long soft shadows. This transient part of the day is so exciting with flashes of warm sunlight catching the tops of sand hills and landscape features.

my design strategy

The main focus of this painting was the flash of warm sunlight on the sand dunes just before sunset. In this painting the paths of sand, although in shadow, very obligingly lead the eye to the focal point. I often work with a photo up to 75% of the painting, then discard it and work from memory or just develop the painting and allow it to evolve to a finished piece.

Peter Taylor lives in Lancashire, UK → Bakegallery@aol.com

my working process

- I mix acrylic primer with some filler powder to give a textured base to work on, and normally give the board a warm base color to kill the stark white — a mix of acrylic Burnt Sienna and white primer.

- with a turpsy-mix I establish the composition, getting in the main dark areas, keeping as warm as possible but subdued in the shadow area. I will lay in the lightest light — the flash on the dunes — to confirm the balance and make sure the dramatic effect is correct. In general, I will work from the horizon forward. I scrub in the grasses with varying mixes of greens, ochres, orange and siennas.

- The shadow area of the paths of sand are placed with a variety of blues, pinks and violets with edges softened.

- I further refine the brightly-lit dune and work carefully over the whole painting, adding minimal touches of detail.

what I used

support
Heavy primed hardboard

brushes
Synthetic flats

oil colors

Ultramarine Blue	Cobalt Blue	Cerulean Blue	Alizarin Crimson
Cadmium Orange	Cadmium Yellow	Yellow Ochre	Naples Yellow
Burnt Sienna	Raw Umber	Viridian	

My painting was all about the water.

Early Spring, watercolor, 18 x 24" (46 x 61cm)

Jane Flavell Collins

ARTIST 61

my inspiration

Living in New England, the first signs of spring are very exciting to me. This scene came from a small photograph that I chose from a large selection that were taken at this time of year. The ice under the water appears to be both beautiful and dangerous at the same time. You are aware that the water is flowing quickly under the ice, yet the surface water is quiet enough to reflect the slim trees and bushes in the foreground.

my design strategy

Having the simple trees so close to the center of the composition was a challenge. I felt that making them lean slightly to the right side made for a stronger composition. Since this painting was all about the water, I chose to make it darker on each side and bright enough in

the middle to guide the viewer into the scene and to the rich coloration in the background. Also, the slipperiness of the water was enhanced by the direct and simple reflection of the trees.

my working process

- I made a very small value sketch from the photograph. The photo was very colorless and gray, so I decided to experiment with my new Quinacridone Gold paint. Every color I mixed it with became different from what I expected and it was very exciting.

- After wetting the paper, I put in the colorful background first. I wanted to hint at a warm sky without actually showing it.

- The water area, being so large in the painting, was very important. I first painted it with blues and grays to show reflectability. While still wet,

I added some browns mixed from the Quinacridone Gold and various blues.

- I then laid in the shadow area in the background using the very transparent Cobalt Blue, Cerulean Blue and Permanent Rose.

- While the dense background colors were still damp, I lifted some tree shapes out to create depth. You can use the beveled end of a plastic watercolor brush or even just your fingernail to do this successfully.

- I then painted the trees and bushes and all the trees in the background, as well. I carefully added the reflection in the foreground and the delicate secondary shadows of the trees in the background. Yellow Ochre was used for the grasses. I used a rigger brush to accomplish the tiny bushes and tree limbs and kept them as uniform as I could.

- Lastly, a wash of Naples Yellow over the snow created the warm glow that forecasts the beginnings of the big meltdown.

what I used

support
Cold-pressed watercolor pad

brushes
1", ¹/₂" Flats
#4, #6 Kolinsky riggers
1¹/₂" Squirrel flat wash brush
1" Cat tongue brush
#4, #6. #8 Rounds

watercolors
Lemon Yellow
Naples Yellow
Aureolin Yellow
Cadmium Red
Alizarin Crimson
Permanent Rose
Quinacridone Gold

Yellow Ochre
Burnt Sienna
Cobalt Blue
Cerulean Blue
Prussian Blue
Sepia Brown

Jane Flavell Collins lives in Massachusetts, USA → janezcol@adelphia.net

I created an "S" line to lead the viewer's eye into the seemingly endless distance.

Sozopol, Black Sea, watercolor, 20 x 26" (51 x 66cm)

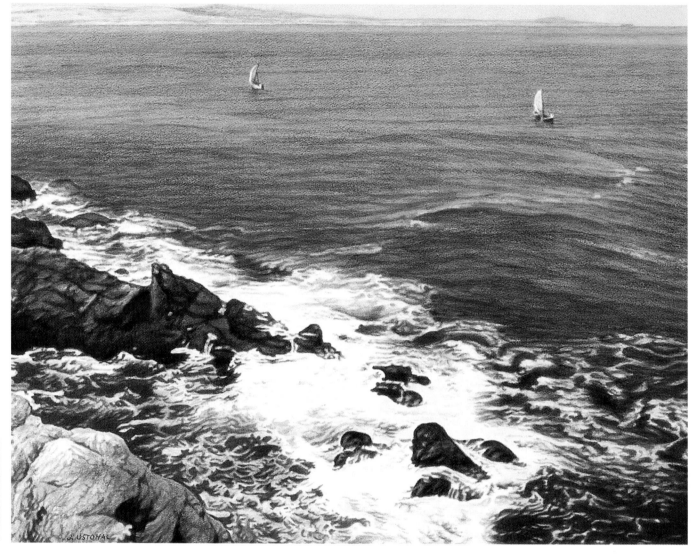

my inspiration

The inspiration for this painting came from two trips to Bulgaria. Most seascape paintings I have seen have been painted from the beach. I wanted to paint the sea from above.

my design strategy

My task was to capture the serenity and seemingly endless distance. To do this I divided the painting into three sections: horizon, middle area, and foreground. The foreground throws the viewer's eye down and across the sea. Then I developed an imaginary "S" line starting in lower right hand corner.

my working process

- I stretched a full sheet of cold press 140lb. watercolor paper and lightly sketched only the major forms.

- It was important to retain the white paper for all whites. I was careful to make the edges soft and even fade in places.

- I first applied a thin wash of Cerulean Blue using a #16 brush over the whole paper, avoiding all the whites.

- Then I used a #12 brush for a wash of Cobalt Blue, avoiding places where I wanted the previous Cerulean Blue to come through. These secondary washes were stronger in tone and started to cut shapes. The third washes were Phthalo Blue in different values.

- After that was completely dry, I dragged an almost dry brush with Indigo to create drawings and deep dark blues. The land on the horizon has a thin wash of Alizarin Crimson and Indigo. Ivory Black was used at the end for the darkest darks.

- The front rock had interesting colors and there was even some growth that looked like lichen. So I used a little bit of Sap Green for that and Burnt Sienna for any grasses and plants. The oats were painted with Alizarin Crimson and Indigo.

- At the end I often use glazes such as these blues to tie the painting together. It gives the painting life and sparkle.

what I used

support
Cold press 140lb watercolor paper

brushes
#6, #12, #16 brushes

watercolors
Alizarin Crimson
Burnt Sienna
Cobalt Blue
Cerulean Blue
Phthalo Blue
Indigo
Sap Green
Ivory Black

Jiri Ustohal lives in Ontario, Canada

A few richly colored, truthful shapes, produce a personal, intimate and powerful statement.

River in December, oil, 16 x 20" (41 x 51cm)

my inspiration

This river valley nourishes my creativity. It is different every day. I want the viewer to experience the music of the scene.

my design strategy

I begin with a black pattern of lines and geometric shapes — circles, ovals, squares, and rectangles — creating a three-value sketch, covering the entire canvas with black, mid-value grey and the white of the canvas. Keeping the paint very thin, I experiment with the three values until a bold and balanced expression is achieved.

my working process

- I consider the three-value design to be the most important step in my process. However, "ribbons of color" make up my DNA, so I fill in each shape with cool and warm transparent paint. Each shape or series of shapes has its own color.

- I then paint into the damp multi-colored ground. I load the brush with thick opaque white with one appropriate color for the shape to be painted. I apply thick vertical brush strokes, mixing on the canvas. Some of the ground is lifted and some shows through, as I paint wet-in-wet.

- The brush strokes introduce a softness to the original design and relate the shapes to each other to form perspective and to create rhythm, movement, luminosity and mystery.

three pieces of advice

- Paint today.
- Break the entire surface of the canvas into interlocking shapes. This is the source of originality, your handwriting.
- And, always paint from life or memory.

what I used

support
Canvas

oil colors

brushes
1½" and #20 Square flats

CADMIUM LEMON YELLOW
CADMIUM YELLOW MEDIUM
CADMIUM RED LIGHT
ALIZARIN CRIMSON
ULTRAMARINE BLUE DEEP
PHTHALO BLUE
IVORY BLACK
VIRIDIAN GREEN
TITANIUM WHITE

Marguerite Robins lives in Colorado, USA → www.mrobins.net

The challenge for me was to capture not only the sight but also the sound and smell of this fast-flowing river.

Near Huelgoat, oil, 18 x 26" (46 x 66cm)

my inspiration

This river, quick flowing down a boulder-strewn valley in Northern France, reminded me of similar rivers I had explored during many childhood holidays in North Wales.

my working process

- To establish the basic feel of the scene, I stained my canvas panel with very pale blue (Azure) acrylic paint after making a very rough preliminary drawing in waterproof pen. Still working very freely, I then scumbled in a color structure in mixes of Lemon Yellow, Hooker's Green, Burnt Sienna, Burnt Umber and Cobalt Blue, again using acrylic paints.

- When these colors were dry, I turned to oils, starting by laying a glaze of Cerulean Blue and Titanium White over the whole picture to unite and soften back the underpainting.

- I then started to develop the range of colors I had seen in the foaming waters, the rocks and the enclosing valley. In the water itself, the colors range from Yellow Ochre on the left, through dark ambers (Burnt Sienna and Cadmium Orange) in the pools beneath the trees, to bright blues (Cerulean and Cobalt, with a hint of Permanent Rose) reflecting the sky down-river, and strong purples on the right.

- When painting running water, I find it necessary to tease out the recurring patterns in the flow, paint these in quickly, then use a rag to smudge some edges.

- The general rule when working in body-color is to establish a mid-tone, then work in both directions, in turn adding darks and highlights, with the brightest highlights always being added last. I make my darkest colors with mixtures of Ultramarine and Burnt Umber, to which I can add Permanent Rose for more warmth. Cobalt Blue is a wonderful distance color.

what I used

support
Canvas-covered panel

brushes
Flat synthetic brushes

oil colors

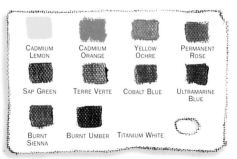

CADMIUM LEMON · CADMIUM ORANGE · YELLOW OCHRE · PERMANENT ROSE · SAP GREEN · TERRE VERTE · COBALT BLUE · ULTRAMARINE BLUE · BURNT SIENNA · BURNT UMBER · TITANIUM WHITE

Bob Brandt lives in Norfolk, UK → www.clockhousestudio.demon.co.uk

Wanting to accentuate the lighting in my subject, I enhanced the contrasts in values and color temperatures.

Chicago Creek, Colorado, oil, 30 x 40" (76 x 102cm)

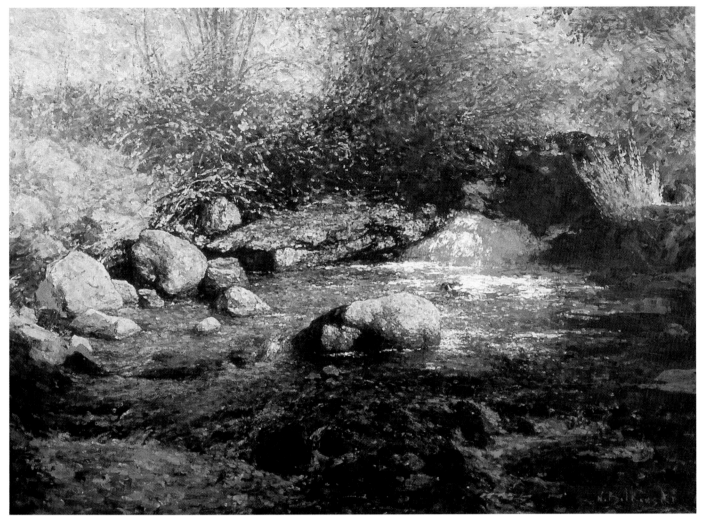

Nikolo Balkanski

ARTIST 65

my inspiration

On my way to Echo Lake, I stopped to look at Chicago Creek, where the sun was casting long, dark shadows. The way the lighting pierced through the shadows and reflected off the hill behind created such a unique atmosphere that I had to stop and paint a small study of the creek.

my design strategy

When I returned to my studio, I decided to turn the small sketch into a large canvas. This gave me a chance to refine the design and composition. For example, I wanted an interesting balance of shapes, so I broke up the rocks in the center to create a few smaller shapes. Then, to bring out that unusual light, I decided to exaggerate the contrast of the tonal values. What unifies the whole painting is the color. The same natural, earth colors are repeated across the canvas, although I used slightly warmer versions in the sunlit areas and cooler versions in the shadows.

my working process

- Using purples and sepia colors thinned with turpentine, I did a quick block-in of the large, dark shapes. I left the light areas as open canvas.
- Working back to front, I began to lay in the local colors. This was somewhat unusual in that there was a very light area in the background, which required heavier paint. I had to keep the dark foreground and other shadowed areas quite thin and transparent.
- Switching to smaller, softer brushes, I began to build up layers of colors. Because this was a large canvas, I could afford to get quite intricate and complex with my brushwork.
- I allowed the objects around the perimeter to remain somewhat soft and suggested, but went in with a palette knife to enhance the level of detail and texture around the central elements, especially on the waterfall and nearby rocks. This helps lead your eye into the center of interest.

what I used

support
Double-primed cotton canvas

brushes
Large hog-hair flats
Smaller softer brushes
Palette knife

medium
Turpentine

colors
Naples Yellow
Chrome Yellow
Yellow Ochre
Cadmium Orange
Alizarin Crimson
Raw Umber
Dioxazine Purple
Viridian
Permanent Blue
Cerulean Blue
Titanium White

Nikolo Balkanski lives in Colorado, USA → nikbal@msn.com

Focusing on the warm evening light, I wanted to capture the mysterious and peaceful mood of Laguna Beach.

Evening Light, oil, 18 x 24" (46 x 61cm)

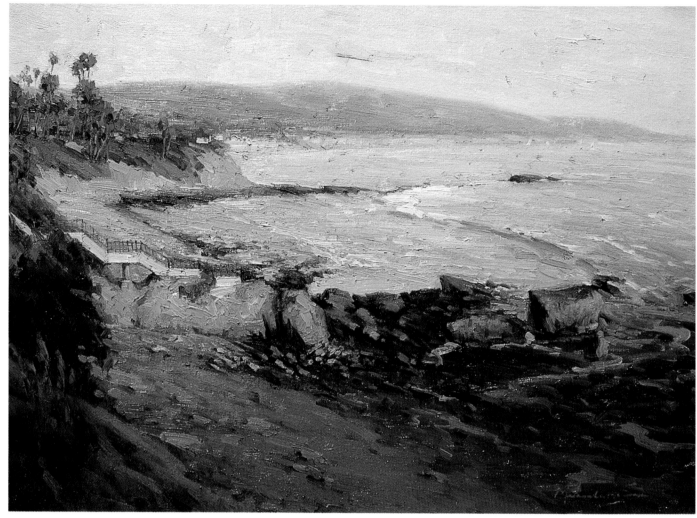

my inspiration

This was painted at Heisler Park at Laguna Beach, California, which has a beautiful full view of the beach below. I wanted to convey the mystery and beauty of the moment before the sun set in Laguna and the beach was transformed.

my design strategy

The line of vision for the painting is higher on the canvas because I wanted to bring depth into the piece. My other focus was on the color; I wanted to capture the intensity of the rocks in the light and contrast that fire with the rest of the scene.

my working process

- I began "Evening Light" with a small plein air study and several digital pictures for reference.

- First, I began with a #4 brush, painting all the basic shapes in light red. I wanted to focus just on the rocks and leave the rest of the painting simpler.

- Then I took two #10 flat brushes, with one for cool colors and one for warm colors, to paint outwards from the focal point. I began at the rocks, painting the shadows and highlighting with warm reds and oranges to focus my painting. I wrapped the entire rock area with cooler colors to make the light stand out.

- I waited for the basic layer of paint to dry a little and went back in to add detailed strokes to the piece. my references. I added in the palms on the cliff in the left top corner, but I blurred all the homes on the mountainside and simplified the texture of the water. I wanted

the focus to be the rocks, so I went back with my warmest colors, adding heavier strokes to give the viewer the texture of the rocks. I went to the ocean behind the rocks, painting with a cooler palette, ending with

the sky. I like to finish the piece at one sitting so that the mood is complete. After I finish, I wait until the next day, so that I can come back with a fresh eye.

what I used

support
Canvas

brushes
#6, #8, #10, #12 Flat
#2, #4 Round
Palette knife

medium
Linseed oil
Painting medium
Odorless turpentine

oil colors

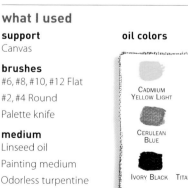

CADMIUM YELLOW LIGHT · YELLOW OCHRE · CADMIUM RED · LIGHT RED · CERULEAN BLUE · COBALT BLUE · FRENCH ULTRAMARINE BLUE · VIRIDIAN · IVORY BLACK · TITANIUM WHITE

Michael Situ lives in California, USA → www.michaelsitu.com

The strange beauty of this desolate and lonely place benefits from being painted fairly large.

Marauder - Thornham Beach, watercolor, 21½ x 29½" (55 x 75cm)

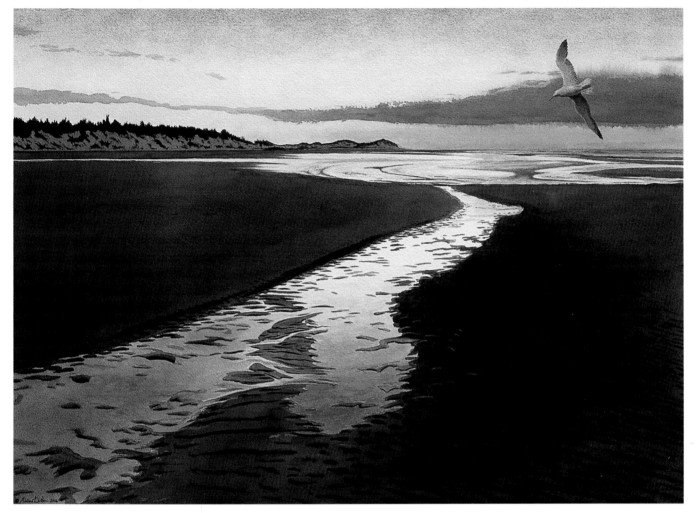

my inspiration

There are some magnificent beaches in my area, which tend to be virtually deserted in late evening, and especially in wintertime. I wanted to share with others the remarkable wild and mysterious beauty of this beach at sunset.

my design strategy

The strong diagonal makes a powerful composition. The addition of the gull gave the painting a different feel, but enhances the feeling of loneliness.

my working process

• Having drawn the shapes very lightly in pencil on a stretched full sheet of paper, I painted the gradated washes in the sky and foreground water, wetting the sheet thoroughly, and allowing it to dry between applying the Cerulean Blue and the basic yellow, which is mostly Yellow Ochre, with a small addition of Cadmium Yellow Pale.

• The deeper blue at the bottom is Cerulean with added Cobalt Blue, added wet-into-wet. The orange tinge above the horizon was added wet-into-wet again, whereas the cloud formation was painted once the paper had dried, to achieve the ragged edges top and bottom, catching the rough texture of the paper with the side of the brush.

• The dark sand was difficult, necessitating repeated washes of a thick mixture of Yellow Ochre, Light Red, and Payne's Gray. Then the dark shadows in the sand were added before the area was completely dry.

• There was only one logical place for the gull, which is where the diagonal of the water leads the eye.

my main challenge

I feel that this kind of subject benefits from being painted fairly large, to help give the feeling of space experienced at the scene. Large washes can be quite tricky, and only succeed with careful, methodical working, which will yield the kind of skies that seem to go on forever, and satisfying clean, pure colors.

what I used

support
300lb (640gsm)
Rough watercolor paper

brushes
2" Flat synthetic brush
#4, #7, #8, #10, #14 Synthetic brushes

watercolors

Andrew Dibben lives in Norfolk, UK → www.andrewdibben.com

While looking for gemstones in this unspoilt and tranquil place, I was inspired by its color, warmth and atmosphere.

Fossickers Upper Hunter River Region, oil, 24 x 36" (61 x 91cm)

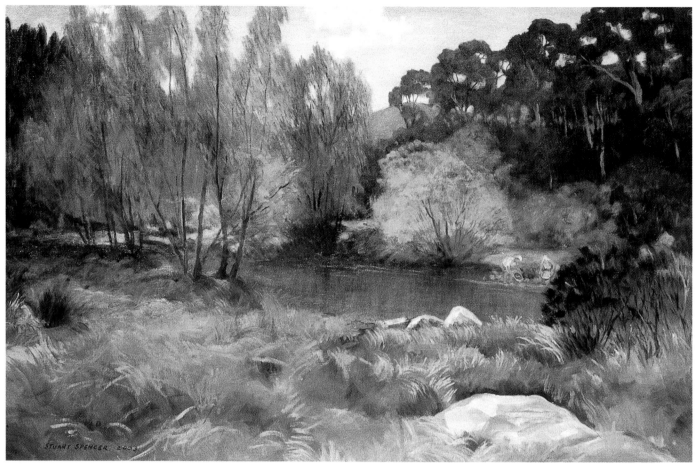

my inspiration

On a journey home from Sydney, I discovered this fossicking site near the Hunter River. As a member of the Caloundra Lapidary Club, I wished both to record my visit as well as invite my friends and fellow members to enjoy my interpretation of a scene where gems are to be found.

my design strategy

The area of water most prominent suggested an elliptical design which could be supported with a curvilinear-diagonal arrangement to describe the main masses of vegetation. Tonal value and color harmony were highly important in the overall design and to direct the eye around the painting.

my working process

- I chose to develop the painting on a support stained with an application of yellow ochre thinned with turps.

- I drew my design on the board with a hard charcoal stick.

- I put in the darkest areas early, followed by the rocks in the foreground, continuing with the sky to get a feel for the light. This allowed me to establish the tone of the foreground grasses and the main diagonal movement.

- I painted in the distant mountain, reserved some color for the water, and mixed Raw Umber and Viridian for the dark trees and the main diagonal on the left, followed by the trees on the right. I then applied the mauve color reserved for the water and, to help with the reflections, dragged some of the dark tree color down to form the band and the dark bush in the foreground, including the two fossickers drawn with a small nylon brush.

- I put in the shadows under the trees with Burnt Sienna and Raw Umber. I then painted in the willows in short, directional strokes and followed with the grasses in the foreground, also in a directional fashion, adding highlights.

what I used

support
Canvas-covered board

brushes
#4, #6, #8, #10, #12 Brights and Filberts

Palette knife

oil colors

Stuart G. Spencer lives in Queensland, Australia → zatorski@iprimus.com.au

Creating a picture of hope, I used my ideas, my aesthetics and my technique in the service of nature.

River Vasishthi, oil, 14½ x 14½" (37 x 37cm)

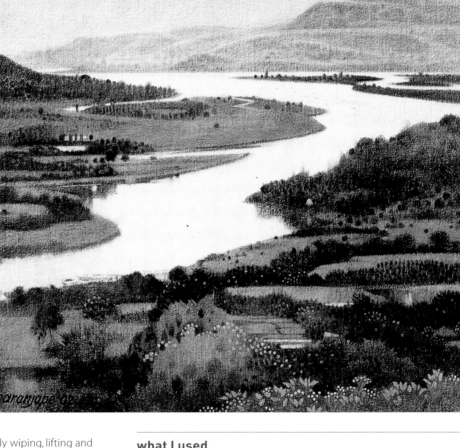

Ravi Paranjape

ARTIST
69

my inspiration

As a painter, I am always in search of real situations in nature and life that offer scope to create abstract but joyous relationships between size, shape, line, color, texture, tonal values and space. The view of River Vasishthi, as seen from the hill at Iote Parshuram, Chiplun, Maharashtra State, India, was an ideal sight in this respect. It inspired me to paint a picture of hope,.

my design strategy

The evident horizontal lines receding in the three-dimensional space of the river view struck me as a structure for this painting. Respecting this structure, I made several quick pencil thumbnails in my sketchbook. I decided upon the one with a square format as it reinforced the horizontal linear structure. The white area of the river was clearly the dominant and central feature of the river scene. I took a snapshot of the river view as a general reference in my painting process.

my working process

- Since the view of river Vasishthi was perfect for picture making, placing a right size square mask on the photograph was my first step. My compositional problems thus sorted out, I enlarged the masked photograph on to the canvas board with an HB Pencil.

- I applied two coats of polymer gesso on the canvas board. My pencil drawing thus was obscured to the desired level.

- When the gesso coats thoroughly dried for a day, my painting process began. From top to bottom, from lighter tonal values to darker ones, with the traditional fat over lean, and wet-into-wet, dry-brush technique, I completed the river painting. Controlling the edges was easier with this technique.

- Suitably wiping, lifting and glazing oil paint at the desired drying stages achieved tonal values. The white area of the river was untouched canvas that was eventually protected with a coat of alkyd glaze and painting medium. At no stage in this painting was white paint ever used, as if I was doing a pure watercolor that never looked like one.

what I used

support
Canvas

brushes
#1 - #5 Filbert and flat-round brushes

#1 Flat sable brush

Worn-out hog-hair bristle brush

oil colors

other materials
Alkyd painting and glazing medium

Turpentine

Stand oil

Paper towel

Opaque projector

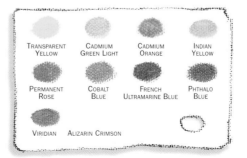

TRANSPARENT YELLOW • CADMIUM GREEN LIGHT • CADMIUM ORANGE • INDIAN YELLOW
PERMANENT ROSE • COBALT BLUE • FRENCH ULTRAMARINE BLUE • PHTHALO BLUE
VIRIDIAN • ALIZARIN CRIMSON

Ravi Paranjape lives in Shivajinagar, India → www.raviparanjape.com

I chose an unusual encaustic medium to achieve specific results.

Bruno Capolongo

Water Snakes, encaustic, 17½ x 18¾" (44 x 48cm)

my inspiration

The massive, oddly shaped trunk, along with the tree's setting and reflection, interested me for years. The adjacent panels and image were designed and chosen to extend and complement the larger image. What results is a product of careful balance in color, form, line and light, where each detail and panel are indispensable.

my design strategy

By cropping down low on the tree and portraying its entire reflection, the pattern of converging branches create a strong focal point. This pleasant pattern slows the viewer's gaze, which smoothly branches outward to secondary panels. Thus, there is little eye-hopping. Furthering this transition and harmony between panels is the consistency of palette.

my working process

- I worked on thick, pre-cut panels, roughed with sandpaper. After cleaning the panels, they were painted upon raw.
- The molten medium (encaustic) fuses directly onto the support. Working *alla prima* (all in one session), I painted with greater concern for color and form, minding myself with detail progressively.
- Encaustic dries almost instantly, so for areas requiring greater detail and finer work, I employed a cold wax medium (made by adding two parts turpentine to one part encaustic). After cooling, this medium was applied in paste-like consistency with brushes and fused with a torch.
- I chose encaustic for its fast drying and textural qualities. It can also be reworked with ease at any time.

my advice to you

As with any other type of subject, study the masters: how they expressed, envisioned, and depicted water. Consider the different styles and techniques employed, and why their works are successful. Spend time on location; don't depend too heavily on photographs.

what I used

support
Thick wood panel

tools
Palette knives
Synthetic and hog-bristle brushes
Torch
Portable stove
Muffin tray

medium
Bees wax
Powder pigments
Sapped tube oils
Turpentine

encaustic colors
Burnt Umber
Burnt Sienna
Raw Sienna
Yellow Ochre
Cerulean Blue
Sky Blue
Prussian Blue
Titanium White

Bruno Capolongo lives in Ontario, Canada → www.BrunoCapolongo.com

Painting from life, I was able to better capture both depth and mood.

Orland River, oil, 8 x 16" (20 x 41cm)

my inspiration

Although I had painted at this location before, the season, the weather, the light, and the mood were all different and created a more dramatic subject. As I observed the river and landscape surrounding it, the depth caused by aerial perspective and the overall mood of the landscape drew me in.

my design strategy

This painting is as much about atmosphere as it is about the actual water and land. Contrast in values, edges, and color were vital to the success of this painting. The contrast between the light sky and its reflection in the water, as well as the contrast between the dark foreground and the lighter background, work together to create depth. The narrow, horizontal format of the painting emphasizes the dramatic line of the river while eliminating unnecessary elements.

my working process

- I toned the canvas with a thin wash of paint to eliminate the stark white of the canvas.

- To establish the composition, I did some very basic drawing with a brush and paint to indicate the placement of the larger masses on the canvas.

- As the light illuminating the clouds was likely to change quickly, I began by painting the sky using larger brushes loaded with paint.

- Then, working basically from the background to the foreground, I tried to paint as directly as I could, using oil paint with no mediums other than mineral spirits. Painting in the dark masses in the middle-ground and foreground allowed me to more accurately compare the value contrast with the background.

- After completing the background and middle-ground, I focused on the foreground landscape and water. Although I tried to keep the darks thin, I painted the foreground trees, bushes, and grasses with varying thicknesses of paint to introduce more variety and texture. Using brushes and a palette knife, I completed the foreground water last with both impasto and thin paint.

what I used

support
Medium texture oil-primed linen canvas

brushes
#2, #4, #6, #8, #10, #12 Flat sable brushes

Filbert and flat bristle brushes

Palette knife

oil colors

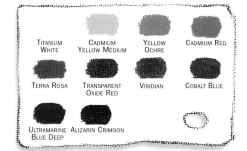

Titanium White · Cadmium Yellow Medium · Yellow Ochre · Cadmium Red · Terra Rosa · Transparent Oxide Red · Viridian · Cobalt Blue · Ultramarine Blue Deep · Alizarin Crimson

Steven Hileman

ARTIST **71**

Steven Hileman lives in Maine, USA → www.stevenhileman.com

Strong diagonals and value contrast enabled me to create a forceful painting.

A Rushing Torrent, watercolor, 15 x 22" (38 x 56cm)

Katherine Haynes

my inspiration

In this watercolor I attempted to capture the excitement of spring run-off in the Selkirk Mountains of North Idaho. I want my viewer to hear the roar of this mountain stream which seems in a great hurry to join the Kootenai River.

my design strategy

I wanted this to be a forceful painting, hence the use of strong diagonals. I used the value contrast of the foaming water and the deep shadows to capture the viewer's attention. The large log, prominent because of its size, is lighter against dark shadows and darker and warmer where its tip barely touches the white foam.

my working process

- Most of the time I work from light to dark and I did that in this painting: starting with the shadows and the movement of the water. At this point I dropped clean water in a very few spots, then using my 1" brush, I dragged and pushed the paint around while holding the brush almost parallel to the paper for a dry brush effect.

- Next I painted in the small green bits of tree branches with lighter and darker greens. Then I was ready for the rocky banks, using my 1½" and 2" slanted brushes for both the sunlit and shadowy areas. The debris on the right side was painted in blotches of lighter and darker browns, and then scraped with the sharp end of my aquarelle brush to make it look like old dead needles. I had to do the scraping just after the shine of wet paint disappeared.

- The big log is the most detailed: light against dark, then darker against light. The two logs at the top were in shadow and joined to form an arrow that leads us to the big one.

- Last of all, I dabbed some greens at the bottom left to look like young leaves on a bush. The branches were then painted in with the tip of my palette knife, holding it upright and drawing it across the surface. I think it is important to paint the leaves first and then join them with lines to give a more natural look.

what I used

support
300 lb. Cold pressed watercolor paper

brushes
1", 2" Slanted soft synthetic brushes
1" Aquarelle brush
#4 Round

watercolors

Katherine Haynes lives in Idaho, USA ➔ www.katherinehaynes.com

Transparent glazes were used to build deeper, richer colors for a sense of serenity.

Reflections in a Blackwater Creek, oil, 28 x 22" (71 x 56cm)

my inspiration

This painting was originally done as an entry in the US Arts for the Parks competition. I enjoy finding unique and beautiful subjects, and many of the lesser known national parks and monuments have wonderful little secrets that get bypassed for the better known ones. This scene I found at Moore's Creek National Battlefield in eastern NC. I wanted to show the beauty and serenity of the park.

my design strategy

I rely on instinct when I do a painting. Most of my work is done from my own photos, and I usually "design" the painting through the lens of the camera. I try to make notes to myself if there is something I might not remember later. I never copy my photos, though. I usually make changes in color, value, and contrast to make a more interesting piece.

my working process

I usually start by laying in my farthest, lightest background areas first, then build layers as I move forward. I use painting medium with my paints so that I can control the opacity and drying time, and I like to move from light to dark. I also use transparent glazes to build deeper, richer colors. My larger background areas are usually laid in with flat glazing brushes, and as I work forward, my brushes become smaller and rounder; many times I finish details with a small liner brush.

my advice to you

Always remember that water seldom appears the same, even in the same location. It was important to me to learn to see all the colors that water can become, and to learn to translate them to a color palette. For me, photos were a big help in learning to do this. I have also found that transparent glazes, built up over more translucent ones, usually give more depth and range of color to water, and therefore more life and movement.

Debi Davis

what I used

support
Masonite coated with gesso

brushes
1/4", 3/8", 5/8" Flat wash
#8, #9 Round
#5/0, #2 Liner

oil colors

Titanium White	Cadmium Yellow	Yellow Ochre Pale	Yellow Ochre
Raw Sienna	Burnt Sienna	Van Dyke Brown	Cobalt Blue Hue
Dioxazine Purple	Payne's Gray		

Debi Davis lives in North Carolina, USA → www.DebiDavisArt.com

Two paint colors were all I needed to find the tonal range in the crumbling "Water City" of Venice.

Morning Light, oil, 30 x 44" (76 x 112cm)

Kay Cornell

ARTIST 74

my Inspiration

I was attracted to the idea of capturing the mystery and romance of water, light and the movement in Venice. This painting is the result of such inspiration. This unique city quickly seduces with its contradictions; shifting light, changing moods, warm dark shadows, subtle movements, the meditative silences and reflections of the morning light.

my design strategy

I get a buzz out of capturing recession by the warm darkish foreground that recedes to the cooler lighter background. I am always chasing light, so the source of light is important for my compositions. I consider the time of day or night and how the atmosphere interferes with the quality of light.

my working process

- Using Raw Umber and odorless turps, I made small indications on the canvas to give me the direction, perspective and placement of the subject.
- Then I went straight in with my bigger brushes and painting thinly with Raw Umber and Cremnitz White, blocked in the darks, lights and mid-tones. I find the easiest way to see the darkest darks and the lightest lights is by closing both eyes to the point where the lashes almost touch. Then I fill in the gaps with the mid-tones. In this way, abstract shapes are usually easier to see.
- I prefer to paint "what I see" in tone and shape and not what I "want to paint." My eye is constantly assessing the tones across the painting as I work. I reassessed the painting and adjusted any tones and finally added highlights and checked for reflected light. I reminded myself not to over-paint when I reached this point. I find that the more time I spent on the truth of tonal values, the easier it is to add color and glazes later.

my color scheme

After completing the tonal painting, it appeared to hold its own, and amazing subtle greens, yellows and mauves appeared out of the Raw Umber. I realized by using Raw Umber and Cremnitz White I could portray this unique crumbling, sinking city with its rustic feel more effectively.

what I used

support
Belgian linen

brushes
#4, #6, #8, #10, #12 Round hog-hair brushes
Smaller Round sable brushes

other materials
Black tile (for checking tones in its reflection)

oil colors
Raw Umber
Cremintz Lead White

Kay Cornell lives in Sydney, Australia → www.kaycornell.com.au

Triangular patterns provided the visual interest; and color temperature.

Cleansing, oil, 16 x 20" (41 x 51cm)

my inspiration

Water comforts me and at the same time I find the movement exciting. I choose what to paint from my emotional response to the subject. Cleansing reminded me of God's greatest gift, washed and renewed in loving forgiveness.

my design strategy

I noticed repeating triangular patterns. The strong diagonal crevice deep in the riverbed repeats this pattern, bringing the viewer back up and around to once again flow over the waterfall. Also, the size of the rocks had no reference — leaving the size of the waterfalls up to the viewer. The rich warm color beneath the water and the cool sky reflecting on the water's surface created depth and volume.

my working process

• Painting on site, I first took some time to organize the design. I toned the canvas with a warm violet to harmonize with the caramel riverbed. In the final piece I planned to leave areas of the toned canvas exposed.

• Important questions: where is my darkest dark? The deep warm diagonal fork of the riverbed. Lightest light? The cool white of cascading water. Sharpest edge? The exposed edge of a lit rock. This is my map to keep me on course.

• The sketch was direct on the canvas with a round brush and paint without medium for more controlled and sensitive lines. The transparent darks were thinned with a turpentine substitute in order for the light to pass through and reflect back, creating depth.

• I used large brushes to lay in the big shapes, creating variation within the same value. Squint! This helps to see true values and edges. It was especially fun to paint the movement of water in warm and cool reflecting violets that created the feel of clear water over the warmth of sun-kissed river rock.

what I used

support
Canvas

brushes
#4-12 Round and filbert hog-bristle brushes

Palette knives

medium
Turpentine substitute

Liquin painting medium

oil colors

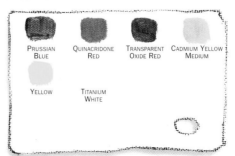

PRUSSIAN BLUE QUINACRIDONE RED TRANSPARENT OXIDE RED CADMIUM YELLOW MEDIUM

YELLOW TITANIUM WHITE

Lori Beringer lives In Wisconsin, USA → www.picturetrail.com

I wanted the viewer to see that this painting has a paradoxical mood: It is both dynamic and serene.

Killarney Dusk, pastel, 18 x 24" (46 x 61cm)

Aili Kurtis

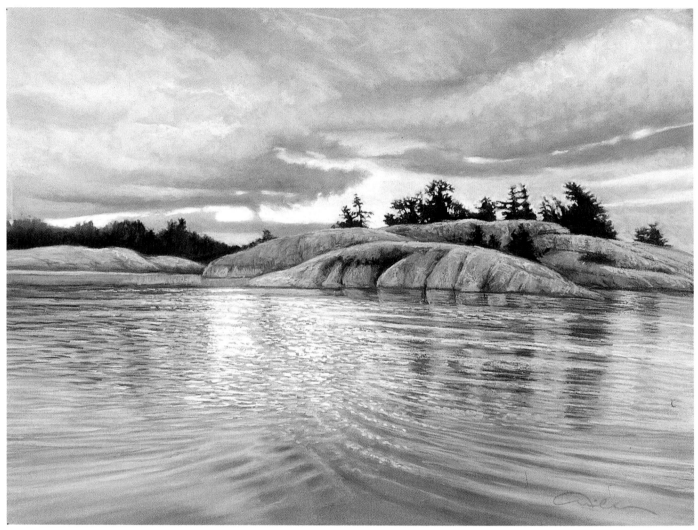

my inspiration

As I was kayaking near Killarney on the Georgian Bay (Canada), I was awestruck by the beauty of the evening light reflected on the water. In my travels I tend to witness patterns in nature and sense a spiritual relationship between abstraction, reality, and humanity.

my design strategy

I designed this painting as a loose "x" with a horizontal band running through it. The center of attention is the center of the "x." The focal point of the painting is the break in the clouds, which contains the lightest light as contrasted to the darkest dark of the trees.

my working process

- I use a digital camera for reference to remind me of the fleeting moment of light reflected on the water, and to see the underlying design elements that I can enhance and develop in the painting.

- I start with a few quick strokes of hard pastel to establish the abstract composition of the painting. I try to remain faithful to this simple design, despite spending most of the time working on realistic details.

- My underpainting is done in soft pastels, which I spread by using a bristle brush or my little finger. I then spray the underpainting with reworkable fixative.

- I work on top of the underpainting with soft pastel. On occasion I may smudge with my finger, but mostly I just lay one stroke or dot on top of another to blend the colors.

- Towards the end of my painting I worked with my softest, most buttery pastels, to add extra color and highlights. I did not use fixative at this stage because I was afraid that it might darken the final highlights.

what I used

support
Slightly sanded card stock

media
Hard and soft pastels

other materials
Bristle brush
Surgical glove
Rag
Reworkable fixative

Aili Kurtis lives Ontario, Canada → www.ailikurtis.com

The contrast of the icy lake with the late afternoon sun was solved by balancing the color temperatures.

Winter Rest, watercolor, 12 x 29" (30 x 74cm)

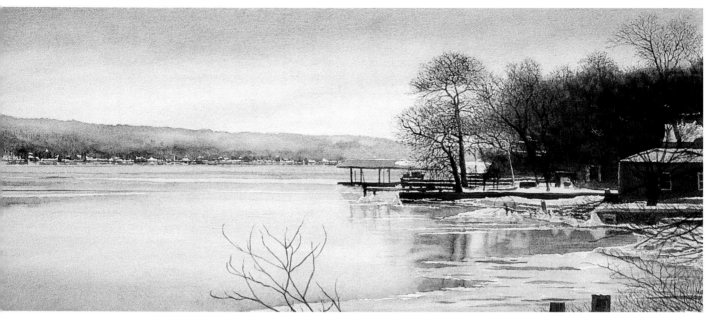

my inspiration

The inspiration for Winter Rest was the solitude and serenity on Cayuga Lake, brought about by the bone-chilling temperatures of last winter.

my design strategy

Nature designed this composition, but the strength of the composition is found in the large number of horizontal and vertical lines within. I made a conscious decision to include more water than sky so I could play up the cool colors of the water and the contrasts in the reflections at the center of interest. I added the tree at to bottom left center to help balance the contrast and detail of the right side

my working process

- This painting was executed in five basic steps: (1) Complete a detailed drawing; (2) Mask all light objects within the large dark wash areas; (3) Paint all the large wash areas; (4) Remove the masking and wash the masked areas; and (5) add detail. This order of events allows for large continuous areas of colors to be painted first to ensure a good balance and an interesting composition.

- The order of washes was to paint the light blue of the sky and water first. After this was dry, the complete paper was wet with clear water and the yellow was added with a single stroke into the cloud ridges at the horizon. Next, the greens and violets in the water were carefully mixed, sampled and added to the water in long horizontal strokes. After everything was dry, the lake area was re-wet with water and the reflections were carefully but loosely added with sienna and sepia mixes.

- I chose to paint the reflections before the trees and docks because they are lighter in tone than the objects they reflect.

- All the masking was removed and the mid-ground tree trunks, large branches and docks were painted with a fairly dry brush. The foreground trees were rendered last.

what I used

support
300lb cold press watercolor paper

brushes
Large squirrel-hair quill brush

#6 Round sable brush

#3 "triple loader" dagger-shaped brush

watercolors

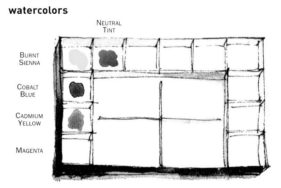

NEUTRAL TINT

BURNT SIENNA

COBALT BLUE

CADMIUM YELLOW

MAGENTA

William Mowson

ARTIST
77

William Mowson lives in New York, USA → bmowson@twcny.rr.com

Oil glazes achieve luminosity while a low horizon creates a monumental sky in what I hope is a symbolic work.

Daybreak, oil, 44 x 36" (112 x 91cm)

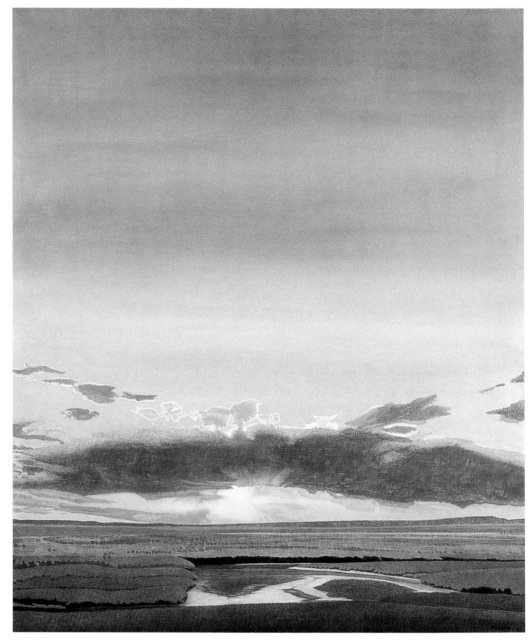

Clay F Wagstaff

**ARTIST
78**

my inspiration

The idea of this painting was to portray the landscape environment in which I live. I wanted to show the calm, yet dramatic, feeling of the approaching dawn to portray the advance of brightness and hope.

my design strategy

This painting was designed with a low horizon, allowing for a monumental sky with deep space at the horizon. The orthogonal (perspective) lines and other design elements point to the center of interest: the sun. A combination of opposites provides a dynamic nature to the value, line, color, and so on.

my working process

- Rabbit skin glue ground was applied to a wood panel. This ground offers good support for the multiple glazes I use.

- The scene was constructed using smaller sketches and multiple photographic references.

- A full-sized composition was drawn on the panel, making adjustments and changes as needed.

- The sky portion was created with numerous transparent glazes.

- The cloud layer was blocked in.

- The foreground was blocked in.

- I painted the water area.

- Several unifying dry-brush layers were applied until I had the effect I desired.

- An overall transparent final glaze was applied.

my preference for oil glazes

I use oil glazes over a white ground. Light filters through these layers, bouncing off the ground and back through the translucent layers, visually mixing the colors used in each layer. There is no other way to achieve a truly luminous effect.

what I used

support
Rabbit skin glue over wood panel

brushes
Badger-hair brights and filberts
#4 Bristle brush

medium
Turpentine/damar varnish

oil colors

TITANIUM WHITE · YELLOW OXIDE · YELLOW OCHRE · GREEN EARTH
COLD GRAY · WARM GRAY · MARS VIOLET · ULTRAMARINE BLUE
IVORY BLACK

Clay F Wagstaff lives in Utah, USA → wagstaffart@fastmail.fm

Bear Lake gave me a ready-made scene built around contrasting shapes and sizes, variation and color harmony.

Bear Lake, oil, 36 x 48" (91 x 122cm)

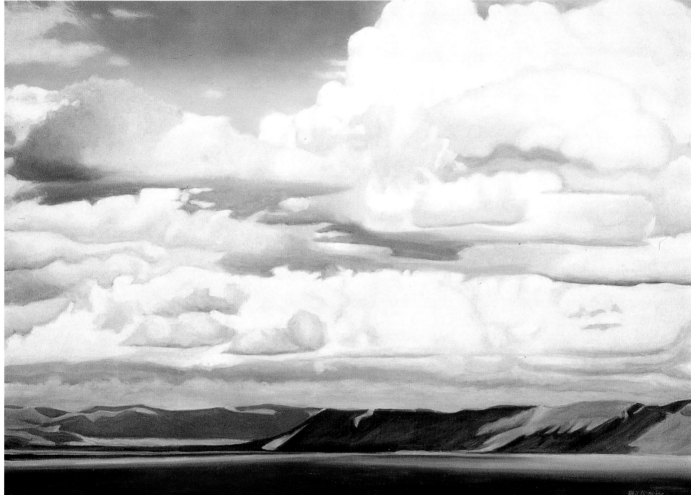

my inspiration

After having passed by Bear Lake, Utah, many times in my car, I was impressed by the occasional large cloud formations over this beautiful lake. I knew I wanted to eventually paint this landscape of towering clouds, barren landscape, the mountains and the contrasting placid, dark marine blue of the lake from the many photos I had taken.

my design strategy

For this painting, I made a pencil sketch from the photo I had selected and then scaled it up to the size for my finished painting. My reason for choosing this subject in the first place was because it already had many of the principles of design needed to create a beautiful painting. The scene had dominance of contrasting shapes and sizes, variation, and color harmony throughout.

Philip V Hopkins lives in Utah, USA → www.philhopkinsart.com

my working process

• I selected a 36 x 48" horizontal canvas for my painting and primed the canvas with gesso.

• I sketched the scene using a charcoal stick on the dry primed canvas surface. After "fixing" the charcoal, I proceeded painting the cloud-filled sky, then the barren hills and lastly the lake, paying attention to their proper color values and painting from thin to thick.

• Colors were mixed and matched using a simple palette of seven colors mixed with medium. Later, if there were areas I wanted to work on that became dry, I would wet the dry surface with clear medium so it would be easier to soften and blend the edges of shapes in the painting.

• I used a combination of large to small bristle brushes and fan brushes for paint application.

• After the painting was completed and dry, I painted a thin, clear glaze of medium overall to even it out.

what I used

support
Gesso-primed canvas

brushes
#4, #6, #8, #10, #12 Bright and filbert brushes

#4, #6, #12 Fan brushes

oil colors

TITANIUM WHITE · LEMON YELLOW · YELLOW OCHRE · MADDER

MARINE BLUE · ULTRAMARINE BLUE · PAYNE'S GRAY

A distant horizon helped to create a feeling of space in this marsh scene.

Ipswitch Marsh, oil, 24 x 36" (61 x 91cm)

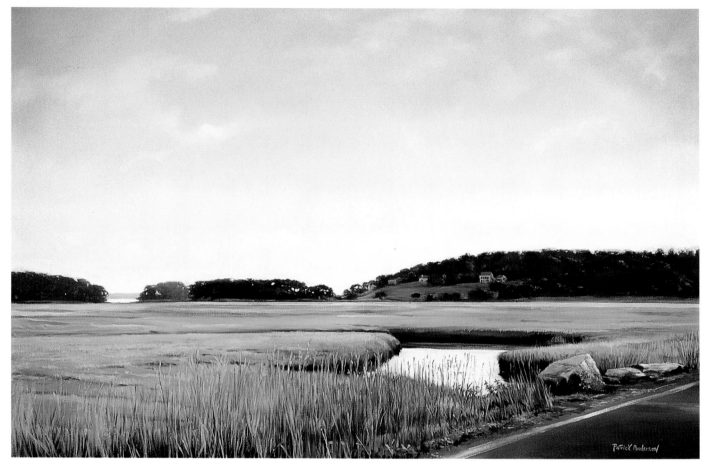

Patrick Anderson

my inspiration

I had passed this northern Massachusetts view in the morning, but it went unnoticed since the light didn't have the same effect as it did in the late afternoon. An irregular cloud pattern added interest in the landscape as well as the sky. I thought something with a distant horizon would be a welcome change from my usual cityscape subjects.

my design strategy

I wanted to emphasize the feeling of distance. First on a linear basis, then by tonal variation, and finally with textural divergence between background and foreground. The path of the water in this painting should take the viewer's eye from lower right/center up to middle center and the distant buildings on the hill. The buildings add scale to this distance.

my working process

- I began choosing my best angle through the photographs and made several thumbnail sketches.

- I drew out the design on a medium gray primed canvas. Thought was given to the dimensions of the painting as well. A width greater than the height would suit the feeling I was looking for.

- I masked off the horizon line to keep the dark and light areas clean from each other and to be able to continue painting wet, using large brushes especially in the background where I wanted little or no brush strokes visible. Starting with the sky, I worked down to the foreground, masking off the water as I went so that at the end of this first stage, I had the whole canvas covered with full value color.

- When the first stage had dried, I went back softening edges with glazes where necessary and picked away at the detail.

what the artist used

support
Neutral gray primed canvas

brushes
#2, #4, #6, # 12 Filberts
#2, #4, #6, #8, #12 Flat and bright brushes
#12 Fan brush
2¹/₂" Flat

other materials
Masking tape
Painting medium
Mineral spirits

oil colors

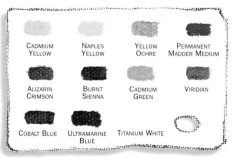

CADMIUM YELLOW NAPLES YELLOW YELLOW OCHRE PERMANENT MADDER MEDIUM
ALIZARIN CRIMSON BURNT SIENNA CADMIUM GREEN VIRIDIAN
COBALT BLUE ULTRAMARINE BLUE TITANIUM WHITE

Patrick Anderson lives in Massachusetts, USA → www.patandersonart.com

Spontaneous thick and thin oil painting expresses both calm and excitement in my light filled scene.

First Light, oil, 30 x 40" (76 x 102cm)

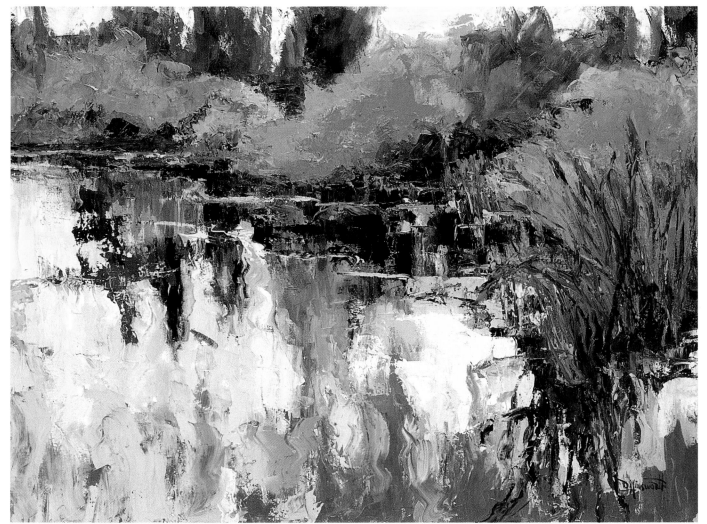

Diane Ainsworth

my inspiration

My inspiration for this painting was the challenge of capturing the light in the scene and the excitement of the reflections in the water. I always look for that "ahh" reaction I have to certain scenes — this usually is connected to light and dark contrasts.

my design strategy

I worked from thumbnail sketches first (whether outdoor or from photos). Utilizing the largest dark shapes, I made an abstract design. A thumbnail made this easier to see and stick to if the light changes while I paint. In this painting, the dark shapes along the shore line divide the canvas. Darkening the water under the reeds helped pull the darks together and combine with the shore. The dark tree

reflections were added last to balance the whole canvas.

my working process

- I made a small thumbnail sketch to work out the composition and values.
- Using a white double-primed canvas, I drew with a brush using thin paint (Indian Yellow) and turpentine. I drew in a gesture first (which gives me quick proportions), then go over it in a contour drawing using a contrasting color — usually Alizarin Crimson. This is a simple broad drawing of large shapes. I squint to check the drawing.
- I fill in the shapes, working dark to light. This is done in thin washes and with almost a watercolor treatment. I use a quick-drying medium to speed

the process. I squint to check values and lost edges.

- I started using thicker paint in the light areas, thin paint in the darks. I squint often to check

values and edges again. This was the intuitive, fun part. I didn't have to think or figure things out because I already did that in the thumbnail stage.

what the artist used

support
Thick double-primed canvas

brushes
#2, #4, #6, #8, #10
Hog-bristle filberts
Painting knives

mediums
Mineral spirits
Quick-drying medium

oil colors

INDIAN YELLOW CADMIUM ORANGE CADMIUM RED LIGHT SAP GREEN

VIRIDIAN TRANSPARENT OXIDE RED LIGHT BLUE VIOLET ULTRAMARINE BLUE

QUINACRIDONE RED TITANIUM/ZINC WHITE

Diane Ainsworth lives in Washington, USA → www.DianeAinsworth.com

I chose a low eye level to convey the sheer grandeur of the Rocky Mountains.

Morning at Dream Lake, oil, 30 x 40" (76 x 102cm)

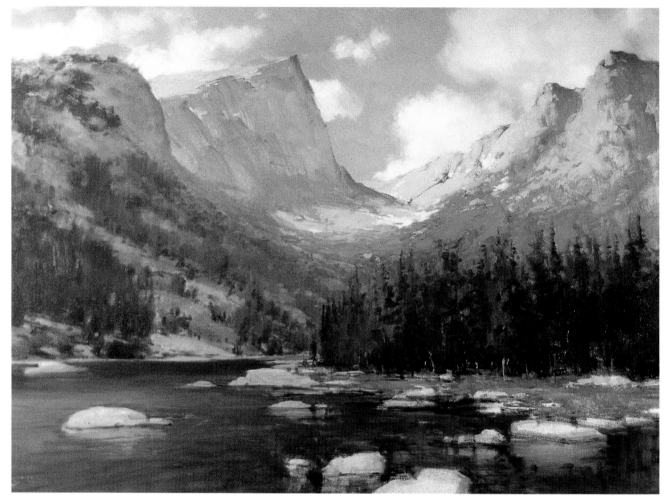

Brian Blood

my inspiration

The Rocky Mountain National Park in Colorado, has always interested me. The high mountain lakes are great subjects to paint. I have seen countless other artists paint similar scenes and now it was my turn. Besides, the location was inspiration enough, absolutely beautiful.

my design strategy

This was a composition that didn't need any changing. It was aesthetically desirable right from the start. I kept a low eye level to convey the sheer grandeur of the mountain. I rearranged the rocks in the water and the cloud pattern to create a more interesting compositional flow, to lead the eye into the painting. I made great efforts to keep my paint application as fresh as possible. The strokes were very direct without a lot of reworking. I believe this gives the overall

appearance a more spontaneous and natural look.

my working process

• I started with a toned canvas using Burnt Umber. I draw out the big shapes very simply.

• I then applied cool-toned washes with oils, thinned with odorless turpentine. I blocked in all the large masses, allowing the light-toned canvas to represent the lightest values.

• Once all the masses were blocked in with the appropriate value patterns, I began to move around the painting and refine each area. I was always squinting and comparing each area against each other. Thinking about atmospheric perspective, I left areas in the distance less defined while reworking and modeling the areas in the middle and foreground more. (I like to push the color contrasts

as well as value, until I believe the overall effect has been reached.)

• Deciding when to quit can often be difficult, but it was important to do so, because I did not want to overwork and ruin what may be a fresh and exciting painting.

hint

Cameras are not a good source of reference by themselves. The pictures often are either washed out or the shadowed areas are too dark. Using accurate location studies bridges these gaps and allows the artist to obtain truer information.

what the artist used

support
Medium-weight primed canvas

brushes
#12, #16 Filbert hog-bristle brushes

oil colors

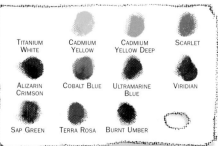

Brian Blood lives in California, USA → www.brianblood.com

I kept a mental note to use warmer and darker colors up close, cooler and lighter in the distance.

Stanley Park, pastel, 11 x 18" (28 x 46cm)

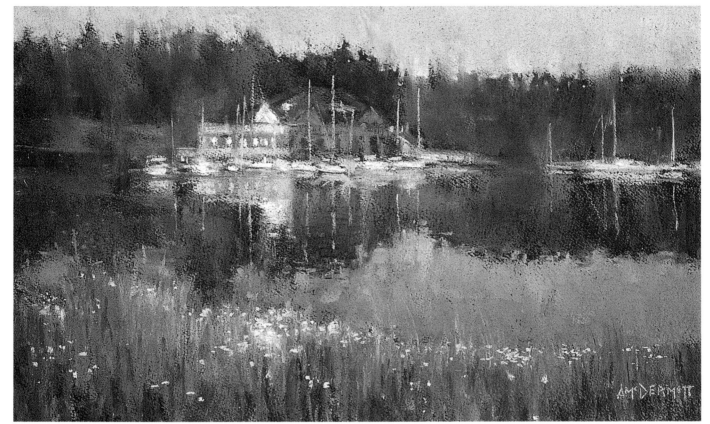

my inspiration

I'm a believer in the theory that it's not about what you paint, but how you paint it. Saying this though, I always paint an image that somehow captures my eye. Lighting plays a strong part in what I find visually interesting. In this instance, how the boathouse and boats reflect on the water really caught my eye.

my design strategy

Although there are basic rules in design and composition, my theory is to make changes as you go and take some chances. I use my judgment to see if it feels right and if it doesn't, I'll alter design elements along the way.

my working process

- I began this piece with a quick gestural sketch using a colored conté stick.
- Starting on the boathouse, I began blocking in warm oranges and yellows, gradually building up my colors, layering them until I got the desired color. (I often play around with the relationship of opposites, warm against cool, lights against darks or soft edges against hard edges.)
- In this piece, I began my lights early, eventually building my mid-tones and darks, finishing my piece with a few coats of final fixative spray.

my main challenge

The main challenge in this painting was how to connect the grass in the foreground with the rest of the picture. I achieved this by allowing a small section of the reflection to touch the grass and by adding lights in the flowers in the same area to help catch the viewer's eye.

what the artist used

support
Black pastel paper

medium
Hard and soft pastels
Final fixative spray

Andrew McDermott

ARTIST
83

Andrew McDermott lives in British Columbia, Canada → mcdermottart@hotmail.com

This breathtaking view was accomplished using aerial perspective and color temperature contrasts.

Lake Dunstan, acrylic, 12 x 24" (31 x 61cm)

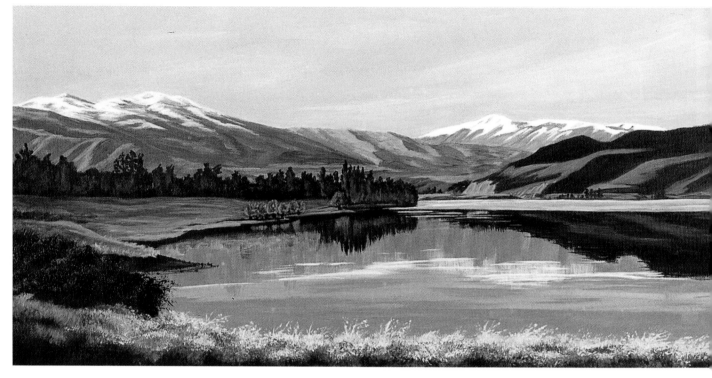

Lorna Allan

my inspiration

This lake took my breath away. It had that "Wow" factor! I wanted to say: "Look at this. Amongst all the sad and bad in the world today, there is still infinite beauty, peace and serenity."

my design strategy

Lake Dunstan was formed by the building of a dam on the river at Clyde to generate electricity. Nature had taken over and designed it to perfection. All I left out was the roof of a barn that barely showed on the left in front of the distant trees. Care with aerial perspective was important to draw the eye from the warm sunny grass in the foreground to the cool distant mountains. I warmed up the scene a little in the foreground to create better contrasts.

my working process

- The timing was perfect for the light. I worked from a quick sketch and photographs back in my studio.

- I always begin with the sky, because this sets the mood of the painting, the temperature of the day and everything below

is affected by it. I then work my way forward, being mindful always of aerial perspective. I occasionally worked back and forth between areas to maintain harmony of tonal values.

- Note that the color of water, while it reflects the sky, always appears darker. I kept it muted and slightly hazy on the edges to help provide an effect of slight movement. A downward drag of reflections, using a fairly dry-brush method and horizontal lines to depict movement, also helped. A light strip of water in the background shows an area where there is a little breeze and adds interest to the painting by splitting the dark reflection from the hill on the right.

- The lovely warm grass in the foreground was created using my treasured old bristle fan brush.

what the artist used

support
Canvas panel

brushes
#8, #14 Synthetic brights
#16 Synthetic flat
Worn bristle #10 fan brush

watercolors

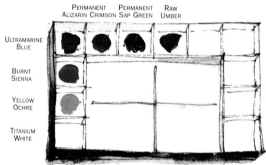

Lorna Allan lives in Auckland, New Zealand → ldoone@coolkiwi.co.nz

My aim was to lead the viewer into "the calm after the storm" and keep them there via a zig-zag path.

Footprints, oil, 16 x 24" (41 x 61cm)

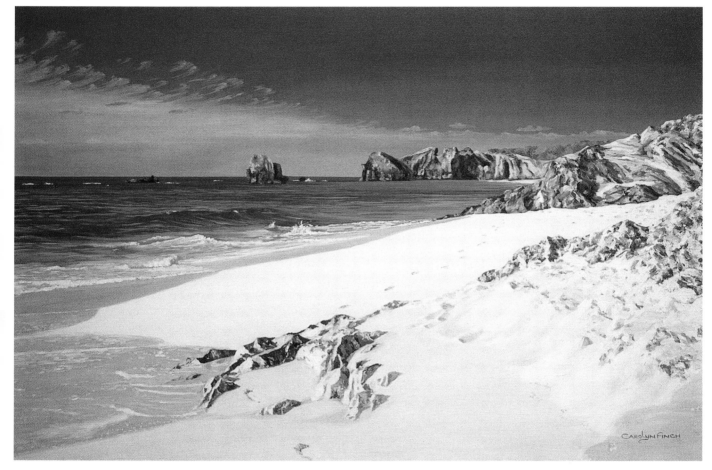

my inspiration

Whenever a hurricane passes near Bermuda, the resulting high tides remove much of the sand from the beaches. The day was perfect — the calm after the storm. The desire to find out what was around the next corner was what I wanted to convey with this piece.

my design strategy

To make sure the viewer's eye stays in the painting, I made use of diagonal lines and a "Z" shape, which links back, middle and foregrounds together. Depicting a calm sea just after a breaking wave prevents the viewer's eye being stopped in the middle ground by too much white foam. Lastly, the line of footprints gives the strip of sand aerial perspective and introduces the human element to the scene.

my working process

- Working from the top down with a 1¹/₂" flat brush on oil-primed canvas, I painted the sky a mix of Cobalt Blue, Cerulean Blue and Titanium White, adding more white and a touch of Vermilion Hue as I neared the horizon. Painting wet-on-wet, I flicked in some white clouds with a #3 round brush.

- The background trees were completed using French Ultramarine Blue and Naples Yellow.

- On a dry painting at the next sitting, I started adding detail to the rocks using French Ultramarine and Burnt Umber for the darks and Raw Sienna, Cerulean Blue and Naples Yellow for the lights. During subsequent sittings, I "played" with the sea using a ¹/₄" flat brush, and varying quantities of Turquoise, Indigo and Titanium White, allowing it to take its own shape.

- At the shoreline I put in the white foam to shape the edge of the water and touches of sand color. The dry sand was made by mixing Titanium White with Naples Yellow and a touch of Vermilion Hue. Adding French Ultramarine to this mixture created the wet sand color.

- After putting in the shadows to form the footprints, the painting was finished.

what the artist used

support
Oil-primed canvas

brushes
¹/₄", 1¹/₂" Flat
#2, #3, #4 Round

oil colors

medium
Cobalt driers
Odorless turpentine

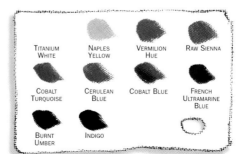

TITANIUM WHITE · NAPLES YELLOW · VERMILION HUE · RAW SIENNA
COBALT TURQUOISE · CERULEAN BLUE · COBALT BLUE · FRENCH ULTRAMARINE BLUE
BURNT UMBER · INDIGO

Carolyn Finch lives in Isle of Wight, UK → carolyn.finch@virgin.net

Carolyn Finch

ARTIST
85

The contrast of sparkling light and dark rocks made my pastel vibrant.

Boy Playing in the Shallows, pastel, 15 x 22" (38 x 56cm)

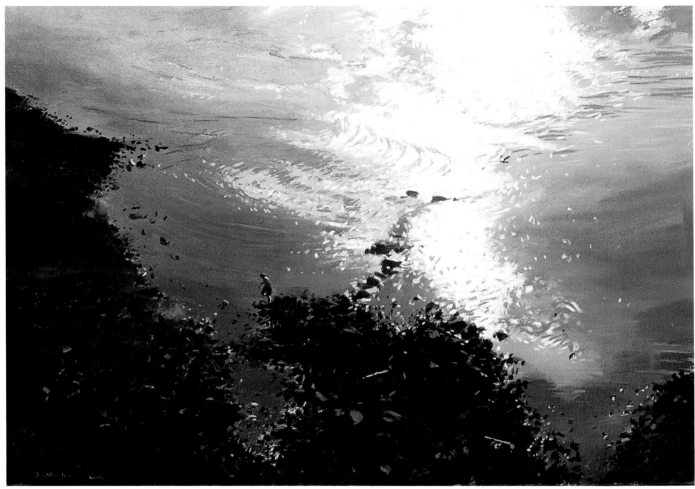

Jonathan Taylor

ARTIST 86

my inspiration

I saw this whilst crossing a bridge over the river late one afternoon. I was attracted by the contrast of the light sparkling on the water and the dark mass of rocks and boulders. I wanted to capture the movement of the water, echoed in the actions of the boy.

my design strategy

By creating a strong line of light (off-center) leading into the picture, I hoped to lead the viewer's eye down to the shore, across to the boy and then up to the top of the painting. I wanted a very strong tonal contrast but the three main elements — water, light and shoreline — also needed to be harmonious.

my working process

- I took a photo at the time and also sketched the boy as he played, so I had various positions to choose from.

- I drew the composition onto stretched paper and used watercolor to create a basic tonal ground on which to apply pastel.

- Once dry, I worked on the water with the pastel, putting in all the dark and medium tones first, painting around the highlights. I wanted to create a glittering, lively surface and not deaden it with too much detail.

- Next I used very dark browns and grays for the shoreline rocks, applying the dark tones first and then adding the lighter tones. For the sandy areas I used the pastel on its side, dragging it across the paper and letting the texture show through.

- Finally I went over the whole painting, adding touches here and there, pulling it together.

why I chose pastel

I thought the bold, direct mark-making that is possible with pastel would lend itself to this subject. I love the physicality of pastels and getting my hands dirty.

what the artist used

support
220gsm cartridge paper

pastels
Soft chalk pastels

Jonathan Taylor lives in Worcester, UK → joptay@hotmail.com

To produce a painting that recreated the tranquility of the seashore, I looked for pattern, dimension, and depth.

The Rocky Shore, watercolor, 11 x 14" (28 x 36cm)

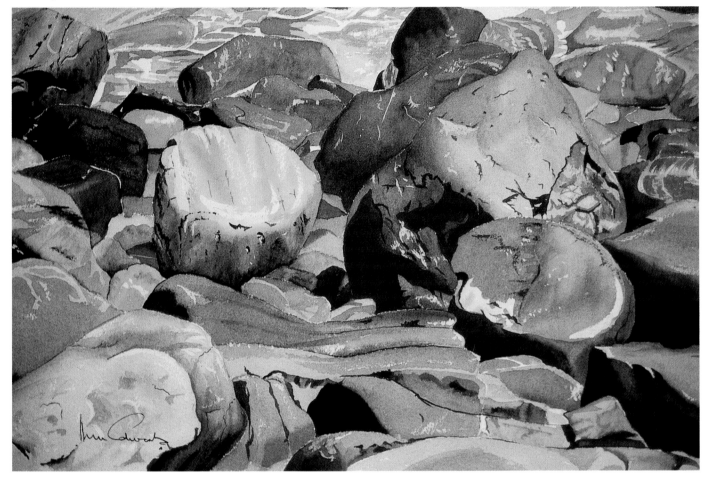

my inspiration

The varieties of shapes and colors on the rocks fascinated me. I walked along the shore and found this particular area the most pleasing, with the horizontal rocks in the foreground giving a lead-in to the picture.

my design strategy

The three main rocks in the center area — one large and two circular rocks at its base — formed a dominant triangle around which the other rocks appeared ideally placed. The variety of colors and tones gave me the opportunity to put a "dimension" into the painting. I was only in the area very briefly and relied only on a photograph on this occasion.

my working process

- Having drawn in shapes lightly with a 2B pencil, I then put a light color wash to represent each of the rocks. Ultramarine Blue and Light Red gave a nice soft blue/gray for many of them. Yellow Ochre was ideal for the light rocks.

- I like strong color, and starting with the main rocks in the center area, I completed these wet-into-wet, ensuring that I achieved a nice blend of color.

- The foreground rocks were then painted slightly lighter, followed by the darker ones immediately behind the main group. The background rocks were made lighter and more diffuse to give depth to the painting.

- Next, the shadows were added, the very darkest from a mixture of Ultramarine Blue, Light Red and Payne's Gray.

- Finally, the highlights were done with Designer White gouache.

Alun Edwards lives in South Wales, UK → alun.edwards@ntlworld.com

what the artist used

support
140lb Rough watercolor paper block

brushes
Sable watercolor brushes

body color
White gouache

watercolors

LIGHT RED BURNT UMBER BURNT SIENNA YELLOW OCHRE

CERULEAN BLUE

COBALT BLUE

PRUSSIAN BLUE

ULTRAMARINE BLUE

CADMIUM YELLOW

NEW GAMBOGE

ALIZARIN CRIMSON

PAYNE'S GRAY

Alun Edwards

ARTIST
87

Using warm values and rich color helped me create an inviting focal point.

View of Diver's Cove, acrylic, 18 x 24" (46 x 61cm)

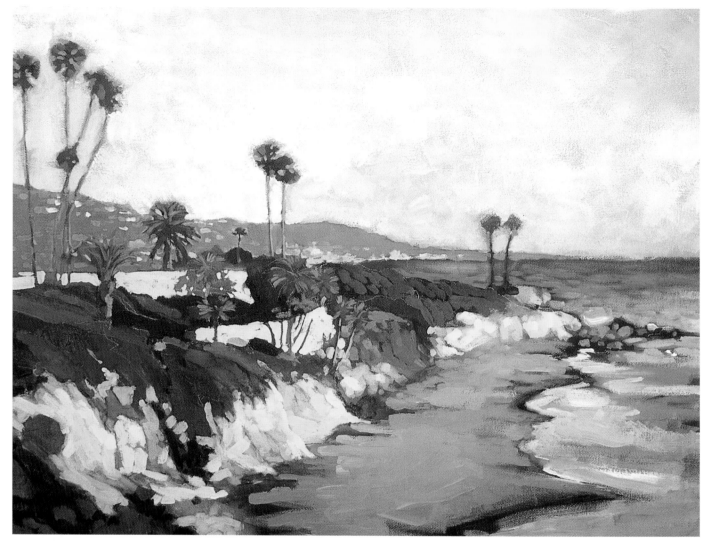

Jeff Yeomans

my inspiration

I was inspired by the soft glow of late afternoon sun radiating from the sandstone bluffs. I hope it says: "Relax and enjoy the warmth."

my design strategy

The walkway walls and palm tree shadows create a natural focal point. The angle of the face of the bluff is a mass that helps anchor the composition.

my working process

- I use vine charcoal on primed canvas to loosely block in large shapes and resolve the overall composition. I turn over the canvas frequently to look at the balance and "feel" of the piece.

- I paint in the darkest tonal values with a combination of Phthalo Green and Dioxazine Purple, which creates a rich dark, almost black.

- To establish a sense of depth, I mix a "puddle" of a color for each element: trees, grass, beach, etc. Using that value as a key to the tonal range, I work from foreground to background, mixing a puddle for each series of things I paint. I add white and blue to help make an object appear to recede.

preliminary sketches

I usually do a simple sketch to use as a reference. I use black, white and gray and establish a simple tonal "chart." It helps me see and edit the composition to resolve spatial relationships.

Jeff Yeomans lives in California, USA → www.jeffyeomans.com

what the artist used

support
Primed canvas

watercolors

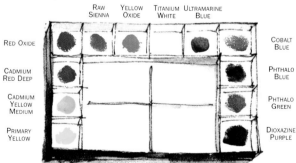

Here, contrasts in color and temperature are essential: the cool draws you in, the warm allows you to stay and rest.

And the Greatest of These is Love . . . , watercolor, 18½ x 27" (47 x 69cm)

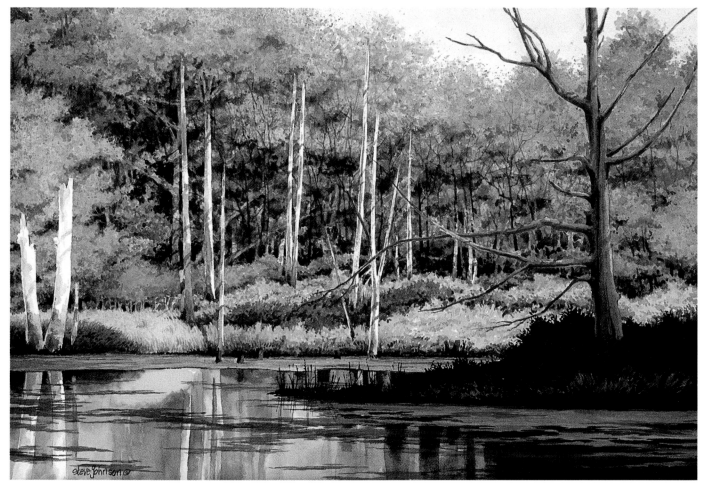

my inspiration

My inspiration for painting this particular piece was the striking contrasts in value, color, and most of all, temperature.

my design strategy

One of the two striking elements for me in this piece was the very strong repetition of strong vertical line, in the form of the dead trees on both shore lines. Coupled with the stark contrasts in value and temperature, the tree shapes stood tall and stark as soldiers demanding you look at their strong weathered shapes. With the extreme contrasts of the warm shore against the cool shapes in the foreground, the viewer's eye is directed to naturally rest on the warmth of the distant shore.

my working process

- The first step in this painting was to lay in the sky wash. I laid in a wash of Cerulean Blue, with a touch of Cobalt Blue to the upper third of the painting.

- I employed a wet spatter technique using a 1" watercolor flat brush to create the soft edge tree tops of the background wooded areas.

- Tackling the reflective part of this extremely still water was solved by creating the "mirror image" of the shoreline and woods behind. This was all painted on a semi-wet surface. I wanted some soft or lost edges in the reflections, but also needed to have some defined or found edges for some of the trunk shapes.

- Using a #6 round, and with the paper completely dry, I mixed Cerulean Blue and Sap Green in different values to lay in the algae at the distant shoreline.

- The extremely cool tree shape was totally in shadow. The cool color that played against the very warm opposite shoreline was the whole purpose for painting this piece.

- The tree in the foreground, on the island was underpainted with Cerulean Blue. Then Cobalt Blue, Cobalt Violet, and Ultramarine Blue were added in a dry-brush method to indicate the weathered look to this enormous dead tree.

what the artist used

support
140lb Cold press watercolor paper

watercolors
Yellow Ochre
Raw Sienna
Raw Umber
Van Dyke Brown
Sepia
Cadmium Red Medium

Alizarin Crimson
Lemon Yellow
Cadmium Yellow Medium
Cadmium Orange
Sap Green
Hooker's Green Light

Hooker's Green Dark
Cerulean Blue
Cobalt Blue
Ultramarine Blue
Spectrum Violet
Cobalt Violet

brushes
#4, #5, #6, #8, #10, #12 Rounds
½", ¾", 1" Flats
Old, worn fan brushes

Steve Johnson

ARTIST
89

Steve Johnson lives in Indiana, USA → makeart3@aol.com

To create a wintry mountain mood, I chose bold design, limited color, a variety of edges and collage.

Lake Louise Mood, watercolor/collage, 22 x 30" (56 x 76cm)

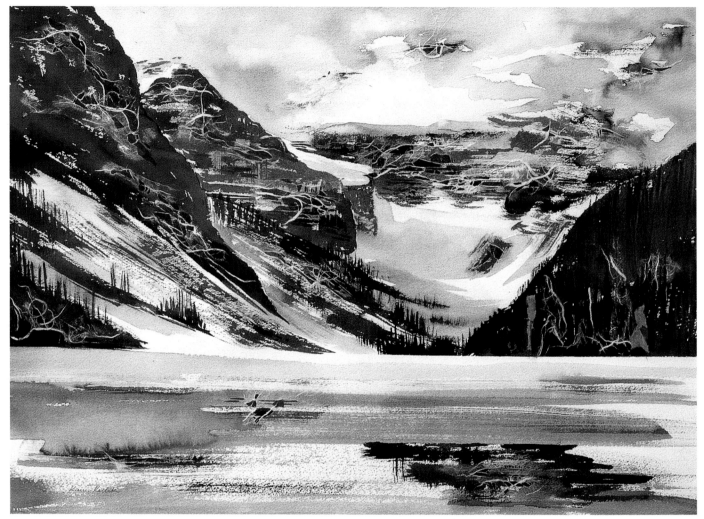

Karin Richter

my inspiration

Lake Louise, called the jewel of the Canadian Rockies, has been an inspiration to many artists and I am no exception. I am lucky to live nearby and can visit whenever I choose to be inspired by the ever-changing mood of this magnificent spot. This day was particularly magical with the mountains peeking in and out of the clouds and the breaking ice on the lake revealing lovely reflections. Sharing such magic is part of the joy of painting.

my design strategy

My strategy was to create a simple design that highlighted the exciting contrasts of bold mountain shapes versus the delicate, misty cloud cover. The break-up in the ice provided a balance in the lower part of the painting and made for an interesting diagonal design. I kept this wintry scene fairly monochromatic, opting for strong tonal values.

my working process

• I took a photograph on location and back in my studio, started by doing a thumbnail sketch to figure out composition and values.

• I used a stiff fan brush to dry-brush the mountain shapes. I kept a larger wash brush handy to diffuse the paint for the soft cloud shapes In order to achieve a variety of hard and soft edges.

• Once dry, and with acrylic matte medium, I started to collage Japanese rice papers, one fairly transparent with long irregular fibers in it; the other more opaque with pieces of bark and leaves embedded in it. I tear small pieces of these papers according to what the design might call for. I look for the texture or direction of the fibers that will enhance the brushstrokes already on my painting. I just apply the collage where beneficial, only to enhance, not to create a totally mixed media piece of art.

• Dry again, I assessed what was in front of me and started painting into some areas, specifically the spaces between the fibers to further enhance the appearance of the rocks or trees or floating ice. This made a more interesting and three-dimensional painting.

what I used

support
140lb Cold pressed watercolor paper

brushes
2" Flat wash brush
1" Flat sable brush
Small bristle fan brush
#5 Round Sable brush

other materials
Japanese rice papers

watercolors
Burnt Sienna
Permanent Magenta
Ultramarine Blue Deep
Phthalo Blue
Prussian Blue

Karin Richter lives in Calgary, Alberta, Canada → www.cosmopolitanart.net

The mist flattened the view obscuring incidental detail and throwing the foreground objects into sharp relief.

Mid-Morning Cliché, oil, 24 x 36" (61 x 91cm)

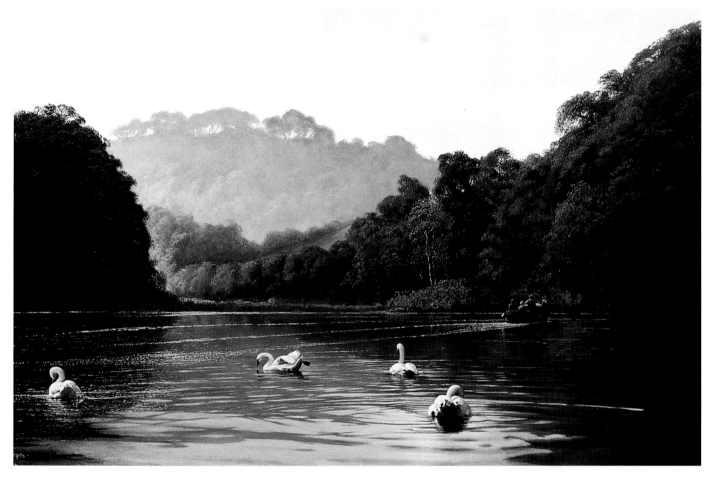

my inspiration

This was painted to satisfy a 20-year ambition to capture the charm of a photograph that I had always considered compositionally near complete. I took the photograph on a boat trip along the Looe River in Cornwall in the early Eighties. The river seemed to have an almost primeval quality.

my design strategy

The source image would be a gift to any artist. The two swans to the left of the painting were moved to initiate the primary eye-line, which cuts diagonally right towards the boat along its wake. Supplementary devices, such as right and left tree-lines, render the focal point almost inescapable. To consolidate and complete this aspect of the composition, the contrast between light and dark vegetation at the focal point was exaggerated.

Chromatically, the non-sky components of the picture were simplified to a composite color and four of its tints to ensure harmony.

my working process

- To avoid the feathering of brushstrokes, the entire canvas received five layers of a lean mix of Vermilion, Ultramarine Blue and white to remove the weave. The basic sky color was evenly gradated light to dark and left to right.

- Color consistency was achieved by pre-mixing Oxide of Chromium, Vandyke Brown and Ultramarine Blue to form the basic composite. Half of this color and half the resulting tints were progressively mixed with an equal quantity of white to produce a lighter, subsequent, tint.

- I began painting wet-on-wet immediately after the last preparation layer had been applied. This further lightened the tints and assisted the process of creating aerial perspective.

- Background and mid-ground areas received very little additional attention, with the furthermost trees receiving only highlights to indicate the light source. The overpainting of detail work on the foreground was left until the surface was tacky and malleable. The deep composite color was kept pure and unthinned to ensure additional mediums were not required to provide lift.

what I used

support
Fine-grain linen canvas over board

oil colors

brushes
#1 - #4 Synthetic brights and rounds

1/2", 3/4" Synthetic brights

Keith G. Cardnell lives in Kent, UK → cardnell.demon.co.uk

Keith G Cardnell

ARTIST
91

I wanted the viewer's eye to move down a vertical path.

Gold Coast Sunrise 1, pastel, 22 x 15" (56 x 38cm)

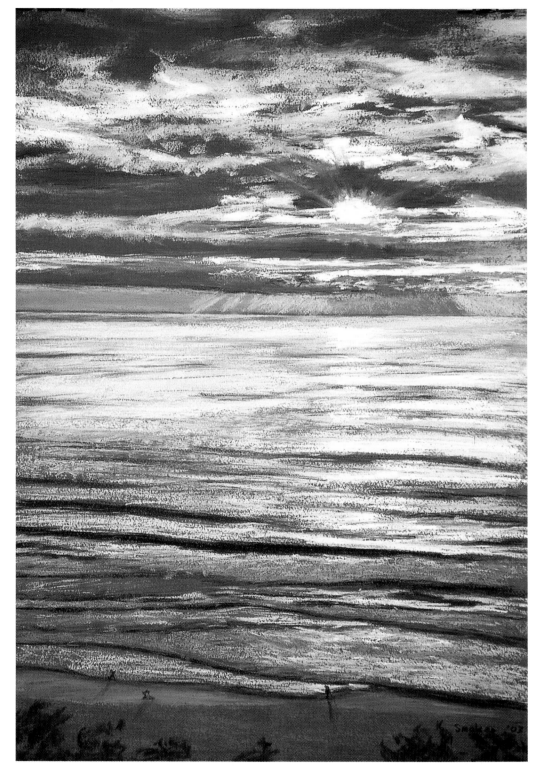

my inspiration

While staying in a 24th floor apartment on the Queensland Gold Coast, Australia, I looked out at this fantastic easterly view of the ocean. The color of the sky and ocean at sunrise was beautiful, and I wanted to try and capture the intense color and tonal contrasts.

my design strategy

I wanted the viewer's eye to move from the sun to the clouds immediately below, down the vertical path (created by the sun's reflection on the water) to the beautiful colors and intense contrasting tones of the breakers near the beach. I included the figures on the beach to help describe the sense of scale.

my working process

- Because of the rapidly-changing colors and tones, it was impractical to try and do a color sketch. Instead, I set up my camera and tripod and took photos as the sun rose. I also made written color notes because photos rarely show accurate color or tone. I later used my photos and color notes to do this painting.

- I used the darkest flinders blue-violet and prussian pastels for the breaker shadows; navy, red-violets, reds and oranges, turquoises and mid blue-violets in clouds and water; lemons, white, pale pinks, greens and oranges for the lightest tones; as well as green-grays and apricots on the quieter areas of distant ocean.

my advice

- If you're not sure whether you can paint water (or anything else), just go ahead and try. The more we practice, the better we're likely to get.

- Look at how other artists portray water and read any information they supply.

- Take color notes and/or on-site color sketches. Don't rely on photos because generally the tones and colors are inaccurate.

what I used

support
Smooth side of a half sheet of tobacco-colored pastel paper

medium
Soft pastels

Kathy Smoker lives in New South Wales, Australia → kathysmoker174@hotmail.com

I wanted to create warmth under this blanket of cool snow.

The Frozen Grand, oil, 42 x 71" (107 x 180cm)

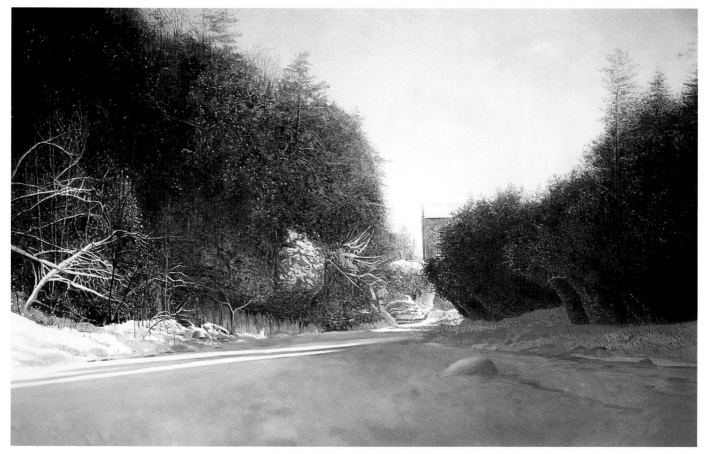

my inspiration

I have lived near the Elora Gorge most of my life and found its wonders in every season. It has such power that it is almost foolproof in composing its natural elements. One side is always bathed in light and the other in shadow. This sets up a perfectly balanced composition.

my design strategy

When on climbs down into this 50-foot gorge, with looming limestone walls on either side, it is easy to compose using an "X" composition. The focal point is always read at the golden ratio, which provides a great comfort zone, and once that is established, the eye flows in a circular motion around the canvas. The eye always searches the light source and this is easily achieved at the apex of two converging triangles. Color harmonies are much sought after in any powerful landscape composition, but one primary goal was to create a sense of warmth under the guise of a blanket of cool snow.

my working process

- My painting was based upon my watercolor experience. I always try to create a larger work using several smaller studies. I love the challenge of attempting to control this very difficult watercolor medium. As well, the medium demands several layers of transparent washes, moving from unmixed primary colors, to eventually 6 to 8 layers. Dry-brush techniques are then applied to achieve the overall effect. White pigment is avoided but will be used if necessary.

- When working in oils, I have attempted to preserve this same layering process, except reserving the use of white until the very end. This gives the painting sparkle through the rich layering of color and texture that many impatient painters fail to achieve.

hints

- Have a game plan, have a vision, see the painting completed in your mind's eye, then paint it and try not to steer away from your original inspiration.

- Try painting layers in watercolor. Watercolor is an excellent medium to practice the layering process. Control this and with the virtue of patience all will come to fruition.

what I used

oil colors

CADMIUM LEMON CADMIUM ORANGE ALIZARIN CRIMSON CADMIUM RED LIGHT

SAP GREEN CERULEAN BLUE COBALT BLUE BURNT SIENNA

DIOXAZINE PURPLE PAYNE'S GRAY TITANIUM WHITE

Barry McCarthy lives in Ontario, Canada

I orchestrated color temperature to lead the eye.

Columbia River Flats, acrylic, 22 x 18" (56 x 46cm)

my inspiration

The Columbia River flows along a highway in the East Kootenays of British Columbia and whenever I drive sections of this road between Invermere and Golden, I get the urge to start a painting.

my design strategy

The focal point for the piece was established at the horizon, a bit to the right of center. Here the dark blue hills provide the backdrop for the greatest contrast with the brilliantly lit marsh vegetation. Once the focal point was set, then the slope of the distant mountains was used to help direct the eye to it. There is no sunshine on the foreground vegetation so that it does not compete with the highlight at the focal point. The majority of the mountains are also in shadow to keep them from becoming too interesting.

my working process

- In acrylic landscapes I nearly always start at the sky and work forward from the most distant to the foreground, because quick-drying acrylic is easy to work in successive layers. In this instance, the large portion of foreground water was treated as if it was a sky upside down. The entire surface of the lower half of the canvas was covered in blue layers of sky and mountains before any of the marsh vegetation was put in place.

- The immediate foreground water, though, was made much darker than it would have been if it was a sky. Viewing a reflective surface at this steep angle means that much of the light from the sky does not reflect and the surface of the water at the bottom of the image is consequently much darker than one might expect. This dark foreground is very useful in keeping this area from being competition with the focal point.

- When the paint of the reflection was dry, the rushes and cattails

were added on top of the water. I was careful to create a pathway of open water that formed an "S" shape to take the eye to the focal point. The bright area where the sun is striking the dead reeds was enhanced at the end to brighten this important part of the painting.

what I used

support
Canvas

brushes
1/4", 1/2", 2" soft flat brushes

acrylic colors

Phthalo Cerulean Blue
Naples Yellow
Ultramarine Blue
Cadmium Orange

Quinacridone
Magenta
Raw Sienna
Cobalt Blue

Payne's Gray
Hooker's Green
Burnt Sienna
Raw Umber

Mark Hobson

ARTIST
94

Mark Hobson lives in British Columbia, Canada → www.markhobson.com

Capturing a fleeting moody moment was my challenge.

Stillwater - A Touch of Heaven, oil, 20 x 30" (51 x 76cm)

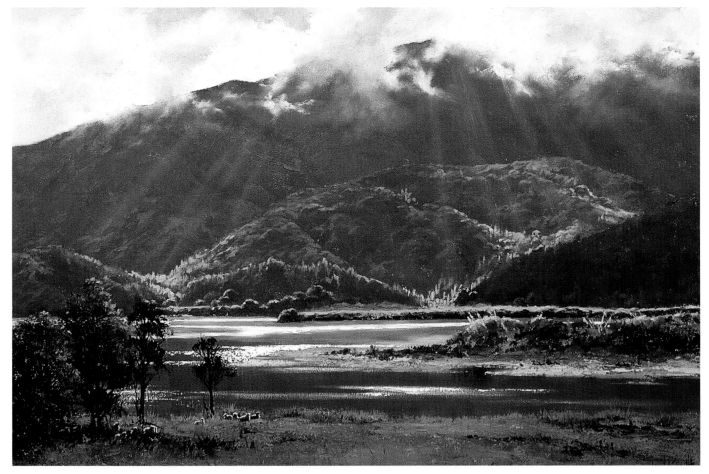

my inspiration

My inspiration for this painting was the unique atmospheric light and color that changed as I watched it. Sketching quickly, I was challenged to capture the moment, the luminosity of the sunlit clouds, the sparkling light upon the water and the soft rays of sunlight touching the distant hills.

my design strategy

For my composition, I kept my eye level low to emphasize the height and contour of the rolling hills & the long rays, giving the viewer a good eye-path to the focal light playing on the river. The diagonal foreground lines of the river and trees gave shape, variation and eye-path. Important to me was the choice of a limited palette helping to create harmony.

my working process

- Gathering my location work, I drew up a working composition.

- My composition was drawn onto my canvas with charcoal and fixed before a coat of Yellow Ochre and Cadmium Red acrylic was washed over. I brushed in my distant hills' blue values quickly and thinly, allowing the warm underpainting to show through. I deepened and warmed them slightly as I moved toward the eye level.

- The water color was also painted in at this stage. The darker tones of the foreground trees were knifed in, along with the river bank's cool shadows.

- I was then ready to paint in some warm color, starting with the river flat sands (graying them into the distance) and the foreground grass. My light sky was brushed in next with the warm gray clouds worked in and around the light. The distant foliage colors were scumbled on with a painting knife and softened with a brush, as were the foreground trees.

- Finally, when touch dry, the rays of light were dry-brushed in, determining where all other light would fall: on the water, distant hills, riverbank, trees and grazing sheep.

what I used

support
Stretched canvas

brushes
#10, #20 Filberts
#10 Synthetic chisel
#1 Rigger
Painting knife

oil colors

Titanium White	Yellow Ochre	Cadmium Yellow	Light Red
Alizarin Crimson	Cobalt Blue	Raw Umber	Ivory Black

Gail Boyle lives in Auckland, New Zealand → www.gailboyleart@ihug.co.nz

I love to use the painting knife on landscapes. It allows rough and smooth textures in thick paint.

Rocky Mountain Summer, oil, 18 x 24" (46 x 61cm)

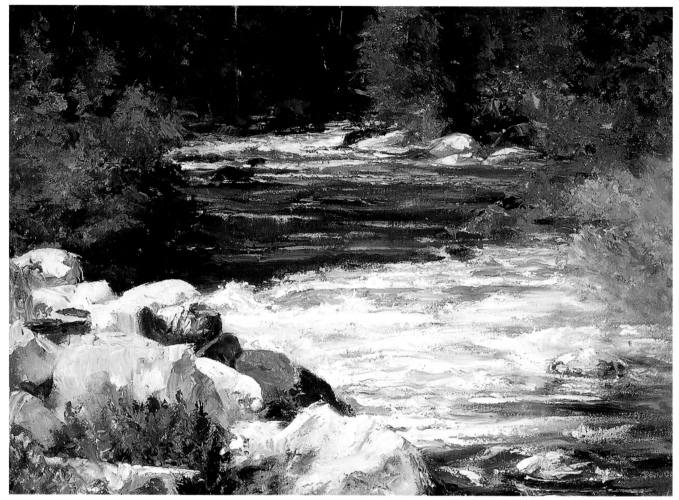

my inspiration

The dark mysterious woods, and the bright sunlit rocks and water, were in sharp contrast. The stream of sunlight across the dark area formed the perfect focal point.

my design strategy

- I planned the three main values in different amounts. The foreground would be the lightest and largest value. The background would have a smaller amount of the medium value. In this area the darkest value would be above the focal point.
- I decided to keep the woods and rocks soft and low contrast, so the horizontal lines of the water would predominate.

my working process

- I used Cadmium Red Light acrylic very thin to coat the canvas and let it dry.

- I used Burnt Umber and Ultramarine Blue in a very thin mixture to sketch lightly the large masses and then heavier to establish the middle and dark values. With the darkest mixture I added more Ultramarine Blue and a bit of Alizarin Crimson.
- I then started using a modified painting knife to work in the next lighter values. I used Cerulean Blue and white in the water next to the focal point.
- I used Ultramarine Blue with a touch of Burnt Umber in the middle values of the rocks and the water.
- In the foreground, I used a little of this mixture with a small amount of white for the lighter values. I added a bit of Ultramarine Blue to white and followed the pattern of the water, leaving small amounts of the Cadmium Red Light-stained

canvas showing through where the values of the paint were close.
- A bit of Cadmium Yellow Light in White on the rocks and water gave the sun effect. I also added this yellow to the green mixture for the front bushes to bring them forward.

- To finish up, I put a small amount of white on the water at the focal point. I then ran the painting knife up very lightly through the light areas on the water, softening the edges, and added a few dots of white for sparkle.

what I used

support
Smooth canvas

oil colors

brushes
#8, #10 Filberts
Painting knife

BR Gates

B R Gates lives in Texas, USA → B-R-Gates-Art.com

ARTIST
96

The large, stable elements of this composition set the stage for the natural drama I invite the viewer to enjoy.

Evening Cypress, acrylic, 48 x 24" (122 x 61cm)

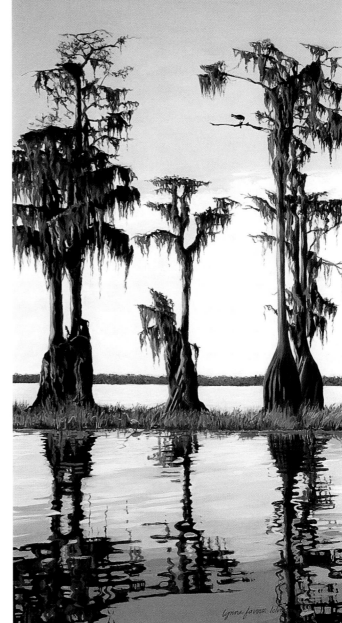

my inspiration

My inspiration was the evocative beauty of the cypress trees that abound on the Central Florida lakes where I grew up.

I took many photographs to help me construct a painting that conveys the colors and textures as afternoon begins to move to evening.

my design strategy

In many ways the composition of this piece is static because of the very strong verticals and horizontals. There is a symmetry created by the large trees anchoring either side of the composition; this is compounded by the symmetry presented by the reflection on the water. To give a sense of depth to the piece, I needed to balance the values of the trees in the foreground, those reflected in the water and the trees on the horizon.

my working process

- I selected a 48 x 24" canvas to emphasize the vertical composition.
- Since this painting was so large, I premixed many colors of acrylic paints (adding retarding medium to extend drying time) so that I would be able to work quickly as I blended areas of the painting. These premixed colors were helpful in any touch-ups required for the large un-patterned areas of the piece.
- I roughed in the entire composition, taking advantage of my grid.
- Then, working from light to dark, I blocked in the sky and water using glazing medium to blend areas of changing color. At this point I was painting over the previously roughed-in trees. The transparency of the acrylic paint allowed me to still see the rough shapes of the trees as I began to work back into them and refine their shape and color. Through the whole process, I would work on many areas of the painting at the same time in order to bring each area to the same level of completion as the work progressed.

what I used

support
Canvas

brushes
#0 - #12 Synthetic rounds
Brights
Filberts

medium
Acrylic glazing medium
Retarding medium

acrylic colors

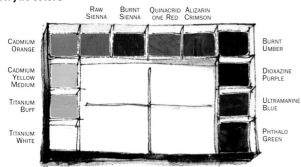

CADMIUM ORANGE
CADMIUM YELLOW MEDIUM
TITANIUM BUFF
TITANIUM WHITE

RAW SIENNA
BURNT SIENNA
QUINACRID ONE RED
ALIZARIN CRIMSON

BURNT UMBER
DIOXAZINE PURPLE
ULTRAMARINE BLUE
PHTHALO GREEN

Lynne Farmer Lehman

ARTIST
97

Lynne Farmer Lehman lives in Georgia, USA → www.lynnefarmerlehman.com

I used symbolic and historic gold to convey the vibrancy of light in this landscape.

Mist and Light, Rakaia River, New Zealand, acrylic, 30 x 40" (76 x 102cm)

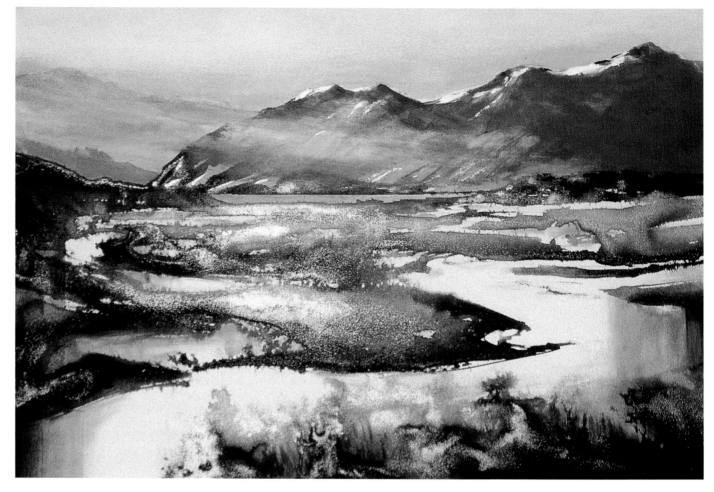

my inspiration

I draw on the beautiful use of gold throughout art history to convey the vibrancy of light in landscape. Influencing me have been ancient artifacts in museums, illuminated manuscripts and icons, and the works of Gustav Klimt. In some paintings I use the high color of modern colorists, and design elements from Mondrian and the Cubists.

my design strategy

For this painting a photograph captured the atmospheric moment. The eye path follows complex river towards the brilliance of the light, catching the cliffs beneath the mist. Dark colors were chosen to contrast with the metallic gold.

my working process

* The general plan is of fundamental importance, and I draw this most freely on a large flat canvas using diluted acrylic in a fine-tip squeeze bottle.
* Having 40 years of watercolor experience, I then try to achieve the flawless washes of England's J.S. Cotman, and the later adventurous American watercolor school.
* Then, dark or colored areas contrast with sharp-edged white as design elements. Metallic gold or copper acrylics give the final punch, sometimes dramatic, but often subtle.

my main challenge

In this type of landscape, the challenge is to leave out distracting detail to courageously achieve the drama. Long experience with large washes helps to use them in sweeping artistic shapes, which create a satisfying design. This process must fulfill the original vision.

what I used

support
Gesso-primed canvas

brushes
Broad bristle brushes for washes
Fine flats for hard edges

acrylic colors

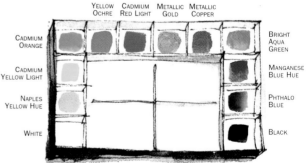

Harold V. Coop lives in Auckland, New Zealand → www.newzealandpainting.com

Ground shadows anchor the dunes and describe the contours of the surface upon which they fall.

Dune Shadows, watercolor, 22 x 30" (56 x 76cm)

my inspiration

I've lived in Florida for over 35 years and I've never tired of painting the coast. I enjoy the challenge of painting new and imaginative ways of showing it.

my design strategy

My strategy was to use the vegetation to lead the viewer from the bottom of the painting into the dune where the windblown sea oats guide the eye to the seagull. The long shadows anchor the dune and show the undulating contour of the surface. The shadows, because they reflect the sky, are kept cool. I keep my palette limited to as few colors as necessary.

my working process

- I usually work from a small tonal pencil sketch with color notes.

- Because I wanted this painting to be a transparent watercolor, I applied a little masking fluid to the sailboats and seagull and to the tips of the sea oats to preserve the white of the paper. I allowed it to dry.

- Then I wet the entire sky area and painted the clouds using Ultramarine Blue and Burnt Sienna. After that dried, I painted the water using Gamboge, Viridian and Ultramarine Blue.

- I painted the dune shadows using the same color combination as the sky. I removed the masking fluid and painted the sea oats using Ultramarine Blue, Gamboge, Burnt Sienna and Burnt Umber, going from light to dark.

what I used

support
300lb cold press watercolor paper

brushes
Red sable

watercolors

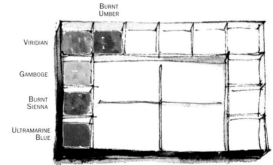

Tom Bond

ARTIST
99

Tom Bond lives in Florida, USA → www.tombondart.com

When anchored by more realistic background areas a large foreground allows for creative abstraction.

Where the Moors Meet the Sea, oil, 24 x 24" (61 x 61cm)

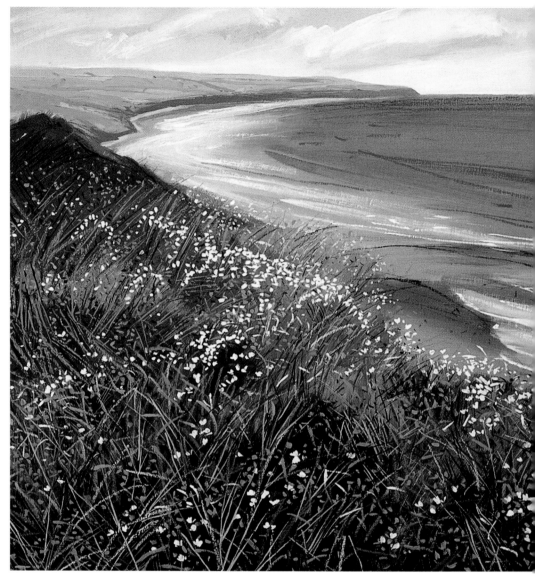

my inspiration

The genre of traditional landscape painting occupies an essential part of my work. As soon as I came across this sweeping clifftop view, I knew I had to secure it as one of my coastal subjects.

my design strategy

I often look for subjects that give me large areas of foreground. Such areas provide me with opportunities to scribble and stroke paint down in a loose and semi-haphazard way. I can apply the paint in marks and flourishes without trying to illustrate, for example, grasses, meadow flowers and other vegetation. An abstract element such as in this painting is anchored down as "visual play" when middle distance or background areas are represented in more realistic terms.

my working process

- The first mark made is in pencil on primed white board and declares where the horizon is to be. Then I lightly establish the curvature of the land and the generous foreground area. This is to be blocked in with black to provide ground for the inventive hatching and pattern making, to be applied later. I then return to the high horizon and lay in some soft cream and blue tones of the sky.

- Next, I use greens for the cliffs — the same greens I will use for the grass at the bottom half of the picture, but with a touch of Blue and White to subdue the intensity of the color and help the distant cliffs appear to be miles away into the fading scene.

- The first coat of Monestial Blue is applied with its edge blunted with white and a little black. A gray tone warmed with Yellow Ochre is added in the center-right of the composition where beach shale is to be located as the painting takes shape.

- All this paint is allowed to dry before further modeling, then finer detail and line made with oil pastel helps indicate the cliff top growth.

what I used

support
Primed white board

other materials
Oil pastels

oil colors

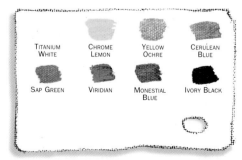

TITANIUM WHITE CHROME LEMON YELLOW OCHRE CERULEAN BLUE

SAP GREEN VIRIDIAN MONESTIAL BLUE IVORY BLACK

Alan Morley

Alan Morley lives in Middlesbrough, UK → alanmorleyartist@hotmail.com

ARTIST
100

Terms you should know

abstracting Taking from reality, usually simplifying, to suggest a general idea. Not necessarily related to real forms or objects.

acid free For greater permanance, use an acid free paper with a pH content of less than 7.

acrylic Viewed historically, this is a fairly recent member of the paint family. Acrylics are waterbased, so they can be diluted to create thin washes, or they can be mixed with various mediums to make the paint thicker or textured.

aerial perspective Dust, water droplets and impurities in the atmosphere gray off color the further away it is from us. These impurities block light, filter reds and allow blues to dominate, so that in the distance we see objects as less distinct and bluer. This is an important point for landscape painters to grasp. Objects in the foreground will be sharp, more in focus and will have more color.

bleeding Applies mainly to watercolor where the pigment tends to crawl along the surface outside the area in which it was intended. Can be a good or a bad thing, depending on your intention.

blending Juxtaposing colors so that they intermix, with no sharp edges. Applies to pastel, where you blend colors by rubbing them with fingers or paper stumps, and to oil, where you would use a broad soft brush to blend colors.

body color Mainly gouache or opaque paint, as opposed to transparent paint. Can be used to create richness of color or to cover up errors. Chinese White (a zinc opaque watercolor) is often used to restore or create highlights. Many watercolor purists insist that a watercolor painting should only be created using transparent pigments, but countless leading artists use opaque paint in moderation. That is the key — only use opaque color on transparent watercolor paintings very sparingly.

brushes
Wash A wide, flat brush used for applying washes over large areas, or varnishing.
Bright A flat paintbrush with short filaments, often called a short flat.
Filbert Similar to a flat brush, with rounded edges.

Round A pointed brush used in all mediums.
Spotter A brush with a tiny, pointed head which is used for fine details.
Liner/Rigger A brush with a long brush head used for fine detailing.
Fan A crescent-shaped brush head for blending and texturing.

brush sizes The size of flat brushes can be expressed in inches and fractions of an inch measured across the width of the ferrule, or by a size number. A 1" brush is roughly equivalent to a no. 12 and a no. 6 brush will measure about ½".
 The size of a round brush is the diameter in millimeters of the brush head where it emerges from the ferrule. For instance no. 5 measures 5mm (¼ inch) in diameter.
 Be aware that sometimes brush sizes may vary slightly between brands, even though they may both be labelled say, no. 10 round. Instead of choosing numbers, choose a quality brush in the size you prefer.

canvas Mainly for oil painting. Canvas can be bought in rolls, prestretched or already stretched with support strips or mounted on a still backing.
Canvas is fabric which comes in cotton, linen and synthetic blends.
 Linen is considered better than cotton because of its strength and appealing textured surface. Newer synthetics do not rot and do not sag. You can buy canvas raw, (with no coating), or primed, (coated with gesso), which is flexible with obvious canvas texture. You can also buy canvas that has been coated twice — double-primed canvas — that is stiffer with less texture.
Canvas board is canvas glued to a rigid backing such as cardboard, hardboard or wood. Note that cardboard is not suitable for serious work because cardboard is not acid free, and will not last.
 Wood and hardboard must be prepared properly.

cast shadow A cast shadow is one thrown onto a surface by an object blocking the light. It is important to remember that the edges of a cast shadow are not sharp.

center of interest (focal point) This is the area in your painting that you want to emphasize. It is the main point. You can create a center of interest with color, light, tone, shape, contrast, edges, texture, or any of the major design elements. Any

center of interest must by supported and balanced by other objects. And do not simply place your center of interest smack in the center of your painting! Make it your mission to learn something about the elements of design.

chiaroscuro This is an Italian word meaning light and dark. In art is means using a range of light and dark shading to give the illusion of form.

collage A work that has other materials glued on, including rice paper, paper, card, cloth, wire, shells, leaves.

color temperature This term refers to the warmness or coolness of a paint. Warm colors are those in the red, orange, yellow, brown group. Cool colors are those in the blue and green group. However, there are warm yellows and there are yellows with a cooler feel to them.

composition and design Composition refers to the whole work, while design refers to the arrangement of the elements.

counterchange When you place contrasting elements — dark against light.

drybrush Mainly for watercolor. If you use stiff paint with very little water you can drag this across the paper and produce interesting textured effects.

frisket Frisket fluid (masking fluid) can be painted over an area to protect it from subsequent washes. When you have finished the frisket can be rubbed off. You can also use paper frisket that you cut to fit the area to be covered.

gesso A textured, porous, absorbent acrylic paint that is used mainly as a preparatory ground for other mediums such as oil or acrylic.

glaze A thin, transparent layer of darker paint applied over the top of a lighter wash. This richens, darkens, balances, covers up or adds luminosity.

high key/low key The overall lightness (high key) or darkness (low key) of a painting.

impasto Applying paint thickly for effect.

lifting Removing pigment with a brush, sponge or tissue.

Collect all these titles in the Series

**100 ways to paint
STILL LIFE & FLORALS
VOLUME 1**

ISBN: 1-929834-39-X
Published February 04
AVAILABLE NOW!

**100 ways to paint
PEOPLE & FIGURES
VOLUME 1**

ISBN: 1-929834-40-3
Published April 04
AVAILABLE NOW!

**100 ways to paint
LANDSCAPES
VOLUME 1**

ISBN: 1-929834-41-1
Published June 04
AVAILABLE NOW!

**100 ways to paint
FLOWERS & GARDENS
VOLUME 1**

ISBN: 1-929834-44-6
AVAILABLE NOW!

**100 ways to paint
SEASCAPES, RIVERS
& LAKES
VOLUME 1**

ISBN: 1-929834-45-4
Publication date: October 04

**100 ways to paint
FAVORITE SUBJECTS
VOLUME 1**

ISBN: 1-929834-46-2
Publication date: December 04

How to order these books

Available through major art stores and leading bookstores.

Distributed to the trade and art markets in North America by

F&W Publications, Inc.,
4700 East Galbraith Road
Cincinnati, Ohio, 45236
(800) 289-0963

Or visit: www.artinthemaking.com